CHATS
ON OLD SILVER

SILVER-GILT CUP AND COVER
GEORGE II, 1746

By Peter Taylor

(*By courtesy of Tessiers Ltd.*)

CHATS
ON OLD SILVER

BY

ARTHUR HAYDEN

Edited by
CYRIL G. E. BUNT

Revised, with a new Chapter
on American Silver by
JESSIE McNAB DENNIS
Assistant Curator of Western
European Arts, The Metropolitan
Museum of Art

DOVER PUBLICATIONS, INC.
NEW YORK

Published in Canada by General Publishing Company, Ltd., 30 Lesmill Road, Don Mills, Toronto, Ontario.
Published in the United Kingdom by Constable and Company, Ltd., 10 Orange Street, London, WC2.

This Dover edition, first published in 1969, is a newly revised and enlarged edition of the work which was first published in 1915 and which in 1949 was revised by Cyril G. E. Bunt and published by Ernest Benn, Limited. A new chapter on American silver has been specially written for this Dover publication by Jessie McNab Dennis, who also made extensive revisions in the original text and selected new illustrations.

Standard Book Number: 486-22086-9
Library of Congress Catalog Card Number: 69-17528

Manufactured in the United States of America
Dover Publications, Inc.
180 Varick Street
New York, N.Y. 10014

PUBLISHER'S NOTE

THIS third revised edition of *Chats on Old Silver* includes a chapter on American silver written especially for this Dover publication by Jessie McNab Dennis, Assistant Curator of Western European Arts at the Metropolitan Museum of Art. Mrs. Dennis has also made further revisions and additions to the text on English silver as it was published in 1949. A number of illustrations appearing in the second revised edition have been replaced and a few new ones have been added, bringing the total number in the book to 133. Revisions to the 1949 text consist largely of descriptions of these illustrative replacements. Other interpolations include translations of Latin inscriptions, definitions of technical terms used, clarification of some historical references which might otherwise have been unfamiliar to American readers, a few changes of dating in the light of more recent research, and correction of minor printers' errors.

FOREWORD TO REVISED EDITION

OVER thirty years have passed since Arthur Hayden first published these *Chats on Old Silver*. In 1915 we were in the throes of the First World War and since then have passed through a second and more devastating conflict, leaving collectors, surprisingly enough, more interested than ever before in the subject of old silver. During these thirty years the book has been three times reprinted, so great has been its popularity. In spite of these new impressions, the volume has long been out of print and has been unprocurable even through second-hand book shops. The latter fact proves incontrovertibly the intrinsic popularity of a book which, once secured, is never discarded by its owner.

No excuse is needed, therefore, for the issue of a new and revised edition. At the same time, it has been felt that it should be kept as nearly as possible in the form in which its author left it, for to have materially altered its format would have taken from this deservedly popular book just those features which have been one reason for its popularity in the past. Some slight textual alterations have, however, been made—alterations which, it is felt, will make the book still better than it was.

In the process of revision the present writer has been agreeably impressed by the general accuracy of the original text and the thoroughness with which the intricacies of hall-marking have been marshalled and explained. In all essentials the subject-matter can never be out of date.

7

CHATS ON OLD SILVER

Only two matters call for special remark here as being the subject of material alteration.

One of these, and the more important, is that of the illustrations. It has been found impossible in many cases to obtain new photographs of the pieces which formed the plates in Hayden's original edition. A considerable number had been selected from fine examples then in the hands of dealers, which have long since been dispersed in various collections. It has therefore been found necessary to replace most of them with photographs of other examples equally suitable and to alter the text to meet these new conditions. For permission to make use of these and other photographs the publishers have to thank the Directors of the Victoria and Albert Museum, the Royal Scottish Museum and the Metropolitan Museum of Art, New York; Commander How, Messrs. Tessiers Ltd., S. J. Phillips, Messrs. Holmes Ltd., the Masters and Wardens of the Clothworkers' Company and the Mercers' Company, the Wardens of Christ's College, Cambridge, the Rev. J. A. Goundry of St. Mary Major, Exeter, the Rev. H. Ross of St. Augustine's with St. Faith's, and Mr Joseph Wilson for his Table of Marks on page 255.

The other matter which calls for remark is that of the Sale Prices quoted at the end of certain chapters. These were, of course, compiled in 1915 and have been retained because, keeping this in mind, they may be found to have a degree of interest for the present-day collector. But the prices of the past have very little practical use in these phenomenal post-war years for the ordinary collector of silver. A few recent prices have nevertheless been added to show how values have advanced since 1915. But a few hours spent at the salerooms from time to time will be a much better guide to the trend of the antique market; or, better still, a careful comparison of retail

8

prices in the shops—for we must remember that auction figures are not retail prices. Those who buy to sell again naturally expect to make some profit.

Moreover, to the enthusiastic collector the price of an article is of secondary importance, even though he may feel he is making an investment by purchasing. The true fascination of silver is its beauty; and the pleasure derived from its possession or use is the main source of its appeal. It is this conviction, kept in mind by Mr. Hayden throughout his book, which provides the primary ground for our belief that these *Chats on Old Silver* will supply a new generation of readers with just the information they need to help them.

September 1948. CYRIL G. E. BUNT.

AUTHOR'S PREFACE

THE study of old silver usually begins when the inquiring possessor of family plate sets himself the task of ascertaining the date and the probable value of some piece long in his family or possibly lately bequeathed to him.

With old china, and probably with old furniture, the taste for collecting is oftentimes an acquired one, but it is in the Englishman's blood to ruminate over his old plate, and the hall-marks of the assay offices in London and in the provinces, in Scotland and in Ireland, have been placed thereon with aforethought. The plate closet is cousin to the strong-box, inasmuch as the coin of the realm and gold and silver plate have been subjected to stringent laws extending over a period of five hundred years. The technical word "hall-mark" has become a common term in the language synonymous with genuineness. The strictest supervision, under the parental eye of the law, has upheld the dignity of the silversmiths' guarantees. Hence the pride of possession of old silver. Pictures, furniture and engravings whose ancestry is doubtful may come into the market without fear of the watchful official eye. But old silver bearing the hall-marks of ancient and honourable guilds of silversmiths, stamped at the accredited assay offices, is, with few exceptions, what it purports to be. It is a proud record and a splendid heritage.

In dealing with the subject of old silver in a volume of this size sufficient details have been given to enable the collector to identify his silver if it be in the main stream

of silversmiths' work. On the whole, except where it is necessary in certain fields to illustrate the only examples, sumptuous specimens have been avoided in the illustrations as being outside the scope of this volume and the public to whom it is intended to appeal.

The collector of old silver must have a pretty taste and a fine judgment. It is not an absolute law that age determines beauty. Hall-marks, though they denote date, do not guarantee excellence of design. Everything that bears the hall-mark of the Goldsmiths' Hall of London is not beautiful, whether it be old or whether it be new. The connoisseur must digest the fact that the assay marks of the lion, the leopard's head, the date mark, and the rest, are so many official symbols, accurate as to date and sufficient guarantee as to the standard of the metal, but meaningless in regard to the art of the piece on which they stand. The assay offices are merely stamping machines. What Somerset House is to legal documents so the assay offices are to silver and gold plate, and nothing more. Hence the necessity of placing such mechanical control under Government supervision.

The excellence of a piece of plate is governed by the same laws which control all other branches of decorative art.

Rarity is a factor not especially considered in this volume. Rare specimens are not necessarily beautiful even though they be unique.

In covering so wide a field in so small a volume, much has had to be omitted. There are many volumes on old English silver plate, but, in regard to research, the work of Mr. C. J. Jackson, *English Goldsmiths and their Marks*, with over eleven thousand marks, stands alone and supplants all other volumes. Every collector regards this work as the bible of silver-plate collecting.

I have given sufficient space to marks in the present volume to indicate those used by the London and other assay offices. Some marks are given which do not appear elsewhere, and the arrangement of the tables should enable the beginner to come to a definite conclusion as to the date of his silver. In particular, the Table of variations in the shapes of shields, in the hall-mark and standard-mark employed at the London Assay Office from the accession of Queen Elizabeth to the present day, is a feature not before given in so concise a form in any other volume.

The marks on silver are stamped. The design thus appears in relief, while the edges of the shield on which it appears are sunk. The reproduction of this has offered a difficulty in illustration in all volumes on old silver. To print black letters or designs on a white background, although easy, is unsatisfactory. On the contrary, to print the raised design in white on a dead black background is not a realistic presentation of the mark as it appears to the eye. After many experiments I have reproduced the marks in a manner more closely approaching their actual appearance, and less suggestive of black-and-white designs on paper.

I have to express my thanks for the kind assistance I have received in regard to photographs and wax casts and drawings of marks, and for permission to include them in this volume as illustrations, to the following: the authorities of the Victoria and Albert Museum, the British Museum, and the Royal Scottish Museum, Edinburgh. By the courtesy of the Worshipful Company of Clothworkers and the Worshipful Company of Mercers I am enabled to reproduce some fine examples from their Halls.

It, is, therefore, my hope that this volume will stand

AUTHOR'S PREFACE

as an authoritative outline history of the subject of which
it treats, that it may point the way to possessors of old
silver to arrive at sound conclusions as to their heirlooms,
and that it may indicate to collectors the salient features
of their hobby.

January 1915. ARTHUR HAYDEN.

CONTENTS AND ILLUSTRATIONS

CONTENTS AND ILLUSTRATIONS

CHATS ON OLD SILVER

CONTENTS AND ILLUSTRATIONS

CHATS ON OLD SILVER

CHAPTER ONE

THE MARKS STAMPED UPON SILVER

I

THE HALL-MARK

THIS is the mark stamped upon gold or silver plate by a recognized guild, and signifies that the object so stamped has successfully passed the test applied to it. Officially known as the "assay," the test determined that the legal proportion of copper alloy to pure silver in the wares had not been exceeded. "In this country the system has existed substantially in its present form since the reign of Edward I."[1] In 1300 a law was passed requiring that all silver made in England was to be as good as the silver coin or better, and provincial silversmiths (one from each centre) were to proceed to London to have their work assayed and have the mark of the leopard's head stamped upon it. For six centuries the hall-mark of the wardens of the "Mistery of Goldsmiths" of the city of London has stood as a guarantee of quality. It should be understood that the goldsmith's usual material was silver, because of the far greater cost of working in gold.

This hall-mark, or town mark as it came to be known later, denotes the place where the assay was made. It was struck on all such articles as would bear the "Touch"; this is the technical term synonymous with assaying. As will be seen subsequently, the hall-mark does not stand alone. Very early it was deemed expedient to stamp some

[1] Report of the Select Committee of the House of Commons on the Hall-marking of Gold and Silver Plate, 1879.

further mark, which should denote the date when the piece was actually assayed at the hall or assay office.

This second assay mark, or warden's mark, is known as the date letter.

The Company of Goldsmiths in London, incorporated by charter in 1327, possessed plenary powers which they exercised with considerable rigour. They framed stringent regulations determining trade customs, they kept a watchful eye on recalcitrant members who showed any tendency to lower the dignity of the craft, and they punished with severity all those who counterfeited the official marks of the hall.

This dominance over the everyday transactions of the worker in plate was supported by a series of Acts of Parliament extending over a lengthy period. They are highly technical, and the study of hall-marks is of a complex nature, and adds no inconsiderable task to the hobby of collecting old silver. In the main it will be seen that the power at first exclusively conferred on the London Goldsmiths' Company, and afterwards distributed to various assay offices in the United Kingdom, has been kept under due subjection by the Crown and by parliamentary legislation. There is no trade more protected by Acts of Parliament governing the details of its procedure. The fashioning of gold and silver plate being so intimately related to questions of currency and affecting the coin of the realm, it is not surprising to find that the tendency of legislation has been to relieve the old guilds of much of their former power. We find that one of the recommendations of the Select Committee of the House of Commons on hall-marking, in 1879, was that the whole of the assay offices should be placed under the supervision of the Royal Mint, in order that a uniform standard of quality should be guaranteed.

THE MARKS STAMPED UPON SILVER

We have seen that the London assay office is the oldest of assay offices. At first, plate, although wrought elsewhere, had to bear the London hall-mark of the leopard's head. Seven more cities were appointed, by a statute of Henry VI in 1423, to exercise the right of assaying plate, viz. Salisbury and Bristol for the West Country, Newcastle and York for the North Country, Coventry for the Midlands, Lincoln and Norwich for East Anglia, and London, of course, continued its functions.

Eighteenth-century Assay Offices

At the beginning of the eighteenth century three out of these seven, Lincoln, Salisbury, and Coventry, had discontinued to assay silver, and it was not thought necessary to reappoint them. In 1700 York, Bristol, and Norwich were, in the reign of William III, reappointed for assaying and marking wrought silver. By the same Act, 12 William, *cap.* 4, two new assay offices were appointed, Exeter and Chester, and in the beginning of the following reign by 1 Anne, *cap.* 9, Newcastle was also reappointed. At the end of the eighteenth century, in 1773, two additional assay offices were created at Birmingham and at Sheffield by 13 George III, *cap.* 52. London, during all this time had continued to assay silver in unbroken continuity from the fourteenth century.

It has been estimated by those who have a large quantity of old silver plate passing through their hands, that, in spite of the number of provincial assay offices, over 90 per cent. of old English silver bears the London hall-mark.

The Hall-marks of the Various Assay Offices

In the Appendix (pp. 247-301) are illustrations showing the various hall-marks used at different periods by the wardens and assay masters of the appointed cities. The

23

following indicate the chief marks used. London: the leopard's head, sometimes like the king on a pack of cards, and later, when uncrowned, like a cat's head; Chester: an upright sword between three wheatsheaves; Newcastle (closed in 1884): three castles set in a shield, two over one, similar in arrangement to the Chester wheatsheaves; Exeter (closed in 1883): the letter X with crown above (early mark), three castles, sometimes joined together as one castle with three towers, similar to Edinburgh mark (after 1701); Norwich: castle above with lion beneath, the castle less like a castle than any other of the castle marks; York (closed in 1856): fleur-de-lis, showing only half, the other half a leopard's head (early mark), later mark a shield with cross of England and five lions; Birmingham: an anchor; Sheffield: a crown; Edinburgh: a castle with three towers; Glasgow: a tree with a bird perched on top and a tiny bell suspended from boughs, a fish transversely across the trunk; Dublin: a harp crowned; Cork: ship or castle, two marks.

The Varying Number of Marks Used

It is an interesting fact, but puzzling to beginners in the study of hall-marks, to find that the provincial offices sometimes used, in addition to their own place-marks, the leopard's head of the London assay office. From 1697 to 1719 the leopard's head disappears from all silver, for the reason which is given in detail in Section V of this chapter—"The Higher Standard Mark" (pp. 40-48). In its place two other marks occur—the lion's head erased and the figure of Britannia. These were only used in London between the years 1697 and 1701, during which five years provincial offices ceased to assay any silver. This is a hiatus in provincial marks which the beginner should note. From 1701 to 1719 the provincial offices used their

place-marks together with the two new marks (the lion's head erased and the figure of Britannia), which were compulsory by law. This law was repealed in 1719 and London reverted to the old style mark of the leopard's head, so that London-marked silver of 1720 is marked with the same number of marks as before the Act of 1697, that is four marks. But it appears that the provinces for a long period did not revert to the old style of marking. Newcastle, for instance, adds the leopard's head from 1720 in addition to the town mark; Exeter and Chester similarly took the leopard's head in 1720.

The result of this is that before 1701 Chester had four marks, sometimes only three, but after 1720 five were used; when the duty mark was added (see p. 289) six marks were employed. The leopard's head was not discontinued till 1839, reducing the marks to five, and now, since the abolition of the duty mark in 1890, there are only four. Exeter had, with the use of the leopard's head, five marks, but in 1784 the leopard's head disappeared. Newcastle continued using the leopard's head during the period of the duty mark, thus making six marks, till the closing of the office in 1884.

II

THE STANDARD MARK

Throughout the history of the manufacture of English silver plate the standard maintained has always been equal to that of the silver coinage, and sometimes higher. The control of the standard has long been in the hands of the State, and, it has already been shown, the proving or assaying of all articles, in order that they may

be officially stamped as of sterling silver, was allocated to the wardens and assay masters of the London and provincial assay offices. Obviously, had it been allowed to manufacture silver plate at a lower standard than the coin of the realm, the latter might have been melted down to be made into plate at a profit. In order to regulate the uniform procedure of the trade throughout the country the amount of alloy to be added to silver was very clearly laid down by law. A standard for silver has been in force for six hundred years, since the reign of Henry II, viz. 11 oz. 2 dwts. of silver and 18 dwts. alloy in every pound troy of plate;[1] that is 925 parts of silver in every thousand parts. From the year 1697 to 1720 the standard was fixed at 11 oz. 10 dwts. of silver to the pound troy, that is ·958. This higher or "Britannia" standard is described in Section V of this chapter (pp. 40-48). In regard to this new standard, that is a standard above the sterling of the coin of the realm, special marks were used during the above period and have been used since then to the present day whenever silver plate is of the new standard. It was illegal to make silver plate of less than this new standard during the period 1697 to 1719 (i.e., 1719-20); after this period there are two standards, the higher being optional.

Another period when silver plate was higher in standard than the silver coin of the realm was during a portion of the reigns of Henry VIII, the whole of the reign of Edward VI, and the whole of the reign of Mary, until Elizabeth in the second year of her reign elevated the debased coinage to its former standard of fineness. In 1543 Henry VIII reduced the standard from 11 oz. 2 dwts. to

[1] Silver was weighed by the troy pound—20 pennyweights (dwts.) to one troy ounce, 12 troy ounces to one troy pound.

THE MARKS STAMPED UPON SILVER

10 oz.; that is, ten parts of silver to two parts of alloy. In 1545 he reduced it further to 6 oz. in the pound troy, that is half silver and half alloy. In 1546 he made a still further reduction to 4 oz., so that silver coins of that period contain only one-third silver. In 1552 this was increased to 11 oz. 1 dwt., to be reduced to 11 oz. in Mary's reign. During all these changes the silver plate remained true to its old standard, and, as though in proud superiority over the coin of the realm, the London Goldsmiths adopted in 1545 as a standard mark a new stamp—*the lion passant*, which has been their standard mark from that day to the present time, and has been recognized by many statutes since that time as constituting the standard mark, or sterling mark of the State, or, as it was termed at the time of Queen Elizabeth, "Her Majesty's Lion."

On two occasions, therefore, the silver plate of this country was of finer quality than the coin of the realm: on the first when the coin of the realm was debased, and on the second when silver plate was compulsorily raised to a higher standard than the coin of the realm.

The lion *passant*, which is the standard mark, has naturally been employed by provincial offices as a guarantee of sterling or standard silver. During the period 1697 to 1720 the lion *passant* disappears from all silver in the "Britannia" standard period when other marks were substituted. But in 1720 the lion *passant* mark occurs again on all London silver, and in Chester, Exeter, York, and Newcastle marks. From 1773 both Sheffield and Birmingham have used the mark of the lion *passant*. Scotland and Ireland used their own national symbols as the standard mark. Edinburgh, from 1759, used a thistle; Glasgow, from 1819, a lion *rampant*. Dublin from the year 1638 used a harp crowned. These marks are shown in the Appendix (p. 301).

III

THE DATE MARK

Among the various marks used for the purposes we have indicated, the date mark is one which has a vital significance. It establishes with certainty the year in which a piece of silver was taken to the assay office to be stamped as sterling silver. The easiest plan in regard to date marks would have been to stamp the actual date upon each piece of silver or gold assayed, but this was too simple a procedure for the "Mistery of the Goldsmiths." They employed alphabets of various styles and each year was represented by a different letter, and to add further to the puzzling difficulty of deciphering these symbols, certain letters were omitted. The date letter was changed in May of each year. Throughout this volume, therefore, the years quoted as corresponding to the date letters should be understood to represent the latter half of one year and the first half of the year following. Thus "1700" infers "1700-1701." Moreover, each assay town has its own series of date marks. Letters of the alphabet are used sometimes from A to T, or A to U, or from A to Z; sometimes the letters J and V are omitted, and in one case for a considerable period the letters of the alphabet were used indiscriminately. Various kinds of type were used and they appear in shields of differing shapes. The study therefore of the date marks of the London assay office and of the various provincial assay offices together with the date marks used in Scotland and in Ireland is very intricate, and the determination of these with exactitude might occupy a man the greater portion of his life. The standard work on the subject is *English Goldsmiths and their Marks*, by Mr. C. J. Jackson, which contains over

thirteen thousand marks reproduced in facsimile.[1] Jackson's labours were stupendous; the last (1921) edition represents a quarter century's work. There is no other book on the subject within measurable distance of this encyclopædic work.

In the present volume only a limited number of marks can be illustrated, but the author has given typical examples covering the London marks, which are the most important, and a few examples from most of the provincial assay offices as well as from Scotland and Ireland. These will be found in the Appendix (pp. 249–301).

London

The Goldsmiths' Company of London has an honourable and ancient history and must be regarded as the leading spirit in regard to hall-marks. It is admitted that, from a public point of view, the hall-marks stamped on silver by the various assay offices have a very definite meaning. "Our hall-marks afford a guarantee of value to which, it is not to be wondered at, considerable importance attaches, since these goods may safely be regarded as an investment." The true function of the Goldsmiths' Company is a protective one—protective in the interests of honest traders, protective in the interests of public buyers. We suggest that they might perform an educational service by throwing open their assay office to public inspection. Neither the Royal Mint nor the Bank of England may be said to be an inaccessible holy of holies. The assaying of silver and gold is a process which affects the pocket of the public to a large extent.

As they are historic archives of no insignificant value, there is no reason why such records should not be as

[1] Reprinted in an unabridged clothbound edition by Dover Publications, Inc., 1964.

readily accessible to the general student as are the papers in the Public Record Office which divulge bygone State secrets. Possibly if the assaying were placed under Government supervision, as has so often been strongly advocated, these things might come to pass.

In regard to data undoubtedly the Goldsmiths' Company can claim an ancient record. They are proudly jealous of their reputation and rightly anxious to guard the public interest. There is no doubt that "the laws of hall-marking, scattered as they are over a multitude of statutes, are highly technical, and not the least necessary reform is their consolidation." The Goldsmiths' Company was once a trade guild, but this is the twentieth century, and they exist solely in the public interest. To-morrow they could be swept aside by an Act of Parliament, and all silver could be assayed and stamped at the Royal Mint or by Government assayers.

In regard to the date letters the London Assay Office has consistently, with one exception, 1696, adhered to twenty letters in each alphabet, that is from A to U (omitting J). But the provincial offices were woefully erratic and exhibit a looseness and want of system in not adhering to the same arrangement in alphabets of succeeding periods. It is not necessary to follow these eccentricities in detail; a few examples will suffice. Newcastle from 1702 to 1720 employed the alphabet in Church Text capitals as follows :—A (1702), B (1703), D (1705), F (1707), M (1712), O (1716), P (1717), Q (1718), D (1719), E (1720). Some of these were used for more than one year. In the next two periods, 1721 to 1739 and 1740 to 1758, the alphabet ends at T. Later alphabets run to Z. Chester employed alphabets variously ending as described on p. 288.

The result of the somewhat chaotic alphabet marks has

been to focus the attention of the collector too much on this particular side of the subject. The identification of marks, the outward symbols of time and place, have reduced the study of old silver to a somewhat lower plane than it should occupy by right. It is proper that such determining factors should have their place, but not the first place. There was a time when china collectors ignored paste and glaze and laid particular stress on marks, and it is a very happy accident that a great portion of English porcelain and much of English earthenware is unmarked. It has eventually led collectors to think for themselves and know something more of the technique and to learn to appreciate the artistic value of specimens of the potter's art.

The collector of old silver, however, cannot hope to escape from marks; they are an integral part of the subject, and coming as they do under the strict surveillance of the law, they offer protection to his investment and have the comforting assurance of gilt-edged security. There is nothing of the subtle speculation as to exact period which accompanies the acquisition of old furniture, nor is there the same element of chance which governs the operations of the picture collector. The hall-mark, the standard mark, the date mark, and the maker's mark stamped with mechanical precision proclaim "with damnable iteration" the string of unalterable facts.

In. regard to marks it is interesting to read what Mr. Octavius Morgan, the pioneer of the study of hall-marks, said in 1852: "Every person who is possessed of an article of gold or silver plate has most probably observed a small group of marks stamped on some part of it. Few however have, I believe, regarded them in any other light than as a proof that the article so marked is made of the metal which it professes to be, and that the metal itself is of a certain purity. And this is in fact the real ultimate object and

intention of these marks; but besides this the archaeologist can deduce from them other important and interesting information, as by them he can learn the precise year in which any article bearing these marks was made. It is therefore to these marks that I am about to direct attention with a view to elucidate their history and peculiar meaning." To Mr. Morgan's labours in a then unknown field all subsequent writers on hall-marks are indebted. He was the first collector who realized their importance. It seems amazing that up to 1852 nothing appears to have been known by the intelligent layman or the public at large of these symbols which had appeared on plate for some six hundred years. It suggests the idea that the marking was regarded as in the nature of a trade secret. The "mistery" of the Goldsmiths' Company was not to be penetrated by vulgar eyes. In the light of this it may be conjectured that the chaotic arrangement of alphabets came about not by accident but by design.

IV

THE MAKER'S MARK

This of all the marks should be the most intimate and should indicate the personal touch, as something coming from the craftsman to the possessor. It is the heirloom which the old silversmith hands to posterity. His mark signified his pride in his art, that is in the days when craftsmen were artists and whatsoever their hand found to do they did it with all their might. But the maker's mark, a compulsory mark dating from 1363 under a statute of 37 Edward III, has become eclipsed amid the imposing array of symbols stamped upon it at the Goldsmiths' Hall. That the

piece exists and was brought into being by the humble silversmith is of lesser importance than the row of legally environed escutcheons signifying so much with such unerring veracity: that it was assayed and found of standard quality, so down comes the stamp of the lion *passant*; that the year was so and so *anno domini*, down comes the stamp of the secret date letter, so carefully guarded from the public; that the duty was paid, and not till then, another stamp, this time with the king's head; and last but not least, down comes the stamp of the leopard's head, denoting that all this was done under the surveillance of the Mistery of Goldsmiths of London. Hence the collector, who comes a century or two after these great happenings, by capricious fate casts his lens on the signs manual of standard, and proofs of place and date; but the bare initials of the maker, which came first from the shop to the assay office, now comes last, as insignificant letters merely denoting that the specimen happened to have been made at all.

What would one not give for a few human touches in connexion with our old silver! If only we could imagine that our candlesticks of the year 1750 held the flickering wax candles which were guttering as the dawn broke when our great-great-grandfather lost his fortune at cards in the county of —, or maybe it was somebody else's grandfather. But this is in the realms of fancy, and the fortune is literally fabulous. Why are there no George Morlands in the silversmith's craft? Cannot the guilds dig out their romantic history from their archives? But no. All these initials of makers are empty of such vanities. We can do better with prints. Those who possess the engraved work of Ryland have the satisfaction of knowing that he was hounded by Bow Street runners and hid, like the modern Lefroy, at Stepney, and that he was hanged for forgery.

There is William Blake, who dreamed as great dreams as Joseph of old, who gave imaginary sittings to Pontius Pilate, who wrote wonderful poetry, and who died in a garret. Copper-plates were dear, but he had no poverty of invention, and since the days when as a child he saw angels following the reapers in the corn, he lived for posterity and left his record. But have gravers on silver and inventors of symmetrical goblets of gold less blood than those who drew lines on copper? There is something human missing in these strings of initials and bare names so conscientiously gathered together by dry-as-dust compilers.

In furniture, makers' names have become household words. Chippendale, Sheraton, Hepplewhite have created styles of their own. Of Sheraton we have personal details piquant enough to add fresh lustre to his satinwood creations. There is the story of the one teacup in the back street of Soho, which was handed to his Scottish apprentice in the little shop whence he issued his religious pamphlets.

In china the personal note is dominant—Josiah Wedgwood with his wooden leg smashing vases at Etruria with "This won't do for Josiah Wedgwood." Or Thomas Cookworthy dying of a broken heart in Virginia after his life's failure at Plymouth. Or the Brothers Elers with their secret underground telephone in Bradwell Wood in Staffordshire.

In silver ware the Elizabethan and the Stuart periods run parallel with furniture; the names of makers are rarely known. But in the eighteenth century except for Paul Lamerie, Paul Storr, F. Kandler, Peter Archambo, Pierre Platel, and a few others, the claim to fame of the individual silversmith has been lost sight of in the searchings of collectors for periods, such as the Higher Standard or the style termed "Queen Anne."

THE MARKS STAMPED UPON SILVER

In the earliest years the maker had a device—a dolphin, a star, a cross, or any other symbol—to denote his individual work. Later his initials could serve, and during the Britannia period it was the first two letters of his surname. In 1739 the initials of Christian name and surname were the mark required by law. Nowadays the Goldsmiths' Company of London admit names of firms. Their printed form runs: "Statement to be made in writing by Manufacturers, Dealers and others, bringing or sending Gold or Silver Plate to be Assayed and Hall-Marked." Presumably in the old days prentice work passed as that of the master. But the prentice grew older and was allowed to come out into the light. But X & Co., Y & Co., Z & Co., may send their stamps round to smaller and more original men to impress on their work. The public, caring more for the lion, *et cetera*, than for X, Y, and Z, know no better; as for the real makers the public know nothing. But we ask, is this the way to encourage our workers in plate? Syndicates have no bowels of compassion, but assay offices might be supposed to minister to the interests of the art of the worker in precious metals. To kill or to stifle individuality is a crime against Art. If Sheraton had been a silversmith his name might have been unknown.

By law it has been determined that the initials of the maker shall appear on each article of silver assayed; there is nothing in any statute concerning the middleman. It would be interesting to know what steps the various assay offices take to ascertain that the actual maker's name is upon the pieces to which they affix their official symbols.

To go back to the fourteenth century: there is a fine touch of human nature recorded of one member of the goldsmiths' guild of London who was found guilty of *mals outrages* in connexion with his work. He was fined a pipe

of wine, and twelve pence a week for one year to be given to a poor member of the company.

Among the human touches left there are fragments recorded which are interesting to collectors. Sir Thomas Gresham, the great London goldsmith in the middle sixteenth century, carried on business in Lombard Street at the sign of the Grasshopper. To this day there is a grasshopper as a weathercock behind the Royal Exchange. There is Sir Robert Vyner, who replaced the coronation regalia for Charles II, afterwards stolen by Colonel Blood and scattered in the Minories, who was a goldsmith of Lombard Street. During his mayoralty he entertained Charles II. Sir Robert, when he had well drunken, grew very familiar with the King, who wished to steal away without ceremony and proceed to his coach. But the mayor pursued him to Guildhall yard, and catching hold of him exclaimed with an oath, "Sir, you shall stay and take t'other bottle," and the Merry Monarch, true to his name, with a smile hummed the line of the old song:

"He that is drunk is as great as a king,"

and turned back to finish the bottle. We like this story. A piece of plate with Sir Robert Vyner's initials of the year 1675 would possess added value for this touch of nature which makes the whole world kin.

On the look-out for links connecting the silversmith with things human we find an interesting shop card of Ellis Gamble, to whom by his own desire young Hogarth was apprenticed and learned to engrave on silver plate. It may be imagined that he was not an "Idle Apprentice," and his early work with the graver on the flagons and tankards in Mr. Gamble's shop should stimulate research. It was here that he drew heraldic beasts. His apprentice-ship terminated when he was twenty years of age. There

36

is preserved in *Hogarth Illustrated* (by Ireland) the engraving of the Kendal Arms during his apprenticeship, showing fine design.

We give the inscription on Ellis Gamble's shop card, which is in the kind of frame termed by bookplate collectors "Chippendale." There is a full-length figure of a winged angel standing on a scroll, and the lettering is somewhat crowded below in English and in French:—

"Ellis Gamble, Goldsmith at the Golden Angel in Cranbourn Street, Leicester Fields, Makes Buys and Sells all sorts of Plate, Rings and Jewells, etc."

An interesting sidelight on makers' names is afforded by the various copper tokens which they struck, bearing their names and addresses. We append a short list of goldsmiths' tokens of the seventeenth century. They come from various parts of the country and from Ireland, and readers having seventeenth-century silver bearing these initials may be able to identify the maker.

LONDON.

> The Hermitage (Wapping)
> John Mayhew. Gouldsmith. His Halfepeny
> Neare the Armitage Bridg. I.M 1666

> West Smithfeild
> Euodias Inman. his halfe Peny
> In Smithfeild Rounds. Gouldsmith

> Beech Lane (Barbican) (on a farthing)
> Elizabeth Wood (with the Goldsmiths' arms)
> In Beach Lane. 1656. E. W.

> Seacole Lane (Snow Hill) (on a farthing)
> Samuell Chapell in Seacole Lane, 1671
> The Goldsmiths' arms on reverse

EXETER (on a farthing)
Samuell Calle (with design of a man smoking)
Gouldsmith in Exon (with design of covered cup)

BATH (on a farthing)
Geo. Reve. Goldsmith (with the Goldsmiths' arms)
In Bath. 1658. G. M. R.

OXFORD (on a farthing)
Will Robinson 1668 (with the Goldsmiths' arms)
Gouldsmith in Oxon. W. M. R.

DOVER (on a farthing)
Willian Keylocke (with the Goldsmiths' arms)
In Dover. 1667. W. M. K.

IRELAND
Dublin (on a penny)
Io. Partington. Gouldsme. (Arms: on a bend cotise, an eagle)
Kinges head. Skinner Row, Dublin. 1d.

KILKENNY (on a penny)
William Keovgh 1d.
Kilkeny. Goldsmith (with design of a mermaid)

Among the eighteenth-century American silversmiths there are some that stand out prominently, and the exhibition of old American plate held at the Museum of Fine Arts in Boston in 1906 first brought them to notice. There is the work of John Dixwell from 1680 to 1735 who was the son of Colonel John Dixwell, one of the regicides who fled to America in the early years of the Restoration. But the historic punch bowl made by Paul Revere was the *pièce de résistance*, and was shown together with some forty

other of his creations. It was made for the fifteen "Sons of Liberty." The inscription runs: "To the memory of the glorious Ninety-Two members of the Honourable House of Representatives of the Massachusetts Bay, who, undaunted by the insolent menaces of villains in power, from a strict regard to conscience and the Liberties of their constituents, on the 30th June, 1768, Voted Not To Rescind."

But Paul Revere, silversmith, has another claim to renown as a patriot. Longfellow, in his *Tales of a Wayside Inn,* has a poem telling of "Paul Revere's Ride," seven years after he fashioned this punch bowl. The story runs that he waited, booted and spurred, on the Charlestown shore for secret news to carry through all the countryside.

> . . . If the British march
> By land or sea from the town to-night,
> Hang a lantern aloft in the belfry arch
> Of the North Church tower as a signal light,—
> One, if by land, and two, if by sea.

We know the story of the opening shots at Lexington, the obstinate foolishness of the North Ministry and the deaf ear George III turned to the wisdom of Chatham. Longfellow pays posterity's tribute to the silversmith:—

> A voice in the darkness, a knock at the door,
> And a word that shall echo for evermore!
> For, borne on the night-wind of the Past,
> Through all our history, to the last,
> In the hour of darkness and peril and need,
> The people will waken and listen to hear
> The hurrying hoof-beats of that steed,
> And the midnight passage of Paul Revere.[1]

[1] Publisher's note: for a longer discussion of Paul Revere, see chapter XIII on American Silver, p. 361.

V

THE HIGHER STANDARD MARK

The higher standard mark has a significance peculiarly its own. By 8 and 9 William III, *cap.* 8, it was enacted that any person bringing silver plate from January 1696 to November 1697[1] to any of the Royal Mints, which was marked as sterling silver with the mark usually employed at the Hall of the Goldsmiths' Company of London, should receive "without tarrying till it be melted and assayed," five shillings and fourpence per ounce.

Section 9 of this chapter of the Act contains in official terms an allusion to the grave scandals that had shaken the commerical stability of the country for many years. "And whereas it might reasonably be suspected that part of the silver coins of the realm had been, by persons regarding their own private gain more than the public good, molten and converted into vessels of silver or other manufactured plate, which crime has been the more easily perpetrated by them, inasmuch as the goldsmiths or other workers of plate by the former laws and statutes of the realm were not obliged to make their plate of finer silver than the sterling or standard ordained for the monies of the realm," it was enacted that from and after 25th March 1697 no silver plate should be made that was not of higher standard than the coin of the realm. It was laid down that the legal marks on all silver were to be the maker's mark, now expressed by the two first letters of his surname, and that the marks of the assay offices should be the lion's head erased and "the figure of a woman commonly called Britannia" in lieu of the former marks

[1] A period of eleven months. The assay year "1696" ended on 24th March, and the year 1697 commenced on 25th March.

of the leopard's head and the lion *passant*. In addition to this the date mark was to be stamped to show in what year the plate was made. In this Act of 1696 it will be observed that the mention of the leopard's head and the lion *passant* refer to London marks only. As the manufacture of silver plate of the old standard was illegal after the passing of this Act and the use of the old marks was equally illegal, it would appear that the provincial assay offices were precluded from stamping silver.

That this appears to be the case is suggested by the reappointment of the provincial offices in 1700. York, Exeter, Bristol, Chester, and Norwich, at which cities mints had been opened for the coinage of the new silver, were reappointed by 12 William, *cap.* 4, to assay and mark silver plate as heretofore. The new standard was to be observed. The marks to be employed were the maker's mark, the lion's head erased, the figure of Britannia, the city mark, and the date letter, "a variable Roman letter." This latter provision was not then, and has not since, been observed, as other types have been used.

From 25th March, 1697, till 1700 no plate was therefore assayed at any of the provincial centres.

In 1702 the town of Newcastle upon Tyne was appointed as an assay town with similar privileges and restrictions as in the above-mentioned cities.

The old standard of silver was ·925, that is in every thousand parts only 75 were to be of alloy. The new standard was ·959, that is only 41 parts of alloy could be legally used. This raised the standard of silver plate above that of the coin of the realm.

The new standard was the only legal standard for silver plate from March 1697 till 1720, when the old standard was revived, and with it the leopard's head and the lion *passant*. Silver plate then dropped to the same fineness as

the coin of the realm. But if silversmiths desired to make silver of the higher standard they could do so, and such silver plate would receive the stamps at the assay offices, of the Britannia and the lion's head erased. This is still the case.

It is thus shown that the dates when silver plate had compulsorily to bear the Higher Standard marks are between the years 1697 and 1720. The following note will be useful to collectors.

A piece of silver marked with the figure of Britannia and the lion's head erased may be an example falling under any of the following heads:—

1. Assayed in London between 1697 and 1700, when London was the only office assaying silver plate.

2. Assayed in London between 1701 and 1720.

3. Assayed at Chester, Exeter, York, or Norwich, between 1701 and 1720.

4. Assayed at Newcastle from 1702 to 1720.

5. Assayed at any of the assay offices (except Dublin; no Higher Standard silver being made in Ireland) after 1720 to the present day, although such silver plate of the Higher Standard has not since been compulsory by law since 1720.

The Britannia period is an intricate period in the study of silver plate, but the history underlying the Acts which governed the hall-marking at this period should appeal to the collector who wishes to endow his plate with historic interest. Without going too deeply into those economic questions which threatened to paralyse commerce and to destroy the allegiance to William III, it is of essential interest to the collector of old silver plate to realize the conditions which rendered the Higher Standard Mark of the Britannia and the lion's head erased necessary to prevent financial disasters of considerable magnitude. The

THE MARKS STAMPED UPON SILVER

plate closet provides the historian with many of his facts. It was in the days of Charles I that the loyalists melted down their plate to be converted into coin of the realm. It was in William's day that silversmiths often acquired their material from "clippers"—men who took triangular nicks from the edge of silver coinage.

Till the reign of Charles II coin had been struck by a process as old as the thirteenth century. The metal was shaped with shears and stamped by the hammer. The inexactitude of such coinage became the opportunity for the clipper. A mill was set up at the Tower of London which was worked by horses and superseded the human hand. The coins were exactly circular, their edges were inscribed with a legend, and clipping was thereby made apparently impossible. But the hammered coins and the milled coins were current together. The result was that the light and poorer coin drove the better one out of the current circulation. The milled crown new from the mint became more valuable for shipment abroad or for use in the crucible.

Counterfeiters multiplied because the damaged and defaced coins could be more easily imitated. Hundreds of wretched persons were dragged up Holborn Hill, and in spite of flogging, branding, and hanging, the trade of the coin clipper was easier than highway robbery, and as fortunes were to be made those who followed that avocation took the risks, as did smugglers. It was a dangerous occupation. Seven men were hanged one morning and a woman branded, but this did not deter the hundreds who were undetected. One clipper who was caught offered £6,000 for a pardon, which was rejected, but the news gave a stimulus to the industry. The Government of the day became alarmed at the state of things, which grew from bad to worse. A sum of £57,200 of hammered

money paid into the Exchequer was tested by the officials. It should have weighed above 220,000 ounces; it weighed under 114,000 ounces (*Lowndes' Essay for the Amendment of the Silver Coins*, 1695). A Quaker who came from the North journeyed southwards, and his diary shows that as he travelled towards London the innkeepers were astonished at the full and heavy weight of the half-crowns he offered. They asked where such money could be found. The guinea which he purchased at Lancaster for twenty-two shillings bore a different value at every stage. In London it was worth thirty shillings, and would have been worth more had not the Government fixed this as the highest at which gold should be received in payment of taxes. The *Memoirs* of this Quaker were published in the *Manchester Guardian* some fifty years ago.

It may readily be imagined that such a state of things began to cripple trade. Merchants stipulated as to the quality of the coin in which they were to be paid. "The labourer found that the bit of metal which, when he received it, was called a shilling, would hardly, when he wanted to purchase a pot of beer or a loaf of rye bread, go as far as sixpence." Tonson the bookseller sends Dryden forty brass shillings. Another time he paid the poet in silver pieces that were so bad that they could not be passed.

The Government still believed in penalties, and hoped that drastic punishment would stop the clipping of the hammered coin and the melting and export of the new milled coin. A clipper who informed against two other clippers was pardoned. Any one informing against a clipper had a reward of forty pounds. Whoever was found in the possession of silver clippings, filings, or parings should be burned in the cheek with a red-hot iron. Officers were empowered to search for bullion, and the onus of

44

proof as to its origin was thrown on the possessors, or failing this they were fined heavily. But all in vain were these drastic measures; clipping still continued in defiance of all penal laws. Colley Cibber in his *Love's Last Shift, or the Fool in Fashion*, has a hit at the debased state of the coinage. A gay cynic says, "Virtue is as much debased as our money: and, in faith, *Dei Gratia* is as hard to be found in a girl of sixteen as round the brim of an old shilling."

This is not the place to enumerate the many foolish schemes that were propounded, some too costly, some unjust, some hazardous.

Locke and Newton brought their minds to bear on the subtleties of the question, and adopted the ideas of Dudley North, who died in 1693. His tract on the restoration of the currency is practically the same as that subsequently adopted.

William Lowndes, Secretary of the Treasury, Member of Parliament for the borough of Seaford, " a most respectable and industrious public servant," as Lord Macaulay terms him, was incapable of rising above the details of his office in order to cope with economic principles. "He was not in the least aware that a piece of metal with the King's head on it was a commodity of which the price was governed by the same laws which govern the price of metal fashioned into a spoon or a buckle, and that it was no more in the power of Parliament to make the kingdom richer by calling a crown a pound than to make the kingdom larger by calling a furlong a mile. He seriously believed, incredible as it may seem, that if the ounce of silver were divided into seven shillings instead of five, foreign nations would sell us their wines and their silks for a smaller number of ounces."

Happily Lowndes was completely refuted by Locke

45

in his *Further Considerations Concerning the Raising the Value of Money*, 1695.

Locke recommended what Dudley North had advised, namely, that the `King should issue a proclamation declaring hammered money should pass only by weight. What searching, branding, fining, burning, and hanging had failed to do would have been accomplished at once. The clipping of the hammered coin and the melting of the new milled coin to be made into silver plate would have ceased. But it had one objection. The loss would fall on the individual. Those in whose hands the clipped coin happened to be at a particular moment would bear the loss. But the loss in equity should be borne by the State which had allowed such evils to go unchecked.

It was suggested, in order to remedy this, that all clipped coin after a certain date would be exchanged for good coin at the Mint. But it was soon realized that this would make clipping more profitable than ever.

A real remedy was devised but unhappily it fell through. A proclamation was to be prepared with great secrecy, and published simultaneously in all parts of the kingdom. This was to declare that hammered coin should thenceforth only pass by weight. Every possessor of such coin could within three days deliver it in a sealed packet to the local authorities to be weighed and would receive a promissory note to receive from the Treasury the difference between the actual quantity of silver the pieces contained and the quantity they should have contained.

Anxious days followed in Parliament, but it was determined the public should bear the loss on the clipped coins. It was laid down that a time should be fixed after which no clipped money should pass, except in payments to the Government, and that a later time should be fixed after which no clipped money should pass at all. The

4th of May, 1696, was named as the date on which the Government would cease to receive clipped money in payment of taxes.

Ten furnaces were erected in a garden behind the Treasury, which was then a part of Whitehall, and which lay between the Banqueting House and the river. Every day huge heaps of clipped and unrecognizable coins were here turned into ingots of silver and were sent off to the Mint at the Tower.

The scene may readily be imagined. The second of May 1696 had been fixed by Parliament as the last day in which the crowns, half-crowns, and shillings were to be received in payment of taxes for face value. The guards had to be called in to keep order. The Exchequer was besieged by a vast multitude from dawn to midnight. The Act provided that the money was to be brought in before the 4th of May. The 3rd was a Sunday, therefore Saturday, the 2nd of May, was actually the last day.

During the next few months, as the issues of the new coinage were unduly slow, the tension was very great. The upper classes lived on credit. "Money exceeding scarce, so that none was paid or received: but all was on trust" (*Evelyn's Diary*, May 13th). "Want of current money for smallest concerns even for daily provisions in the markets" (June 11th, *Evelyn's Diary*).

By about August 1696 signs of prosperity began to be observed after a very trying time owing to the scarcity of silver.

Undoubtedly it was a very anxious period for the Government. Malcontents stirred up the populace and tumults occurred in various parts of the country. Jacobite tracts were published advocating violent measures. William had strained his private credit in Holland to procure bread

for the Army. But the crisis was weathered and the coinage question was settled.

It hardly needs an apology from the author to bring these facts tersely together before the reader who is interested in old English silver. The figure of Britannia and the lion's head erased belong to this troublous period. They come as a corollary to the coinage question, and they should provide the collector with food for thought whenever he sees them stamped upon silver in his possession. The standard of silver plate was raised as a further safeguard, in order that the clippers should have no incentive to melt down the new coinage.

From 1697 to 1720 the silver plate, being compulsorily by law of a higher standard than the coin of the realm, stood as a safeguard against the return to clipping.

To collectors, therefore, the Britannia standard should be something more than an indication of rarity. It should induce reflective thought as to the successive stages of crisis, the suggested remedies, and the ineffective punishments which led to the establishment of this Higher Standard.

At a later period the figure of Britannia (but without the accompanying lion's head erased) was again stamped upon silver plate, but the practice was not very extensive. The date when this mark appears is at a period subsequent to 1784 and relates to the drawback or exemption from duty on silver plate exported. (See the "Duty Mark," below.)

VI

THE DUTY MARK

In regard to tax on silver plate, it was first imposed in England and in Scotland in 1719, when the old silver standard was revived. The duty was fixed at six pence per troy ounce. Later by 3 Geo. II, in 1730, the duty was imposed on silver plate assayed in Ireland, and at this date the figure of Hibernia was used to denote that duty had been paid to the crown. In 1784, by 24 Geo. III, *cap.* 53, a duty of six pence an ounce was levied in England and Scotland, and it was enacted that, in addition to the other marks formerly employed by the makers and assay offices, the new mark of the king's head should be stamped on every piece of silver plate on which duty has been paid. By another section of this Act it was a felony punishable by death to use any counterfeit stamp contrary to law. By a later Act, 55 Geo. III, in 1815, the counterfeiting of the king's head duty mark was punishable by death; and this was little more than a hundred and fifty years ago. The duty on silver plate was then 1s. 6d. per ounce.

From 1784, therefore, on English and Scottish silver the duty mark of the head of the reigning sovereign appears on all silver plate, stamped in an oval escutcheon.

In regard to the duty mark on Irish plate, it was not until 1807 by 47 Geo. III that the stamp of the king's head, or that of the reigning sovereign, was added to the other marks to denote that duty had been paid to the crown. The old mark of Hibernia, the original duty mark, was allowed to remain and may now be regarded as the hall-mark of Dublin.

The various sovereigns' heads were used down to 1890, when the duty was discontinued and the mark abolished.

49

In connexion with these duty marks the Act of 1784 has a section which has an interesting provision, and those collectors who may happen to find a figure of Britannia on a piece of silver without its companion mark of the lion's head erased may be puzzled as to the reason of the omission. First it does not denote that the silver plate was of the higher standard. It was a mark stamped on silver which was exported. By the above Act duty was not charged on silver exported, and in order to prevent any of this plate being taken abroad for a short time only, and then landed in this country to be sold here without the duty having been paid, it was stamped with the figure of Britannia.

The following are the Duty Marks used:—

Ireland	1730 to 1807	Figure of Hibernia.
England and Scotland	1784 to 1820	Head of George III.
Ireland	1807 to 1820	Head of George III.
England, Scotland, and Ireland	1821 to 1830	Head of George IV.
England, Scotland, and Ireland	1831 to 1836	Head of William IV.
England, Scotland, and Ireland	1837 to 1890	Head of Victoria.
		Duty abolished 1890.

The illustrations of these duty marks are shown in the Table (p. 255.)

VII

THE FOREIGN MARK

The Foreign Mark is a protective measure. A great amount of foreign wrought plate had found its way into this country and was being sold by dealers without sending it to the assay office. It was of a lower standard than would have been passed by the assay offices, that is to say it was not sterling silver as understood in this country, viz. 925 parts silver in every thousand parts of metal—that is, admitting only 75 parts of alloy in every thousand. In

1842 an Act was passed, 5 and 6 Vic., which enacted that no silver plate which had not been wrought in England, Scotland, or Ireland was to be sold in these countries unless it had first been assayed in the same manner as silver wrought in Great Britain and Ireland. But no provision was made that such foreign silver should bear an additional stamp, nor does it seem that the Act was very much put into operation. The provisions seem to have been evaded till 1867, when by 30 and 31 Vic. all imported plate had to be marked with the letter F in an oval escutcheon, denoting it was of foreign manufacture, although it had passed the tests and otherwise had the stamps of British or Irish assay offices upon it.

This was not very satisfactory. A purchaser obtains a piece of silver plate with the lion and the leopard's head on it, and this to the beginner denotes quality, and allays any fears he may have as to its origin. He may innocently imagine he is supporting home industries, not knowing what the meaning of the letter F may be at the end of the row of symbols.

This foreign mark, illustrated in Table, p. 255, was used from 1876 to 1904.

It seemed unfair to British manufacturers that foreign silver should be assayed for competitive sale with home-manufactured plate bearing the time-honoured symbols that had been used for four hundred years. There was also the possibility that some fraudulent dealer might remove the F, and straightway the piece apparently became British. It was not in the public interest that such a loose state of things should continue and the practice has been altered.

By the Hall Marking of Foreign Plate Act (4 Edw. VII, c. 6), Foreign silver plate was marked by the Assay Offices with the following marks *in addition to* the Standard Mark

51

and the Date Letters. In 1906, by Order in Council, certain alterations were made in the London, Sheffield, Glasgow and Dublin marks for Foreign plate assayed in Great Britain.

From 1904 Birmingham Chester. Edinburgh. Decimal equivalent of standard value of the silver

From 1904 to 1906 London Sheffield Glasgow Dublin

From 1906 London. Sheffield. Glasgow Dublin.

CHALICE AND PATEN COVER
By John Ions, Exeter, *c.* 1575
(*Victoria and Albert Museum*)

ECCLESIASTICAL PLATE

IN regard to sacred vessels in use in England since the Reformation it is noteworthy that in design they cling to a national form and differ very considerably from those used in early mediæval days or at the present time in the Roman Catholic Church.

Prior to the Reformation the plate found on the altar for the celebration of the Holy Sacrament consisted of a chalice, a paten, two cruets to contain wine and water for consecration, which were really two ewers of small size with lids, and the pyx in which the Eucharist was reserved.

The chalice consisted of three parts: the cup or bowl, the stem which in its middle swelled out into a bulb called the knop, for the convenience of holding it, and the foot.

The paten was a small salver slightly sunk in the middle like an ordinary plate.

Henry VIII in his spoliation of the monasteries, their lands and their gold and silver plate, set the pace which was continued under Edward VI. No stone was left unturned to stamp out all traces of the old religion. It is remarkable that anything escaped the blind fury that seized the reformers in their lust for destruction. Whole libraries were destroyed; illuminated books were consigned to the flames as the work of the devil. Stained-glass windows, carved woodwork with figures of saints, brasses with religious emblems, all fell beneath the ruthless hand of the iconoclastic Puritan.

55

"At Sunbury we brake down ten mighty great angels in glass, at Barham brake down the twelve apostles in the chancel, and six superstitious pictures more there: and eight in the church, one a lamb with a cross on the back: and digged down the steps and took up four superstitious inscriptions in brass." So writes one Dowsing, a fanatic, in a diary he kept of his doings, where he and his myrmidons scoured a hundred and fifty parishes. Bishop Hall of Norwich saved his windows by taking out the heads of the figures.

With such anti-religious fervour abroad it can well be imagined that the altar vessels, the fine chalices and other ecclesiastical plate, came under the ban that had been pronounced against relics of a Church which, whatever may have been its dogmas, had always encouraged the fine arts and employed the genius of the craftsman in creating edifices which stand among the noblest of man's handiwork and in embellishing them with decorations as spiritual as the brain of the artist could conceive.

It is not surprising to find the commissioners appointed by Edward VI making as exhaustive an inquiry throughout the land as the valuers of a modern Chancellor of the Exchequer. They seized all the plate in the churches with the exception of chalices and patens, and these they weeded out if they considered the parish too small to have more than one or two. Hence it is rare to find pre-Reformation ecclesiastical plate, even chalices and patens, because the Church authorities preferred to melt it down and use the money for other purposes rather than to have it confiscated.

In 1547 by 1 Edward VI it was enacted that communion in both kinds should be administered to the laity. The old form of chalice and paten remained for a time, as even the Reformation with all its fury could not and did not wholly uproot all the most sacred and deeply seated ritual in

CHARLES I CHALICE AND COVER, 1640
Height 8 in., diameter 4½ in., weight 15 oz., paten 6 oz.

ELIZABETHAN CHALICE AND COVER, 1572
Height 7¼ in., diameter 3¾ in., weight 9 oz., paten 4 oz.

(Parish of St. Mary Major, Exeter)

connexion with religious observances. The subject of the change in the form of the chalice, and the introduction of the severer form of the open communion cup and the flagon, is a study in ecclesiastical and political history which cannot be further pursued here, however.

It is unfortunately true that the early form of post-Reformation chalice is not frequently met with. Carefully guarded by religious bodies, possibly having been hidden, the examples now extant are usually found in cathedral cities or in the custody of corporate bodies or Church authorities. We are fortunate in being able to reproduce illustrations of some fine sixteenth-century Exeter examples exhibiting exquisite symmetry and characteristic ornamentation.

The paten, it should be observed, could also serve as a cover for the communion cup, a style which appears to have been general in Elizabeth's day, when the old pre-Reformation paten was discarded by ecclesiastical law.

In the illustration given (p. 53) of a chalice and cover this form is seen. The specimen is silver-gilt of the style known as the Exeter pattern. The bowl is conical in shape with engraved foliated ornament. The knop has mouldings and the foot is in similar style. The piece is now in the possession of the Victoria and Albert Museum. The maker was I. Ions, and the piece bears an Exeter hall-mark, *circa* 1575.

The marks of another fine example of the Exeter paten, with inscription on the cover "The Paryshe of Trynitye in the yeare of our Lorde 1575," are illustrated on page 285. The maker is I. Ions and the Exeter date mark 1575 likewise.

Another Elizabethan chalice and cover illustrated bears the London hall-mark of 1572. It is parcel gilt, has a straight bowl with slight lip, and engraved foliated bands.

It belongs to the Church of St. Mary Major, Exeter. This is illustrated on page 57 together with a Charles I chalice and cover bearing the Exeter mark of 1640, the date when Strafford was impeached and two years before the outbreak of the Civil War.

An interesting Charles II cup, silver-gilt, is illustrated page 61. The date letter is a black-letter capital G, indicating the year 1664, as illustrated on page 265. Cups such as this have sometimes had portions added to them, converting them into ewers with curved spout and large handle. There is a piece among the corporation plate at York which suggests such an alteration. In the days of Charles II the puritanic form of the few pieces of plate then remaining offended the new spirit of gaiety. Cromwell's cavalry had stabled their horses in cathedrals; with the Restoration, communion cups were converted into vessels for less sacred use.

Illustrated on page 62 is a set of fine Charles I flagons, with the London date letter for 1640. These and other beautiful specimens of English church plate belonging to the Parish of St. Augustine's with St. Faith's are on loan to the Victoria and Albert Museum.

An example of the type of paten on foot later in use is shown on page 65. It is a Charles II specimen bearing the London hall-mark for 1684 and the maker's mark E.G. It will be seen that it bears an inscription which reads *St. George the Martyr in Exon. Richard Mew warden* 1684.

A remarkable communion cup and cover of small size is among the same Exeter plate. This is a George II specimen and is unique. It bears the Exeter mark for 1729, and the maker is James Strong. The stem of this cup is in baluster form of fine proportions. The cover is remarkable, being intended, when removed, for use as a flat paten. In addition to the usual central button is has

CHARLES II COMMUNION CUP
(*Victoria and Albert Museum*)

SET OF CHARLES I FLAGONS, 1640
(*St. Augustine's and St. Faith's, London*)
(*Victoria and Albert Museum*)

62

four small additional feet. It was intended for the use of the sick, hence its smaller size. Altogether it is a most remarkable piece. It has an inscription which runs : *"Deo Christo et Ecclesiae St. Martini Exon in usum infirmorum."* ("To Christ the Lord and to the Church of St. Martin's, Exeter, for the use of the sick.")

CHARLES II PATEN, LONDON, 1684

(Parish of St. Mary Major, Exeter. Copyright, Rev. J. A. Goundry, Exeter)

65

FOURTEENTH-CENTURY DRINKING HORN
(*The Queen's College, Oxford*)

66

THE MAZER, THE STANDING CUP, THE FLAGON, THE TANKARD, THE BEAKER, THE WINE CUP, THE PUNCH-BOWL

IN this chapter it will be seen that a survey is made of the drinking vessels of silver plate in use during the sixteenth and seventeenth centuries. With the advent of coffee and tea, silver plate found a newer field, and the coffee-pots, tea-pots, and tea-caddies of the eighteenth century are dealt with in another chapter.

During the period prior to the general use of glass, metals were employed for domestic plate. Pewter, being less costly, was more used than silver plate, which was confined to the wealthier classes; and for those of lower degree the "black-jack" and the "old leather bottel" sufficed. Faience from the Low Countries and from Cologne early found its way into England. The Bellarmine jugs, large in capacity and strongly made of *gres de Flandres* stoneware, were possibly much in demand for serving sack and beer and other liquors consumed in large quantities. It is the tendency of all simple objects to become ornate. The earliest plain horn cups used by the herdsman and the simples developed into silver-mounted richly-chased drinking horns for use at the castle. Of this class is the fourteenth-century wassail horn belonging to The Queen's College, Oxford (illustrated p. 66), with its claw feet complementing a mounted bird.

The wooden bowl, as we see in the mazer, became

67

enriched with costly mounts. These additions rarely added to the utility of the vessel, but they denoted its elevation into usage by more wealthy people. The plain grey or mottled and excellently potted stoneware jug, the like of which Mistress Quickly must have used to pour out the canary of Falstaff and Bardolf and the thirsty set of tapsters who surrounded the fat knight, was common enough in the early sixteenth century. But in Elizabeth's day it had luxurious additions in the shape of silver or silver-gilt rim, lid, bands and foot.

The mazer, a wooden vessel in form like the more modern punch-bowl, mounted in silver, is the earliest type of our domestic plate. These bowls were ornamented with silver bands and silver rims, and in some cases there was a circular silver plate or boss in the centre of the vessel inside. We illustrate examples (p. 69) mounted in silver-gilt. One has a silver "print" representing the Crucifixion which was formerly enamelled. It dates from *circa* 1480. The other has an inscription on the boss. The wood of these mazers was usually maple, and the name is supposed to be derived from the British word *masarm* (maple). The Dutch word *maeser* means a knot of maplewood. Spenser in the sixteenth century has the lines:

> Then, lo! Perigot, the pledge which I plight,
> A *mazer* ywrought of the maple ware,
> Wherein is enchased many a fair fight
> Of bears and tigers that make fierce war.

Among the earliest of drinking vessels of the Middle Ages this form of the broad bowl followed the earlier horn drinking cup. Few mazers were made after the sixteenth century. The form was not confined to England, for Sir Walter Scott, in his "Lord of the Isles," has the couplet:

> Bring hither, he said, the mazers four
> My noble fathers loved of yore.

68

MAZER OF MAPLEWOOD, *c.* 1480
Mounted with silver-gilt
(*Victoria and Albert Museum*)

MAZER OF MAPLEWOOD, *c.* 1490
Mounted with silver-gilt
(*Parish of St. Mary Major, Exeter*)

THE MAZER

In regard to some of the prices paid for mazers at auction in London, the following may convey an idea as to rarity. In 1903 a fifteenth-century mazer realized £140. In 1902 a sixteenth-century example brought £170. In 1905 a mazer dated 1527 sold for £500, but in 1908 one dated 1534 fetched the colossal price of £2,300. Certainly this is the highest price paid for maplewood. If the bowl had been all silver, and had been sold by the ounce, the sum paid would still have been remarkable.

The specimens which, after centuries of vandalism, have come down to us from the early days differ in character. The mazer is reminiscent of Scandinavian drinking customs. To this day the Dane in drinking your health says "*Scol.*" Etymologists with fine imagination have linked this with skull, and sought to infer that the old Norsemen drank out of skulls. It is a myth as old as the upas-tree. Byron, wishing to pose as a wicked person, gathered a crowd of wayward spirits at Newstead who drank out of a skull. Dekker in his *Wonder of a Kingdom* says:

> Would I had ten thousand soldiers' heads,
> Their skulls set all in silver, to drink healths
> To his confusion first invented war.

We may agree with the sentiment, and we could fittingly drink confusion to a modern intriguer to like end, but, for all that, the derivation is wrong. The *scol* of the Dane has reference to little wooden spoons used with the bowl to ladle out the liquor, much in the same manner as the punch ladle of many centuries later performed the same service. The word scull, the oar of a shallop, is the same word.

Some Historic Standing Cups

Contemporary with the mazers are magnificent standing cups and covers, such as the "Anathema" Cup, of the

date 1481, at Pembroke College, Cambridge, or the Lynn Cup, a century earlier, in possession of the corporation of King's Lynn. The latter (illustrated on page 74), sometimes known as The King John Cup, is silver-gilt and enamelled. The bowl is detachable by bayonet joints to form a separate cup and is of spreading beaker form chased with five foliate ribs and with plain lip. The enamelled panels to the bowl each contain two figures of ladies and gentlemen in mauve costumes on green and mauve grounds diapered with stars; the cover has similar figures with dogs on blue ground; the panels to the border of the foot have hares and one fox; the knop is decorated with stars on blue ground; the interior of the bowl reveals figures of a lady and hawk; and the interior of the cover has a medallion showing traces of a flower. Fourteen and a half inches high, the cup dates from the first half of the fourteenth century and is engraved beneath the foot with an inscription recording repair and re-enamelling from 1692 to 1782.

It must be remembered in the contemplation of our art treasures, and more especially the plate that is left to us, that the data upon which we may form conclusions are sometimes very slender. Happily much that is superlative is left to us, unscathed through centuries of civil war and plunderings and meltings-down; but often two pieces of the same period represent extreme types. One may be merely an ordinary common vessel and the other may be of most exquisite and beautiful work, reaching the summit of excellence even in its own day. Comparisons are odious. But it is as though five centuries hence, all else being swept away, all that the twenty-fifth century had as a basis of judgment on the

THE LEIGH CUP AND COVER, LONDON, 1499

(*The Mercers' Company*)

73

THE KING JOHN CUP, FOURTEENTH CENTURY
(*The Corporation of King's Lynn. Photograph by P. M. Goodchild and Son Ltd.*)

74

eighteenth-century potter were sundry ornate Wedgwood vases and certain crude cottage figures.

By the courtesy of the Mercers' Company an illustration of the famous Leigh Standing Cup and cover is here produced. The date of this is 1499. The vessel is ornamented with raised crossed bands, considered to be later additions, and in the panels formed by their intersection are alternate heads of maidens and flagons, which are the badges of the company. The foot rests on three small, flat bottles, and has a deep chased border with a pierced trefoil enrichment. On the cover are the arms of the City of London and the company. The cover is surmounted by a maiden seated, with a unicorn reclining in her lap, the word "Desyer" on its side. Round the cover and cup are bands of blue enamel, with letters of silver, with the following inscription:

> To Ellect the Master of the Mercerie hither am I sent
> And by Sir Thomas Legh for the same entent.

This specimen exhibits the Gothic style, and this is the second earliest cup known with a hall-mark. The "Anathema" Cup bears the London hall-mark for 1481. The antiquity of these early cups illuminates the field of collecting. The Leigh Cup is contemporary with the magnificent chapel of Henry VII at Westminster Abbey. Here is a work of art wrought by the silversmith only two years after John Cabot made his first voyage to the mainland of America, and on the heels of the discovery of the sea route to India by Vasco da Gama.

The standing cup and cover carries with it rites and ceremonies that have been retained to the present day by all those corporations and companies and clubs which

have a ritual extending into the past. It is not always easy to give the exact reason why customs are still punctiliously observed. To doff one's hat to a friend or a superior is an act which has a long history. To take off one's casque of armour was to become at once unprotected from the sword-cut. One can imagine two knights showing their confidence in each other's honour by removing their casques. Similarly in the taking of wine the observances of to-day in regard to the loving-cup have equally sound reasons to support them, as being a symbolic continuance of similar actions of the past when their meaning was more definitely prosaic than it is now.

There are many recorded instances where treacherous foes have stabbed a guest when in the act of drinking. It is not difficult to realize the sequel and the necessity for the usage. When one man drank, his comrade stood by his side with dagger ready to defend his friend from treachery. The custom to-day at civic banquets and in old clubs in regard to the loving-cup passed round is thus explained. There are always three standing. Two face each other and the third stands behind the person drinking as a safeguard against perfidy.

Poison and the fear of death were always prominently before our ancestors in the Middle Ages. The wine cup was an easy means of perpetrating revenge; in consequence rock crystal goblets, which were said to split or change colour when poison was present, were much in vogue.

There were various forms of standing cups. The craftsman expended his skill and invention in producing novelties. It thus happens that these creations exhibit the silversmith's cunning at its best.

A very interesting cup and cover is that known as the

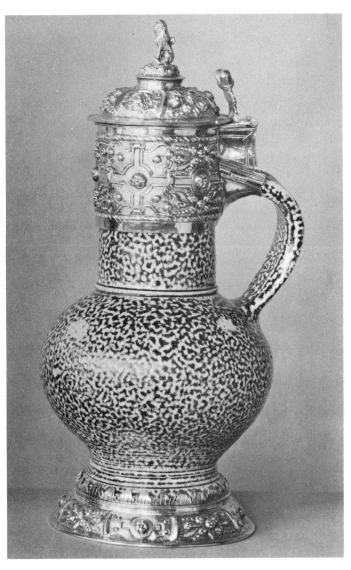

ELIZABETHAN STONEWARE JUG, SIXTEENTH CENTURY
With silver-mounted cover and foot
(*Victoria and Albert Museum*)

77

"Westbury." It is a fine example of the Elizabethan silver-smith's work, and is silver-gilt. It is in the form of an acorn on a stem with flattened knob, and spreading moulded base, with turned knob to the cover. The cup of the acorn is cleverly suggested by a series of stamped rings. This cup has an inscription which runs:

Given to the Church of Westbury by Collonel Waucklen and Mary Contes of Malbrou. 1671.

On the cover are the initials of the donors, T. W. and M. M.

According to Hoare's *Wiltshire*, and Cockayne's *Complete Peerage, Extinct and Dormant*, Mary, widow of the second Earl of Marlborough, was married to one Thomas Waucklen, son of a blacksmith.

This is not too great a demand on our credulity, as a *cause célèbre* in the courts disclosed the fact some few years ago that a countess was married to the son of a coachman who had posed as a prince. We do not know in what manner Colonel Waucklen gained his military title. Possibly during the "late wars" he may have emulated Hudibras,

> When civil dudgeons first grew high,
> And out he rode a-colonelling.

But scandal there is which has settled heavily on the cup and its donors. It is stated that at the time of its gift to the church of Westbury, Mary the Countess had been dead a year and was buried in a turnip field. This Elizabethan cup made its public appearance in the middle of the reign of Charles II, and the said inscription would seem to have been placed upon it by the "Collonel" to screen

the fact that his wife was dead. It would appear to have been for a long time in domestic use before it was handed over to the custody of the Church. It bears the London hall-mark for 1585.

The Stoneware Jug

As has already been said, the stoneware vessels of the Low Countries came into England and were in common use in the time of Elizabeth. Fine examples of mottled "tiger ware" with silver mounts were evidently used by more luxurious possessors, and such specimens bring enormous prices under the hammer. The celebrated West Malling Elizabethan jug sold at Christie's, in 1903, for £1,522. This example was described as Fulham delft or stoneware, splashed purple, orange, green, and other colours, in the style of the old Chinese, and mounted with neck-band, handle mount, body-straps, foot and cover, of silver-gilt. It has the London hall-mark of 1581, the year after Drake returned in the *Golden Hind* from his voyage around the world. The maker's mark is a *fleur-de-lis* stamped in intaglio, repeated on cover, neck-band, and foot. Its height is 9½ inches. The weight of silver straps is only 9 oz. "It may have been used for sacred purposes," said one of the journalistic critics, who marvelled at the price, "but without doubt is nothing more than an old sack-pot."

We illustrate an example (p. 77) with silver-mounted cover and foot, late sixteenth-century, which shows the type of jugs of this class in Tudor days.

There are many examples of this kind of tankard. The Vintners' Company has one of delft mounted in silver-gilt with cover with inscription, "Think and Thank," and "Thank David Gitting for this." It bears a date 1563. The dates of most of the specimens of this class of stoneware or delft flagons range from about 1560 to about 1595.

The Pepys Standing Cup and Cover

In continuing the examination of loving-cups comparison can be made between the early ornate Gothic type exemplified in the Leigh cup, and the applied style of decoration, French in character, found in pieces from about 1670 for the next ten years or so. There is among the York Corporation plate a silver-gilt cup, 17½ inches high, with cover surmounted by a lion couchant. This "Turner" cup has the inscription: "*Iones Turner serviens ad legem Civitatis Eboru Recordator hoc Majori et Communitati ejus de gratitudinis ergo dedit*, 1679." ("Jones Turner, sergeant at law of the city of York, gave this memento in gratitude to his Mayor and Corporation in 1679.") The hall-mark is London, 1679. There is a resemblance in this cup to the Pepys cup: it is finely decorated with acanthus leaves. In 1893 a copy of the Turner cup, with the lion transformed into the lion of England, and embellished with shields of the various Dukes of York, was presented to Prince George by the citizens of York on the occasion of his marriage.

The Pepys cup is about 1677, and typifies the last period. In 1677 he was elected Master of the Clothworkers' Company, to whom he presented this cup (illustrated), which is still used at their dinners.

Its description is as follows: Standing cup and cover, parcel gilt. Deep plain band round rim, below which is a chased laurel wreath. The rest of the cup is overlaid with

80

PEPYS STANDING CUP AND COVER, *c.* 1677
Height 23 in. With inscription at base, "Samuel
Pepys, Admirilitati Angl: Secretis & Societ:
Pannif: Lond: Mr. An. MDCLXXVII."

(*Company of Clothworkers*)

81

an outer framework of pierced and embossed work of ornate character, which is not gilt. The design embraces foliated scrolls with griffins, and included are teazles and two rams, symbols of the Clothworkers' Company. The cover is surmounted by a ram.

The cup bears an inscription: "*Samuel Pepys Admiralitati Angl : Secretis & Societ : Pannif: Lond : Mr. An. MDCLXXVII,*" and a monogram S. P., together with the arms of Pepys.

This piece belongs to the Charles II period, and is typical of the characteristic style of applied decoration, undoubtedly of French origin. It has the maker's mark[1] T G or J G interlaced, and he evidently was an English craftsman working during the latter half of the Charles II period and during the short reign of James II. The vogue then disappeared.

English silver plate at the end of the seventeenth century is worthy of note, on account of its technique. A noticeable feature in this period of free chased work, in pieces with large leaves and fruit or figure subjects, is the bold manner in which the leaf springs from the collet of the foot. Among some of the most treasured objects of this late seventeenth-century outburst of fine craftsmanship are sconces and mirror frames, and especially large beakers and oviform vases and covers with floriated ornament richly chased. It was at that time that Grinling Gibbons the woodcarver revelled in his intricate flower and fruit pieces carved in the soft lime and chestnut woods.

In the sixteenth and seventeenth centuries with so many civil disturbances it was inevitable that easily movable possessions such as plate were the first to be realized upon. It is not difficult to imagine from the

[1] These initials, found on a James II mug, with the date letter for 1685, are illustrated on page 265.

remnants still to be found what the plate must have been like which graced the splendid banqueting halls of the days of Elizabeth. The massive flagons, such as those illustrated on page 85, and the gleaming dishes and lordly plates rightly belong to an age when courtiers wore doublets richly sewn with pearls; when dreams of conquests in the New World set men's minds aflame, when new trade routes were opened and great companies formed, when the sturdy spirit of independence established itself in those realms to take root and develop into world supremacy on the seas, and establish an abiding place in the council chambers of Europe, and when Shakespeare, Ben Jonson, Kit Marlowe, and Edmund Spenser with inspired vision penetrated into the domain of romance and won enduring fame.

But gold and silver plate hold a somewhat insecure place as historic records. The thief with vandal hands put many a cunningly fashioned vessel into the melting-pot to escape detection. The Civil War with its burnings and plunderings on the one hand, and the loyal devotion of cavaliers who gladly saw their plate go to equip Charles's army, on the other, accounts for many more specimens of craftsmanship which have gone for ever. Other treasures left the country; the retinue of Queen Henrietta Maria, her French retainers, her scullions and priests, journeyed in forty coaches to Dover with much plate. Charles I, writing to Buckingham, calls upon Steenie to help him and says: "I command you to send away to-morrow all the French out of the towne, if you can by fair means, but strike not long in disputing, otherways force them away, dryving them like so many wilde beasts, until you have shipped them, and the devil goe with them." How they plundered the Queen of jewels and plate, and of the money they owed in Drury Lane, and of the scuffle they had with the King's

ELIZABETHAN FLAGON
With London date letter 1607. Decorated
with chased formal floral design and guilloche
patterns.

ELIZABETHAN FLAGON
Silver-gilt repoussé and chased. Bearing
London hall-mark for 1591.

(*Victoria and Albert Museum*)

85

Guards who turned them out of Somerset House, is a piquant story. To this day in the vaults, beside dusty documents, three stones record the last resting-place of all that is mortal of three of the Queen's faithful French servants— a scullion, a chaplain, and a waiting-woman.

In these troublous Stuart times many pieces of silver were buried by the owners who never came back, and they may still lie buried to this day. Others were disinterred and proudly grace some of the fine collections. One thinks of John Rivett, the blacksmith, who delivered up broken pieces of copper to the Puritan iconoclasts who had directed him to break up the equestrian statue of Charles I. But the statue itself he buried in his garden at Holborn Fields by night, and at the Restoration it was re-erected in its old place at Charing Cross, where it long stood. Without doubt, some of the most treasured plate has had as eventful a history as the "Man on the Black Horse."

Elizabethan Flagons

To leave standing cups and retrace our steps, we may examine another class of vessel, the flagon. This is tall and usually rotund in shape, having a narrow neck. It belongs practically to the sixteenth century. Many of the specimens remaining are among communion plate, but their use was not confined to ecclesiastical purposes. The name is of ancient origin, and was possibly at first applied to any vessel holding drink—the Danish word *flacon* goes back many centuries. We find various references to it in the older writers. Bacon writes: "More had sent him by a suitor in Chancery two silver flagons," and Shakespeare, in *Hamlet*, has "A mad rogue! he pour'd a flagon of Rhenish on my head once." The relationship of the flagon to the tankard is a close one. The form as it continued to

the end of the eighteenth century was practically unchanged from that of the earliest known types. It differs from the Italianate ewer with its slender neck and graceful proportions. Ale obviously required a broad, swelling vessel. There is nothing finicking about that old English beverage. But wine necessitated something more delicate. Although nothing in silver emulated the Edwardian tall, thin-necked, glass claret jugs with silver mounts, yet there has always been a distinction between ale, the popular drink of the people, and wine of foreign origin more pleasing to the palate of the connoisseur.

In the two Elizabethan examples illustrated (p. 85) it will be seen that, although taller and more grandiose, these are the prototypes of the later tankard, of which the definite form was established in the seventeenth century. The evolution of design, whether it be a continuity of the same technique and medium, or an adaption by the silver worker of the forms of the glassworker, the potter, or the woodworker, is always interesting to the student. There is little doubt that these silver tankards were in a measure derived from Scandinavian types belonging to the earlier era. Man did not suddenly invent new shapes for everyday use which no other had ever conceived. The salt-glazed stoneware of Germany and Flanders without doubt introduced new fashions to the silversmith. The canettes of Jacqueline Countess of Hainault in the fifteenth century, *Vrouw Jacoba's Kannetjes*, the Cologne canette of stoneware of middle sixteenth-century days, and the Flemish cruche, a decorated jug with a pewter lid and mounts, all had an influence on the silversmith. But the law of supply and demand, even in early days, was something which could not be gainsaid. Man himself determined what was best fitted to his needs.

It will be seen that one example illustrated is dated in

London 1607. It has almost straight sides, narrowing slightly towards the top and broadening towards the foot. It is decorated with chased floriated design, relieved by horizontal bands of guilloche pattern. The cover is surmounted by a baluster knop. The handle is bold, and is joined to the barrel by a band.

The other example bears the London date letter for 1591, towards the close of Elizabeth's reign. The piece is of fine proportions, with massive scroll handle. The cover, as usual in these earlier examples, is dome-shaped, and is surmounted by a circular radiating disk with baluster ornament. The billet, or thumb-piece, is chased with a grotesque head. The decoration of the barrel is of the style frequently found upon tankards and bell salts of the late Elizabethan period and in the early years of James I. The body rests on an applied foot, which is repoussé and chased with floral and fruit derivatives, similar to the cover. Two bands pass around the barrel and the lower one secures the handle.

Seventeenth-century Tankards

The word "tankard" belongs to an earlier period than the seventeenth century. It is of widespread derivation. In old French it is *tanquaerd*, in old Dutch it is *tankaerd*, and in Irish it is *tancaird*. And no doubt all three races drank well from these vessels. In the sixteenth century Ben Jonson says:

> Hath his *tankard* touch'd your brain?
> Sure they're fall'n asleep again.

"When any calls for ale," says Swift, "fill the largest *tankard* cup top full." But silversmiths and collectors have their own nomenclature apart from poets, and the tankard belongs, in spite of literary proof to the contrary, to the

seventeenth and eighteenth centuries. It is the poet, again, who has continued the use of the word flagon, regardless of the anachronism. Be it a tankard, a mug, jug, can, pot, bottle, or glass, such prosaic terms are swept aside in verse to figure as the "flagon" or the "flowing bowl."

The tankard of the seventeenth and eighteenth centuries becomes more utilitarian. and more national in character. The body is drum-like in form, and the cover is usually flat. In order to show how little the form differed from Charles II to William III, examples are illustrated on page 91. The earlier example, on the left, is dated 1673 and has a single-step lid.

The other specimen illustrated has a domed lid, and dates from 1702. In comparison with the William III example, the difference will at once be seen. In these examples a noticeable feature is the moulded base. Gradually the spread foot became of diminished size. It was of no practical use. Later forms show a restraint, almost a poverty of symmetrical design, by the absence of the foot. The form becomes more squat. We are accustomed to it in English plate, but it compares slightly unfavourably with foreign plate, where the balance is more sustained. The massive handle really demands a more solid base.

It will be seen that the cover leaves the flat form usual during the long period extending back to Charles II, and resumes the domed shape of the early Elizabethan types. But there is no knob or button with baluster ornament such as in the earlier forms. The dome top of the later period is exceptionally reticent. The flat top did, on occasion, give place to the dome, but as a rule the flat-topped tankard without ornament may be said to extend from about 1640 to 1740.

CHARLES II TANKARD, 1673 WILLIAM III TANKARD, 1702

(*Victoria and Albert Museum*)

THE BEAKER

The Stuart Beaker

The potter and the glassworker were always dogging the heels of the silversmith. Now and again the silversmith borrowed an idea from the other arts. The Stuart beakers are a class apart. We illustrate examples from the first half of the seventeenth century—James I, 1606, to the days of Cromwell. The James I beaker, in date 1606, shows the engraved floral design of well-balanced proportions. It is a tall, cylindrical vessel, and the decoration is in keeping with the surface to be ornamented. The engraving slightly suggests in its character, though not in its technique, the strapwork decoration of the same period. The marks of this piece are given on page 257.

These are interesting illustrations of evolution. The second example of the time of Charles I shows a slackness in design which compares unfavourably with the specimen of the previous reign. Even here, slight as is the engraving, we catch the suggestion of the later Stuart type of decoration employed in other arts, as for instance in furniture.

The Commonwealth beaker, of 1653, has still slighter decoration simply indicated with the chasing tool. It is a really good example of the wave of austerity corresponding to the Puritan outlook on mundane things.

The process of evolution is plain. First the tall shape with the spreading foot, followed by the squatter form with less ornament where the foot disappears, and succeeded in a short time by the plain type. Here we have the precursor of the glass tumbler. What the silversmith made was obviously too expensive for the ordinary person. The glassworkers introduced by the Duke of Buckingham from Venice in the reign of Charles II found a shape ready to their hands. This silver beaker of the days of the Merry

Monarch stands as a prototype of the modern glass tumbler. The succession of forms is something to be proud of in the history of a country. The peculiar usage of words, the continuance of old observances, and the development of costume, have each found exponents to specialize on the evolution of types and the succession to present forms. But who has idealized the glass tumbler of the public-house bar? Here in silver is the definite prototype, and no glass-maker has invented anything more suitable. For wear and tear he has made the base thicker, or shall we say to disguise the fact that the glass contains less than it purports to hold?

The Wine Cup

The Stuart wine cups of silver are of exceptional interest. They are of graceful form and exhibit a variety of baluster ornament of pleasing character. The tall wine cup of the time of James I, illustrated on page 99, is a superb example from the Victoria and Albert Museum collection. The London hall-marks are clearly seen, the date letter giving the year 1616. The stem is slender and of baluster form. The upper part of the bowl has small chased ornaments depending on the line running around the brim. The lower part of the bowl is embossed with leaves and floral conventional pattern. The foot is similarly chased.

Sometimes these wine cups, or grace cups as they are termed, because it is believed that they were used at the end of a banquet to drink a grace, have octagonal bowls. These are found in the early seventeenth century. Other forms are like the modern open-bowled champagne-glass.

Charles I wine cups obviously are not common. The Civil War laid a heavy toll on such portable articles. During the Commonwealth, according to all report, in

94

JAMES I BEAKER, 1606
Marks illustrated p. 257

CHARLES I BEAKER, c. 1640

(Victoria and Albert Museum)

COMMONWEALTH BEAKER
London hall-mark, 1653

the words of Butler in his *Hudibras*, the Roundheads had
a tendency to

> Compound for sins they are inclin'd to
> By damning those they have no mind to,

and we have Lord Macaulay's well-known pronounce-
ment that the Puritans condemned bear-baiting not so
much for the pain which it gave to the bear, as for the
pleasure which it gave to the spectators. It is not to be
supposed, therefore, that wine cups were much in evidence
in the Commonwealth period. To come to the days of
Charles II, the Great Fire of London in 1666 did enormous
damage. The Clothworkers' Hall burnt for three days and
nights on account of the oil in the cellars. The Pepys Cup
happily was saved, as we have seen. This was in September,
but so great was the area of the fire in the city that the
ground continued to smoke in December. Lady Carteret
told Pepys that pieces of burned paper were driven by the
wind as far as Cranborne in Windsor Forest. London
remained in ruins till 1668. Pepys went to Whitehall at
the outset of the fire to tell the King what he had seen,
and he suggested precautions by blowing up houses to stop
the spread of the fire. Pepys was solicitous for the safety
of the Navy Office, which was between Crutched Friars
and Seething Lane, and Sir William Penn brought the
workmen from Woolwich and Deptford yards to demolish
houses on the "Tower Street and Fenchurch sides." It is
interesting to read that the Diarist sent off his money,
plate, and valuables to Sir W. Rider at Bethnal Green,
and then he and Sir William Penn dug a hole in their
garden in which they put their wine and Parmesan cheese.
All this is piquant in regard to the vicissitudes of fortune
through which much old plate has passed.

The wine cups of the seventeenth century stand as

the great prototypes in solid silver of our modern wine glasses.

The baluster ornament is common to the silver cup, the brass candlestick and the wine cup. It is the same factor which predominates in Jacobean furniture with turned rails with varying ornaments. The chain is complete. The silversmith, the brassworker, the woodcarver, and the glassblower each found, according to his technique, this style of ornament pleasing to his mind. Accordingly the collector who comes after may see for himself the influence each has had on the other. The student may see in the established form of the stem of the modern wine-glass something tempting him to linger over the process of evolution.

The Monteith and Punch-bowl

Anthony à Wood, the Oxford diarist, recorded a new silver form in December 1683: "This yeare in the Summer time came up a vessel or bason notched at the brims to let drinking glasses hang there by the foot so that the body or drinking place might stand in the water to cool them. Such a bason was called a 'Monteigh' from a fantastical Scot called Monsieur Monteigh who at that time or a little before wore the bottoms of his cloake or coate so notched U U U ."

The earliest surviving Monteiths bear the date letter for 1684. One (illustrated on page 100) is in The Worcester Museum, Massachusetts, but relatively few seventeenth-century examples have survived. The eighteenth century affords more numerous examples, and these are among the aristocrats of silver connected with drinking. Customarily they have heavy ornament of lion's heads above swing handles, massive gadrooned edges to the scalloped rim, the bowl deeply fluted or otherwise embellished, and the

TALL WINE CUP. JAMES I, 1616

(*Victoria and Albert Museum*)

99

CHARLES II MONTEITH, 1684
Decorated with chased chinoiseries
(*Worcester Art Museum, Massachusetts*)

foot enriched with beaded ornament. Family coats of arms were placed in large, ornate medallions. Sometimes the notched rim or "coller" was removable so that the wine-glass cooler could be converted to use as a punch-bowl.

The silver punch-bowl only makes its appearance about the same time as the Monteith, when the drink had already been in vogue for several decades. The word "punch" is said to have been derived from the Hindustani, signifying the five ingredients—spirit, water, sugar, lemon, and spice. "A quart of ale is a dish for a king," says Shakespeare in *A Winter's Tale*; "Then to the spicy nut-brown ale," says Milton in his *L'Allegro*. With the advent of William III there is no doubt that spirit-drinking became prevalent, though it was not till the middle of the eighteenth century that the evil became a national crime fostered by the greed of the Government for taxes. The drunkenness in the reign of George II was appalling. William Hogarth, the great satirist of the eighteenth century, holds the mirror to his day in the two prints, *Beer Street* and *Gin Lane*, published in 1751. In the former, though it cannot be said to be idyllic, the comparative prosperity of the populace under the beer-drinking regime is satirically compared with their condition under the dominion of Gin in his companion picture, where for gruesome details the graver of the satirist is unsurpassed. In the foregound of this truly horrible print is a woman half in rags, evidently in a drunken condition, while the infant is slipping from her arms into a cellar, from which hangs the distiller's spirit measure. Hogarth does not believe in half-truths. A stupefied wretch close by is clutching a keg of gin. On an adjacent parapet a dog is sharing a bone with a sot. The pawnbroker is shown as doing a busy trade. A woman is giving gin to her infant

from a glass. The tottering buildings with falling bricks are symbolic of the utter rottenness of the social fabric. The spire of St. George's, Bloomsbury, stands out as indicative of the aloofness of the Church to this devilish orgy. St. Giles is triumphant. The lurid background completes a terrible indictment of the Government of the day —the ghouls lifting a man into a coffin with a naked child at the foot, the bandaged heads and lifted stools of a drunken mob, the drunken man in a wheelbarrow with more gin being poured down his throat. Hogarth with his touch of irony combines the pathos of tears, young children standing innocently apathetic to all this, the everyday environment of their lives. This was Hogarth's biting criticism on the attempt to stimulate the drinking of spirits and decrease the consumption of beer. Hogarth is coarse, he is offensive, he is brutal; but he deserves well of all who love truth. Rabelais had to paint his satires in gigantic gruesomeness to reach the ear of his day. Brutishness cannot be exorcised by the sprinkling of rose-water.

The punch-bowl comes straight from this period. We take it as we find it, symbolic of days when Members of Parliament did not disdain to hiccough their drunken speeches in the House, when Cabinet Ministers were not ashamed of being drunk.

This belongs to the early Georgian era; it is associated with Jacobite plots, with suppers held in secret, with toasts drunk in solemn ritual to the King over the water. It belongs to the hunting squires and parsons too, to the nabobs from "John Company," and to the nebulous period of Hanoverian ascendancy. The Stuarts were dead, with their fateful, romantic, and final downfall. Their memory lingered in the people's hearts; it was kept alive by the old religion, and it haunted the songs of the people. But the

Georges, by law elect, had planted their feet firmly—and the House of Hanover survived all romance.

Among punch-bowls the Monteith takes the aristocratic place. Its decoration is pretentious. Its utility, with its removable rim with the scalloped edge, is its claim to recognition by the collector. They remind us of the days of good Queen Anne, of Marlborough and Charles Mordaunt, Lord Peterborough.

The Queen Anne soberness of design seems however to have been discarded in these Monteiths. There is something rococo and elaborate, as though in defiance of established reticence. The heavy ornament of lion's head and handles, the massive gadrooned edge of the scalloped design, the bowl deeply fluted, the embossed medallion with coat of arms, and the foot enriched with beaded ornament, all indicate that such specimens were regarded as the Standing Cup, so to speak, of the period.

With the punch-bowl our survey of silver vessels for drinking comes to an end. The sovereignty of glass was now established. Porcelain and even earthenware had made inroads into the silversmith's domain. The age of modernity was at hand.

SALE PRICES

Prices are always problematical. Specimens vary according to state, and other factors determining the price per ounce at which they are sold. Some of the following prices obtained at auction prior to 1915 may be of interest to readers but they have no relation to present values:—

STANDING CUPS

These are among the most sumptuous pieces of English silver. Prices always range high.

	£
Tudor cup, 6 oz. 15 dwt. (1525)	880
Tudor cup on foot, 14 oz. 3 dwt. (1521)	4,130

	£
Tudor cup and cover (James I) (1640), 66 oz.	4,000
Standing cup, Charles I, 470s. per oz.	82
Standing cup, Charles II, 1 oz. 13 dwts., 520s. per oz.	42
Loving-cup, Charles II (1678), 170s. per oz.	69
Loving-cup, William and Mary (1688), 165s. per oz. ..	88
Loving-cup, Queen Anne (1703), 120s. per oz. ..	140

TANKARDS

	£
James I tankard (1504)	1,720
Elizabethan tankard and cover (1599), 21 oz. 15 dwt. (a record price)	2,300
Elizabethan (Huth sale) (1573)	1,700
Charles I plain tankard (1629), 750s. per oz.	667
Plain tankard; York; maker, Marmaduke Best (1671), 195s. per oz.	234
Commonwealth (1649), maker, AF., 290s. per oz. ..	413

The range of prices was then (1915): Commonwealth, about £20 per oz.; Charles II, £8 to £10 per oz.; William and Mary, £4 per oz.; Anne, £2 per oz.; George I, 20s. per oz.

BEAKERS

	£
Henry VII, silver-gilt (1496), 6 oz. 16 dwt. sold in 1902	1,270
Elizabethan (1599), 490s. per oz.	197
Charles I (1635), 315s. per oz.	73
Charles II (1662), 290s. per oz.	46
William III (1699), 170s. per oz.	66

WINE CUPS

	£
Elizabethan goblet, 7 oz., 530s. per oz.	188
Charles I wine cup (1638), 3 oz. 14 dwts.	88
Commonwealth goblet (1650); maker, HS., 800s. per oz.	118

PUNCH-BOWLS

	£
William III "Monteith" (1701), 100s. per oz.	398
Queen Anne "Monteith" (1705), 70s. per oz.	267
Punch-bowl (1750), 23s. per oz.	15

SALE PRICES

Against these prices we may set a few more recent auction figures to show the general upward trend:

Tankards: (1597), £430; (1630), £620; (1638), £360; (1698) (an Edinburgh piece), £1,800; (1700), £376; (1712), £90.

Beakers: Elizabethan, £305 and £480.

Wine Cups: Vary enormously—one dated 1590 (an exceptional specimen), £1,050. An example by P. Lamerie (1727), £720. A Commonwealth cup, £500.

"Monteiths": (1697), £397; (1704), £360; (1706), £310.

THE SALT-CELLAR

IN the old days when costume differentiated the gentle from the simple, when demarcations of rank were definitely pronounced, when men wore feathers in their hats and swords at their sides, when retainers and menials sat at the same board with their lord and lady, the customs of the table were not our customs. It was only in Elizabeth's day, when dinner was served at a long table, that the oaken floor replaced rushes. The diners threw bones to the dogs, and although sweet sounds came from the musicians' gallery, the scene one may recall is one rather of barbaric splendour than of luxurious refinement. To him who loves to quicken the dry bones of collecting into something pulsating with life, the salt-cellar provides a delight which is not easily equalled. It was an honoured guest at every feast. It was the social thermometer which marked the exact degree of rank of the sitters. Persons of distinction sat above the salt, and between it and the head of the table. Those who sat below the salt were dependants and inferior guests.

If only these salt-cellars reproduced as illustrations could speak the secrets they caught in whispers from the upper end of the table, before the withdrawing chamber, prototype of our modern drawing-room, became a necessity! If walls had ears, or if the salt-cellars of Tudor England or of the stormy days of the Stuarts could have been fitted with gramophone disks, the by-ways of secret history would be less tangled for the historian.

Had this been the case, modern millionaires would have been in competition with one another to secure precious records, as it is only a rich man who can afford to gather together a representative collection of old salt-cellars. But for all that, the collector with small means, who is less ambitious, may obtain specimens that are of considerable interest, and in his quest he may, even in these days when collectors scour Europe, come across examples which may be antique.

As may be imagined, these "salts" are very varied in character. They may be of silver, of earthenware, or of ivory. They may be of simple form with little to distinguish them artistically, or, on the other hand, of such intricate design and rare workmanship as to make them superb examples of the art of the jeweller or silversmith.

Take, for instance, the salt-cellar sold at Christie's in 1902 for £3,000. It was only 7⅝ inches in height. It was silver-gilt, bearing the London hall-mark for 1577, and the maker's mark, a hooded falcon, probably the mark of Thomas Bampton, of the "Falcon." The receptacle for the salt is of rock crystal, and the base stands upon claw feet, which are of crystal. The cover is square, having a circular, domed top, above which stands a delicately modelled figure of a cherub.

A standing salt of the time of James I, with the London hall-mark for 1613, was sold at Christie's in 1903 for £1,150. The height of this was 11¾ inches, and, beyond its special value on account of its age and rarity, its form was not of greater elegance than many a lowly pepper caster whose presence it would scorn on the same board.

From the rare "St. Porchaire-ware" salt, of the sixteenth century, to the humble trencher, the range of salt-cellars is a comprehensive one. The most sumptuous examples, set in a magnificence of chased design exhibiting the finest

craftsmanship of the gold- and silversmith, command high prices on account of their rarity, and old salts of exceptional character pass inevitably into the hands of the elect, whose cabinets are known all over the world. But there are many lesser examples of the silversmith's craft, and it is not yet too late to acquire pieces suggestive of days when at the table "the jest was crowned at the upper end and the lower half made echo."

The City Companies possess many fine examples, and among the college plate at Oxford and Cambridge there are many unequalled specimens of the high-standing old salts. There is the plain silver-gilt salt presented by Roger Dunster to the Clothworkers' Company in 1641, and another, a drum-shaped salt, silver-gilt, the "Guift of Daniel Waldo, Clothworker, Esquire, an° 1660." Then there is the circular salt and cover, 22 inches high, of the Goldsmiths' Company, with the date letter of the year 1601, which was "the guift of Richard Rogers, Comptroller of His Majties Mynt" . . . "desiring the same may bee used at their solemne meetings and to bee remembered as a good benefactor, anno dni 1632." This salt has a body of glass, round which are two silver-gilt collars in chased and repoussé work. The Goldsmiths' Company has other salts, notably one the "Gift of Thomas Seymour" in 1693. The Haberdashers' Company has a circular salt the gift of Sir Hugh Hammersley in 1636. The Innholders' Company has two circular salts the gift of John Wetterworth in 1626, and a circular salt, silver-gilt, 16 inches high, with a dome raised on four scrolls, terminated by an obelisk, the gift of Anne, widow of John Sweete, 1635. The Ironmongers' Company has two fine silver salts, parcel gilt, shaped like hour-glasses, having sex-foiled sides, on three of which foliage is engraved. The date of one is 1518 and of the other 1522. The Skinners' Company

has a silver-gilt octagonal salt 9 inches high, the gift of Ben Albin, a member, in 1676. The Mercers' Company has two, one circular, the other octagonal. The Vintners' Company has a fine silver-gilt salt, the gift of John Powel, Master of the Company, in 1702. It is like a square casket in form, with panels richly decorated with figures in bold relief, and the cover surmounted by an urn upon which stands a female figure.

Some rare examples are in the possession of corporate bodies. There is the silver-gilt salt and cover, 15¼ inches high, belonging to the Corporation of Norwich. This is, as the inscription indicates, "The Gyfte of Petar Reade Esqviar." The plate marks are a roman capital letter D, the arms of Norwich, and a cross mound within a lozenge. It was made at Norwich, and its date is 1568, the year in which Peter Reade died.

Then there is the wonderful Ashburnham salt-cellar and cover of the time of Henry VII, the earliest standing salt, 12½ inches high, bearing the London hall-mark of the year 1508, and the maker's mark, a rising sun. This was bought by Messrs. Crichton Brothers for £5,600.

Later salt-cellars, while still remaining collectors' pieces, depart from the older forms. The old silver salt-cellars of Queen Anne and Georgian days are in another category. The elegance of form and the quaint reticence of design make them desirable acquisitions for any modern dining-table.

During the present century, when the furniture of Chippendale and of Sheraton has been collected with such avidity to refurnish old homes and to give illusion of age to modern mansions, the demand for old silver accessories to the table has been equally great. In consequence, spurious silver of later date, with the old hall-marks cunningly inserted, has appeared in great quantities. As a

warning to the collector of "old salts," it cannot too strongly be urged that in his earliest flights he should consult a friend who has passed through the same stages before him. The same advice is, unfortunately, necessary in connexion with collecting old china and old furniture. The literature of these two subjects is more ready to hand, and there are many popular handbooks designed to set the feet of the novice in collecting on the right path. But in furniture or in china there is no puissant company of furniture experts or china moralists. The buyer may be advised to use his common sense and demand that the dealer put on the invoice the exact description of the goods he is selling. If after expert advice the purchaser finds he has been deceived, he has his remedy in a court of law. But with silver, there are the hall-marks determined by law for the protection of the public. The Goldsmiths' Company exists to safeguard the public against fraud, and their honourable traditions extend, as we have seen, over more than six hundred years. If any buyer has any doubt as to the London marks or the provincial marks on a piece of silver he has purchased, it is easy to establish their authenticity. Some years ago the Goldsmiths' Company set up an Antique Plate Committee to advise them on articles suspected of contravening the hall-marking laws. This committee is composed of experts on antique silver and will examine any suspect pieces submitted to the Company.

You may search the statutes through and through, and you will find nothing relative to punishments specially laid down to meet the case of fabricators of old furniture or old china, but in regard to forging old silver marks there are numerous protective measure. There is, however,

STANDING SALT-CELLAR, 1507
Hour-glass form
(*Christ's College, Cambridge*)

III

reform needed in the laws relating to silver. Reform was urgently recommended by a Committee of 1856, but nothing was done. The Select Committee of the House of Commons, again, in 1879 made further recommendations, but no restrictive measure has ever been laid before Parliament. "There is much to say for the old demand of the Goldsmiths' Company for further powers of enforcing the law than the mere right to sue for penalties." As recently as 1959 a Departmental Committee on Hall-marking, known as the Stone Committee, presented its report to Parliament, but so far no action has been taken, nor is it known when its recommendations may be studied or implemented.

The study of salt-cellars suggests a passing word on the salt-spoon. To quote from an essay by Addison, dated 1711, the *Spectator* says, in an account he gives of dining with a fine lady: "In the midst of these my Musings she desires me to reach her a little Salt upon the point of my Knife, which I did in such Trepidation and hurry of Obedience, that I let it drop by the way, at which she immediately startled and said it fell towards her. Upon this I looked very blank; and, observing the Concern of the whole Table, began to consider myself with some confusion, as a person that had brought some Disaster upon the Family." This is a pretty picture of eighteenth-century "high life." The superstition concerning the spilling of salt is still with us, but helping salt with a knife is no longer in fashion in "polite society."

In general salt-cellars may be classified as follows, commencing with the Standing Salt, with its determination of rank as to those who sat above the salt and those who sat below it:—

Standing Salts.—The earliest are shaped like hour-glasses. These belong to the fifteenth and first half of the sixteenth century.

Cylindrical and casket forms, with rich ornamentation in repoussé work, with chased figures and surmounted by a cover with standing figure, are found in the sixteenth century. *E.g.*, the Standing Salt, part of the Stoke Prior treasure, dated 1563 (at the Victoria and Albert Museum).

The Bell-shaped Salt is of the late sixteenth and early seventeenth century, and the tall Steeple Salt belongs to the same period. The above types often had compartments in tiers reserved for spices.

The circular and octagonal forms of lesser height, with three and sometimes four guards with scroll ends, belong to the seventeenth century.

Trencher Salts.—These were in use contemporaneously with the tall standing salts, either on less formal occasions or at the lower end of the table below *the* salt.

Early forms in the first half of the seventeenth century are circular (1603) or triangular (1630). These were diminutive, measuring only some 3 inches across, and sometimes only 1 inch in height.

Eighteenth-century Salts.—A great variety of form is apparent, and many styles succeeded each other, disappearing only to be revived a quarter of a century later. Circular (1698–1710), oval, octagonal (1715–40), tripod (1750). Circular with three feet; oblong and octagonal, slightly taller (1775), with pierced work on four feet, and with glass liner; oblong, plain, with four feet; tureen-shaped or boat-shaped, plain, with swelling foot, sometimes with rings as handles, or with two handles (1780); shell-shaped salts in vogue 1788; circular, vase-shaped, with lions' heads and tripod feet (1798).

Early Nineteenth-century Salts.—George IV and William IV

ELIZABETHAN BELL-SHAPED SALT-CELLAR, 1594
Having compartments for salt and spices
(*Victoria and Albert Museum*)

115

STUART SALT-CELLAR, 1638
(*The Mercers' Company*)

styles, a reversion to some of the older types. The tureen and the circular-shaped salt, with four or three feet (1820–1830). Circular bowls on stands, with tripod and elaborate feet, the fashion (1810–1830). Many pieces betray classical influence.

The illustrations of the various types of salt-cellars should be sufficient to indicate to the reader the great field which is open to him. The examples range from the rarer earlier periods to the beginning of the nineteenth century. The descriptions given of the successive stages in form and design should stimulate the interest of the student in regard to the undercurrents of evolution, progressive or retrogressive, through three centuries of the silversmith's art.

The standing salt, of hour-glass form, of the Gothic period, at Christ's College, Cambridge, illustrated (p. 111), is dated 1507. Belonging to the great period of Henry VII, it is contemporary with the magnificent chapel in Westminster Abbey. It has survived the spoliation of the days of Henry VIII. Its perfect symmetry, its delicate ornament, its exquisite grace, delight the eye. This salt stands as a perfect creation of the English silversmith. The unwritten, perhaps never to be written, history of such a piece is not the least of its interests. We may revere the exquisite craft of the designer. But there is a tribute we owe to the sagacious custodians who, possibly in fear of death, preserved it for posterity. Its hiding-places, its narrow escapes, its glorious emergence into the light of day, to occupy a niche, almost sacred, in modern regard, are happenings that cannot be chronicled. As an historic relic, a page remaining from the old history of these realms, such an example claims admiration.

A fine bell salt is illustrated (p. 115). It is on three claw-and-ball feet. It has the London mark for 1594. It is

decorated in upright panels, with flat chasing with floral design of roses. It is constructed in compartments for salt, spices and pepper. These bell salts belong to the end of the sixteenth and beginning of the seventeenth century; they are mostly on three feet. At the Dunn-Gardner sale, in 1902, £600 was paid for a specimen. They stand, in point of time, between the hour-glass form and the steeple salts. Few appear to have been made, or, at any rate, few are now in existence, and in consequence they fetch great prices on account of their rarity.

A famous circular Stuart salt-cellar, from the days of Charles I, has the date letter for 1638 (see illustration, p. 116 and Marks illustrated, p. 261). This salt stood on the Mercers' Company table in 1642—eventful year, when Charles was misguided enough to go in person to the House of Commons with his guards to arrest the five members. This was the signal for the Civil War. The salt-cellar we now see was hurriedly put in the vaults of the Mercers' Company. The trained-bands of London were up. The city declared for the Parliament, and Charles raised his standard at Nottingham. John Dethick, the donor, may have fought in the civic cause. Here is the salt he gave to his Company in those stirring days, an illustration of which we are enabled to produce by the courtesy of the Mercers' Company. It has three handles with scroll ends, and is an important piece. It is silver-gilt, and engraved with the arms of the Mercers' Company and the arms and crest of John Dethick.

An octagonal salt belonging also to the Mercers shows the style of Charles II. It has four "handles" with scroll ends. These handles were for supporting a napkin, or some say salver, which was placed over the salt. It is of the year 1679 and is inscribed, "*Ex dono henrici Sumner M*^r." ("The gift of Henry Sumner, Master.")

TRENCHER SALT
Queen Anne, 1708
(*The Fogg Art Museum, bequest of A. A. Hutchinson*)

TRENCHER SALT
George II, 1724
(*The Metropolitan Museum of Art, bequest of Mary Strong Shattuck, 1935*)

119

CIRCULAR SALT
With three feet, 1743
(*The Metropolitan Museum of Art, bequest of A. T. Clearwater, 1933*)

CIRCULAR SALTS
With four hoof feet, 1737
(*The Metropolitan Museum of Art, The Jules S. Bache Collection, 1949*)

This is known as the Sumner Salt, and Henry Sumner, the donor, was Master of the Mercers' Company at that date. Its diameter is $9\frac{1}{2}$ inches and its greatest height is $8\frac{3}{8}$ inches. This is the year of the *Habeas Corpus Act*. This Act defines the liberties of the subject. All prisoners except those charged with felony or treason can demand that they be brought before a judge to test the validity of their detention. All persons charged with felony or treason must be tried at the next sessions or else admitted to bail, or, failing this, be discharged. No person could be recommitted for the same offence and no person imprisoned beyond the sea. Heavy penalties were imposed on those who violated this Act.

Contemporary with the silversmith's work it is interesting to notice in passing what the potter was doing. We possess a Lambeth delft salt-cellar of the late seventeenth century. Its height is only $4\frac{1}{2}$ inches. It simulates the silver style. The guards or handles are more shell-like in form than those of the silversmith. The technique of the potter with his twisting of the plastic clay is responsible for this. But the furniture maker of the period has something to add, too, in regard to this form of ornament. In his technique it is termed the "Spanish foot." It appears in feet and in the scrolls of handles for chairs.

Of trencher salts there is much to say. All that is not poetry is prose, as Monsieur Jourdain found out. A salt may be Standing—that is, it may be a ceremonial piece demanding the ritual of its order—or it may be a mere trencher salt; a name indicating its usage. Instead of being among the great folk, it was among the dependants at the lower end of the table. Trencher salts were menial in the earlier periods, but as time went on the great standing salt disappeared and trencher salts became general for gentle and simple.

Throughout the eighteenth century, from Queen Anne

to George IV (1820), and in succeeding years the salts were all trencher salts—there were none other.

In the early days trencher salts were associated with servility or with dependence, but later the salt at the elbow of the master of the feast carried with it nothing derogatory.

From Queen Anne, 1702, to the end of the reign of George I, 1727, little difference is noticeable and the lowly trencher salt changes very slightly. It is round, oblong, or octagonal. But in practical form it is substantially the same. Two specimens exhibiting this are given (p. 119).

The circular salts, with three or four feet, belong to the late George II and early George III period. Their feet are often of hoof form with cone-shaped terminals.

The early George III period exhibits other varieties of the salt-cellar. There was the wire-work cellar with cast additions, and the pierced and cut sheet silver. Most of these types are oblong in shape and were designed to receive a glass liner. These specimens have usually four feet. The example dated 1780 is of wire-work. The other adjacent example, dated 1776, is in a style which became prevalent in the last quarter of the eighteenth century. The feet of these examples are usually claw-and-ball or lion's-paw feet. It may be interesting to note the contemporary styles of the chair maker. The same influences were at work governing the worker in wood and the craftsman in metal.

Towards the close of the eighteenth century the styles become varied. There is the tureen form, on which type many variations are based. Similarly the boat-shaped salt is typical of many similar plain designs of this nature—some with two handles.

In the above types the swelling foot is a feature, but in other examples, from 1789 to 1803, the foot disappears.

SALTS WITH GLASS LINERS
George III, 1771
(*The Metropolitan Museum of Art, bequest of Edward Nicoll Crosby, 1929*)

SALTS WITH GLASS LINERS
George III, 1783
(*The Metropolitan Museum of Art, bequest of Annie C. Kane, 1926*)

GEORGE III SALT
Pierced. By R. and D. Hennell, 1770
(*Victoria and Albert Museum*)

GEORGE III SALT
Pierced and chased. By John Wren, 1799
(*Victoria and Albert Museum*)

THE SALT-CELLAR

The washing-tub-shaped salt-cellar indicates the decadence of design. The opening years of the nineteenth century show these poor forms in replacement of the early designs.

Specimens of the days of George IV and William IV show a reversion to older forms, the tureen shape with gadrooned edge and with four legs, and the circular form with three legs.

Of the circular form the classic rotund urn or vase shape seized the fancy of the silversmith at various periods. As early as 1771 we find the form in the perforated work, with swags and classic ornamentation, rather suggestive of French fashions, and obviously intended for use with a glass liner.

The story of the salt-cellar comes to an end. Its customs and its dignities are lost except to those who love delving into the record of the manners of past days, "now here, at upper end o' the table, now i' the middle." The salt-cellar has a complete history for three hundred years, and with its evolution *pari passu* is the march of social custom.

SALE PRICES PRIOR TO 1915

STANDING SALTS				£
Elizabethan (1573), 10 oz.	245
Elizabethan (1577), 13 oz. 18 dwts.	720
James I (bell-shaped) (1608)	336
James I (bell-shaped) (1613)	1,150

TRENCHER SALTS				£
William and Mary, 235s. per oz.	20
William III (3) (1698), 132s. per oz.	60

£

Queen Anne (2), oval (1708), 165s. per oz. 40
Queen Anne (2), circular (1713), 195s. per oz. .. 28
George I, from 60s. to 80s. per oz.
George II, about 30s. to 40s. per oz. Sets of four and
 six higher prices per oz.

Here again present-day prices are out of all proportion to those quoted above.

A small standing salt dated 1563 fetched £320 a year or so ago; a bell-shaped salt of 1599, £500; a George II set of eight salts cost £210; and a pair of trencher salts (1736), £120.

By R. Hennell
1775
(*Victoria and Albert Museum*)

GEORGE III SALTS

One of set by Paul Storr One of set by R. and D. Hennell
1810 1799
(*Bentley & Co.*)

BOAT-SHAPED SALT
By William Abby, 1803–1804
(*Victoria and Albert Museum*)

THE SPOON

FROM Elizabeth to the late Georges the range of spoons is a long one, and comprehends, in the early days, classes that are prohibitive in price for the pocket of the average collector. There are spoons and spoons. From the early elaborations in Apostle, Maidenhead, or *lion-sejant* forms to the later styles of rat-tail teaspoon or the fanciful caddy-spoon there is choice enough to suit the idiosyncrasies of most collectors. Indeed, it may be said that the collecting of spoons is a thing apart. Silversmiths themselves became specialists when they made spoons; the craftsmen were on a plane by themselves, and so it comes to pass that the collector, following in their wake a couple of centuries or more afterwards, has to give special study to this branch of silver plate.

It is not necessary, to trace the antiquity of the spoon, to revert to Roman days, to enumerate what has been found in Saxon graves, or to wander through the mediæval period to show the use and development of the spoon. It is sufficient, in the present volume, to take spoons as found in the realm of collectable silver.

Practically, this may be said to begin at the reign of Elizabeth, though in 1903 a set of thirteen apostle spoons of the reign of Henry VIII, and having the London hall-mark for 1536, was sold at Christie's for £4,900. But this is sensational.

There is no doubt that the most popular type of spoon of the Tudor period—that is including the reigns of Henry VII (1485–1509), Henry VIII (1509–47), Edward VI (1547–53), Mary (1553–58) and Elizabeth (1558–1603)— was the well-known apostle spoon. It is rare to find any examples before 1500. The oldest known is dated 1490. They were called apostle spoons because each spoon was surmounted with a figure of one of the apostles with his customary emblem, such as St. Peter with the key, St. John with the chalice, etc. They were thirteen in number to make a complete set—that is, the twelve apostles and the Master spoon, bearing an image of Jesus Christ, although the thirteenth in some cases was St. Paul. The study of apostle spoons does not begin or end with English silver. They originated on the Continent, and the goldsmiths of Nuremberg, Paris, Milan and Madrid fashioned them in like form, each according to the traditions and technique of his school.

It was apparently the custom in Tudor days to offer a set of these spoons, or, if the donor were less rich, a fewer number, as a christening gift. Sometimes only four were given, representing the four evangelists. In modern days the gift of a christening spoon still continues, though the spoon is shorn of its former apostle head. There are many passages in the old English authors referring to this custom, and numerous references in old wills bequeathing sets of these apostle spoons as heirlooms. In Shakespeare's *Henry VIII*, v. 2, Cranmer, who declares his unworthiness to act as sponsor, is met with the rebuke from the King: "Come, come, my lord, you'd spare your spoons."

It is interesting to note the emblems usually found associated with the different apostles. The following list will enable the collector to distinguish the one from the other:—

1. 2. 3. 4.

SEVENTEENTH- AND EARLY EIGHTEENTH-CENTURY SPOONS
1. Apostle spoon, St. Bartholomew, London, 1582
(*The Metropolitan Museum of Art, bequest of Mary Strong Shattuck, 1935*)

2. Seal-top spoon, Provincial English, early 17th century
(*The Metropolitan Museum of Art, gift of Mrs. S. P. Avery, 1897*)

3. Trefoil-ended spoon, London, 1697
(*Victoria and Albert Museum*)

4. Trifid spoon, London, 1700
(*Victoria and Albert Museum*)

LION SEJANT SPOON
London, late 16th century

MAIDENHEAD SPOON
London, mid-16th century

(*Victoria and Albert Museum*)

132

THE SPOON

St. Peter—a key or a fish.

St. Thomas—a carpenter's square or a spear.

St. Andrew—a transverse or saltire cross.

St. John—a cup with a winged serpent.

St. Philip—a cross of varying form, usually on a long staff.

St. Bartholomew—a large knife.

St. Matthew—a wallet or purse, or sometimes a spear or an axe.

St. Jude—a lance or a saw; sometimes a club.

St. James the Great—a pilgrim's staff.

St. Matthias—a halberd or an axe.

St. James the Less—a fuller's pole, because he was killed by a blow on the head dealt him by Simeon the fuller.

St. Simon Zelotes—a saw, in allusion to his martyrdom.

The thirteenth is either St. Paul with a sword, or the Master spoon, with orb and cross and hand raised in blessing. Occasionally, too, the evangelists Mark and Luke occur in spoon sets; Mark, with his lion, replaces St. Simon; and St. Luke, with an ox or calf head, occurs in lieu of St. Matthias in others.

There is no doubt that apostle spoons have been largely sought after by collectors as something desirable and antique. They have accordingly been manufactured by the thousand to meet such a demand, and young collectors cannot be too careful in accepting authentication by word of mouth from any seller. There are always the museum examples for ready reference. They are in glass cases easy of access, and a close inspection can be made at The Metropolitan Museum of Art, which is little short of actually handling the specimens. This remark applies equally to seal-top and other older forms of spoons not frequently handled by the beginner.

Sets of thirteen apostle spoons are very rare. There is

Archbishop Parker's set at Corpus Christi College, Cambridge, including the rare Master spoon and also St. Paul with a sword, which spoon bears the date mark for 1515, while the others are hall-marked 1566. The Swettenham set of 1617 is now owned by the Southern Comfort Corporation. The Goldsmith's Company have a set with the hall-mark 1626, which was presented to them many years ago by Mr. George Lambert.

We illustrate as an example of the apostle spoons one made in London in 1582, with the figure of St. Bartholomew with a large knife (p. 131).

The Seal-top Spoon

Contemporary with the apostle spoon were other types. The terms now applied to them are purely collectors' names. There was the acorn terminal, the seated lion with a shield (*lion sejant*), the seated owl, the pineapple, the mitre, and the head of the Virgin, which continued for a long period and is now known as the Maidenhead variety. But the most common was the seal-top with baluster ornament, which form lasted well into the seventeenth century. We illustrate a provincial example from the early seventeenth century.

The Slipped-stalk Spoon

During the reign of Charles I (1625–49) the bowl of the spoon began to take different proportions, and to depart from the pear-like form. It became more oval and narrower at the base and wider near the stem. But in regard to evolution of form, the modern spoon, as is readily seen, is an inversion of the bowl. It is egg-shaped, but the narrowest part is now away from the handle, whereas formerly the narrowest part was joined to the handle. All the sixteenth- and seventeenth-century spoons

1. 2. 3.

SEVENTEENTH-CENTURY SPOONS

1. Slipped in the stalk, *c.* 1640–1650
(*The Metropolitan Museum of Art, Rogers Fund, 1913*)

2. Puritan, *c.* 1660
(*The Metropolitan Museum of Art, gift of Mrs. Samuel P. Avery, 1897*)

3. Charles II, flat stem, 1665
(*Victoria and Albert Museum*)

show the old form and the later spoons show the opposite. The innovation is shown in the illustration (p. 131) of seventeenth- and early eighteenth-century examples.

The slipped-stalk spoon was simply a radical departure from excessive ornament. It may have been on account of religious motives, it may have been by reason of economy. Obviously such a spoon cost less to produce without its terminal figure. Hence we have the slipped-in-the-stalk variety which was cut off transversely as shown in the illustration (p. 135) of an example made between about 1640 and 1650, which form readily developed into the so-called Puritan spoon with plain, flat handle, which shortly exhibited wider ends. Of this style two examples are illustrated (p. 135).

The Trifid Spoon

This style was a passing fancy. The design was not pleasing nor was the form especially easy to handle. An example illustrated (p. 131) was made in London in 1700 and, like its neighbour of 1697, the marks include the figure of Britannia and the lion's head erased. The beginning of the eighteenth century shows the attempt of the spoon-maker to invent new forms, as we see in the Edinburgh specimen of 1718 (p. 139). It still preserves the rat-tail strengthening of the junction with the bowl—a feature which persists until about the middle of the century.

Various varieties claimed recognition at this period. They were ornamental and essayed to fix new styles, but their day was short. They stand now as collectors' examples. The lobed-end specimen illustrated (p. 139) shows this type with ornament on the back of the bowl, which still retains its rat-tail form in subjection. It is now merely an ornament or a relic of a former style, as the handle ends abruptly and somewhat clumsily before the

rat-tail commences as an adjunct or ornament. Such a fashion was not destined to live long. This has the London hall-mark for the year 1683.

The modern spoon comes in process of evolution from these earlier forms. The straight stem of apostle or seal-top days was still retained in the flat Puritan form. We have seen that the bowl underwent a change in form, but the stem or handle similarly was the subject of inventive caprice. It became "wavy" in form in the time of William III. The Queen Anne type, apart from its pronounced rat-tail back, became developed in the reign of George I into a type which may be termed the Hanoverian spoon. The outline of the end is continued in a curve without a break. This is the new form which has continued to the present day. Whatever ornament was introduced, whether as additional to the bowl or to the handle, the form became established.

Simultaneously with this form, simple and utilitarian, was what is termed the "old English," which is found in the middle of the eighteenth century. The handle was bent back and the rat-tail became a crop, as we have seen.

The fiddle pattern in common use to-day was a late eighteenth-century innovation. There is nothing beautiful in the ears of the fiddle pattern, which might well be lopped off.

It will be seen that the history of spoons is a long one and complicated by fashions. Nor is the study lightened by the various usages to which spoons may be put. It may readily be imagined that the use of coffee and tea brought the small spoon into commoner use. To-day the dainty spoon at five-o'clock tea is a modern usage. But there is some suggestion that in eighteenth-century days the spoon of fashion was trivial in character in comparison with the larger spoons in use.

SEVENTEENTH- AND EARLY EIGHTEENTH-CENTURY SPOONS

Edinburgh, 1718 Lobed spoon, London, 1683
(*Victoria and Albert Museum*) (*The Metropolitan Museum of Art, gift
of Mrs. Samuel P. Avery, 1897*)

THE SPOON

Pope, of the *Essay on Man* and depicter of the *beau monde*, has the lines:

> Or o'er cold coffee trifle with the spoon,
> Count the slow clock and dine exact at noon,

suggesting the dilettante late at breakfast. Evidently the spoons were at that date made for toying with and corresponded with our modern tea and coffee spoons.

Something should be said of the manner of marking spoons. The positions of the hall-marks are worthy of our notice. Before the Restoration (1660), and for some time afterwards, the leopard's head was placed inside the bowl, as is shown in the illustrations we give of various examples. During the reign of Charles II the style of marking may be said to be transitional. In the early years some examples have all the marks on the handle. Even towards the last years of the reign other examples have the leopard's head in the bowl and the rest of the marks on the handle. After this the marks appear on the handle, and about 1781 they were placed at the end of the handle instead of close to the bowl, as was the former practice.

SALE PRICES

APOSTLE SPOONS

It is impossible to fix prices. In July 1903 a set of thirteen with hall-mark for 1536 realized £4,900, while in 1941 a set of thirteen, dated 1607 and 1610, fetched £1,000.

Single specimens may roughly be valued as follows: Fifteenth century, anything from £50 to £300; sixteenth century, from £30 to £100; seventeenth century, £3 to £40. Six spoons (1631) brought £280 and a pair (1622) only £7. "Fakes" are abundant in this class.

SEAL-TOP SPOONS

Prices ranged from £8 to £25 apiece.

CHATS ON OLD SILVER

CADDY-SPOONS

These from middle of eighteenth century are a large class, which should appeal to the collector of limited means. But even in this modest field the faker has been busy.

Recent prices for apostle spoons vary quite as widely as they did prior to 1915. A single specimen dated 1487 brought £1,300. Sixteenth-century specimens have sold for £270 to £350.

Other types of spoon included in later sales may be quoted. Three Puritans (1664), £125; six rat-tails (1695), £150; *Lion Sejants* (1578), £52; (1618), £32.

THE POSSET-POT AND THE PORRINGER

A COLD climate demands hot cordials. There was no elaborate system of hot-water pipes in the draughty, cold, and damp Elizabethan mansions with their rush-covered floors. It was a necessity, apart from long and deep potations of strong drinks, to take a nightcap or caudle-cup of something hot. In the eighteenth century the drinking of hot punch superseded this. But in the sixteenth and seventeenth centuries the custom of the posset of hot sack with spices, and having milk and eggs, as a supper beverage was universal. Not that the posset-cup was idle in the daytime. It succeeded, even if it did not replace, the standing or loving-cup at wedding and other ceremonies. "Mix a posset for the merry Sir John Falstaff" might, and possibly did, refer to any hour of the day, for that jovial soul did not stand on ceremony as to when he drank, so long as it was copious and oft-repeated.

That the posset was of something thicker than mere spiced ale or hot wine is shown by Shakespeare's "Thou shalt eat a posset to-night at my house" (*Merry Wives of Windsor*). And Lady Macbeth, as a last act before the final commission of the treacherous crime, says:

> I have drugged their possets,
> That death and nature do contend about them,
> Whether they live or die.

We have seen that the caudle was curdled milk, with wine and hot spices, and that it was smoking hot. Shakespeare says, "We'll have a posset for't soon at night, i'

faith, at the latter end of a sea-coal fire." It was undoubtedly hot, and it seems to have been, sometimes for medical reasons, made doubly so. Hence Dryden writes:

A sparing diet did her health assure;
Or sick, a pepper posset was her cure.

The object of a vessel, in the end, determines its established form. Its purpose being to receive a hot caudle, demanded that the posset-pot or cup should have a cover to keep its contents warm. Its two handles never seem to have deserted it, until it became a shallow dish or bowl for broth. These handles undoubtedly served a purpose, but the love of ornament and the balance of vessels which were always of beautiful form and perfect symmetry demanded two handles, by which design they succeeded the style of the loving-cup handed around, but it is not possible to conceive that the posset-cup was other than for personal use.

No posset-cup of early days has survived. We have mainly posset-cups of the Stuart period, contemporary with the porringer. We might almost term this the transitional period. But the difference is apparent. Whereas the posset-cup or pot had a cover, the porringer had not. Otherwise in form there is little difference. But it must be borne in mind that the covered vessel was a protection against poison. When this fear was no longer prevalent the open vessel became more popular.

The illustrations show various types of these vessels. They belong mainly to the Stuart period. It is not possible to give a posset-pot from which the contemporaries of Falstaff drank their caudle. We can only conjecture from frequent literary references that such vessels were in common use. They have long disappeared, and there are few Tudor examples. There is a fine posset-pot and cover,

COMMONWEALTH PORRINGER, 1653

Marks illustrated p. 261

CHARLES II POSSET-POT AND COVER
1662

CHARLES II PORRINGER, 1669
Silver-gilt, with marks below
Maker, IN. (possibly Euodias Inman)

of gold, of the sixteenth century, at Exeter College, Oxford.

The earliest porringer illustrated is a Commonwealth example, with the hall-mark for 1653 (illustrated p. 145). Here is a vessel open-mouthed, and there was evidently no intention that it should possess a cover. It is of different form to the contemporary posset-cup, and was not used for the same purpose. Apparently it was for something intended to retain the heat to a lesser degree, hence the absence of the lid. It is futile nowadays to conjecture with exactitude for what purpose these vessels were used. But, presumably, the porringer was for something more solid and less stimulating.

The date of this Puritan porringer is a memorable one. It belongs to the year when the Dutch were defeated off Portland in February, again off the North Foreland in June, and off Texel in July, when Van Tromp was killed. In the year of this porringer Oliver Cromwell forcibly dissolved the Rump Parliament. "Clad in plain grey clothes and grey worsted stockings," Oliver sat in the House listening impatiently to Sir Harry Vane, till at length he could bear it no more. He rose, and after charging the House with injustice and self-interest he cried, "Your hour is come; the Lord hath done with you." Clapping his hat on his head, he strode into the middle of the House with "It is fit you should sit here no longer! You should give place to better men! You are no Parliament!" Thirty musketeers entered at a sign from their general, and the thirty members crowded to the door. The Speaker refused to quit his chair, till Harrison offered to "lend him a hand to come down." Cromwell lifted the mace from the table. "What shall we do with this bauble?" he said. "Take it away!"[1]

[1] *Short History of the English People*, by J. R. Green.

On the same page is illustrated a Charles II posset-pot and cover, with the date mark of London for 1662, and by its side is a small porringer of the date of 1669. This was evidently for the use of a child, which is some indication that these smaller vessels were actually used for something in the nature of food, and the possibility that they derive their name from the word "porridge" is a conjecture not to be easily dismissed.

The bowl of Stuart days has an ogee outline contracted towards the mouth, giving it a pear-shaped form; this is common in porringers and posset-pots of the seventeenth century. In the example with the London hall-mark for 1662 the body is decorated with spheroidal swelling lozenges, giving character to the piece. The cover is plain, and heightens considerably the fine proportions, and is surmounted by a knob of baluster form. The handles are delicate and of gracefully curved form. The handles of the adjacent porringer, it will be seen, are of flat openwork. From 1653, the date of the Commonwealth porringer, to 1669, the date of the small porringer, it will be seen that the handles are in a transitional stage. The upper half of the handle may be likened to a fanciful letter C, the bottom curve of which ends half-way in the interior of the handle, the handle being continued until it joins the bowl lower down. In the second example, 1662, the C stretches from the junction of the handle with the bowl at the top to its junction again at the lower end, the continuation of the handle below this is a slight additional outward curve. In 1669 the handle had become a letter S. The C form is slightly indicated by a break in the upper curve on the inside of the handle.

A comparison of the various forms of handle illustrated in this chapter shows that the C form in combination with the S form varied throughout the seventeenth century.

POSSET-POT AND COVER, 1673
The Sterne Cup
(*Victoria and Albert Museum*)

CHARLES II PORRINGER, LONDON, 1666
(*Private collection*)

In the posset-cup and cover of 1673 (illustrated p. 149), the S form would seem to have become established; but another example, 1683 (illustrated p. 153), shows the letter C again in strong combination with the letter S in the handle.

The potter, we see, was troubled by no such fanciful problems. In the pot illustrated (p. 157) he makes a straightforward simple handle, best suited to his technique. Of the same date and illustrated on the same page is a fine James II posset-cup, and here the handle takes the form of the letter C, and again a second C for the lower half of the handle. By the year 1690 the letter S-form handle in graceful curves had become established.

The illustration on page 149 shows a posset-pot known as the Sterne Cup, now in the Victoria and Albert Museum. It is of silver-gilt and bears the London mark for 1673. The lower half of the bowl is pounced and chased with heraldic cresting and an inscription: "The Gift of King Charles the Second to Arch-Bishop Sterne Lord Almoner." The handles are scrolled and the flattened dome of the cover is surmounted by a turned finial.

It will be seen in comparison with the porringer of the date of 1666, illustrated on the same page, that the caryatid handles, which are similar to early Italian metal-work, are part of the handle itself, and the female bust forms the swelling curve. Here in the first example of the posset-cup the head is set as though it were a thing apart and unconnected with the design of the handle in its entirety. In the lower example of the porringer the head actually becomes full face, and consequently is merely a meaningless survival of the older form and not an integral part of the design of the handle.

The posset-pot and cover, with the London date mark for 1683, exhibits another form; its body has straighter

sides. The scroll handles are similar to some of the older forms, and the woman's head is retained. The acanthus-leaf decoration occurs on the lower part of the body, the rest being plain. Here the proportion of decorated and undecorated surface introduces another factor. It is seen on the lower portion of the Charles II porringer of the date of 1666, and it lingers on into the Queen Anne period.

In the Tudor period we have seen, in regard to the mottled stoneware tankards, that the potter and the silversmith worked in sympathy with each other. In late Stuart days it cannot be said that the silversmith and the potter had very much in common. We illustrate two specimens. The first is a posset-pot and cover of unusual form, with steeple-like cover and baluster terminal. This is on a high foot, and the handles have a massiveness about them not usually associated with posset-cups. It dates from near 1685, an important date in the art of the silversmith. The Edict of Nantes was revoked, and in consequence many hundreds of Huguenot refugees, silk-weavers and metalworkers, came to this country. The Spitalfield looms and the names of French makers on the silver plate date from this influx of foreign craftsmen.

Below this is a posset-cup made by the Staffordshire potter, racy of the soil, and far removed from the subtleties of the worker in silver. This is dated *circa* 1700, and inscribed with the name "T. Shaw." The handles, six in number, are eminently suited to the plastic clay. The convolutions of the smaller handle are suggestive of the glassworker. Here the potter and the silversmith join hands, for the handle of the more elaborate piece is suggestive of the glassworker too. It must be remembered that Venetian glassworkers had settled in London under the patronage of the Duke of Buckingham in the days of Charles II. It is not unnatural to suppose, seeing that the glass-blower,

POSSET-POT AND COVER, 1683
Marks illustrated below
(*Victoria and Albert Museum*)

153

the silversmith, and the potter were all working in competition, that they cast an eye on each other's work.

There is a peculiar design embodied in the work of the old glassworkers of Venice, for centuries embosomed on the lagoons at Murano, which design is taken straight from the waters of the Adriatic. There is a little denizen of those waters, delicate and of extreme beauty, only some 3 or 4 inches long, known as the sea-horse. He swims in the blue water or curls his tail around a weed. His head is like a Roman horse with arched neck. Those who know the delightful configuration of this creature, the *hippocampus antiquorum*, will realize the parallel. The Venetian glassworker adapted this design, ready to hand, as the Copenhagen potters have taken the figures of birds and animals of the Baltic to give form and colour to their work. All craftsmen have done this, from the ancient cave-dweller in the Dordogne who scratched the reindeer in motion which he has left for posterity to criticize, to the Japanese with their fishes and birds and insects. The short-nosed sea-horse with its beautiful and graceful form has been taken by the glass-blower and transfused in the furnace, with skilful and adept art in manipulating the pliant metal, into a handle with conventionalized form. The arched back becomes a row of bead-like ornament in the bow of the handle, a style of ornamentation which peeps out from old Italian glass goblets, still in due subjection. When it crosses the Alps into Germany the foreign glassworker, knowing nothing of the delicate suggestion of the origin of the ornament, straightway makes the handles into hugh appendages, departing more and more from the initial source of inspiration.

The glass-blower of Stuart days and the silver-worker meet at this point, and the bead-like ornament is derived from this old form. It is shown in simpler style in Charles II

porringers, and in more elaborate development in the James II posset-pot. The former are nearer to nature, and possibly nearer to the glassworker.

The potter has similarly twisted his clay with equal swiftness and ease into convolutions similar to the glass-blower's technique, but he has gone away from the original. With an elaboration far and above the three bends he has given to his plastic body in his handle, the German glass-blower has essayed to improve on this form, according to his lights; the result is that some of the German glass consists mainly in a fine elaboration of handle.

In regard to the evolution of design, something should be said of an Exeter piece with the hall-mark of that city, 1707, straight from the days of Queen Anne. The maker of this piece was Edmund Richards. Did he know that in his crane-head handle he was perpetuating something that was to live to the twentieth century? To-day modern Japan has run the crane to death. In textiles and in metal-work the design of the crane appears again and again. It is found in scissors; we have before us an elaborate pair, made for the Great Exhibition in 1851, with crane handles, elaborately finished and gilded.

To terminate the history of the silver vessel intended to be used for posset, caudle, porridge, or broth, we may refer to a type of bowl, or, as it is termed in the old inventories, a "Plum Broth Dish." It begins a new era. The posset-pot and the silver porringer were dying out; the days of the punch-bowl, the tureen, and all the more modern silver vessels for tea, for coffee, for soup, suited for the complexities of a more modern life, were at hand.

It is thus seen that the art of the metalworker is perennial; it belongs to no especial period and to no particular country. The working of silver is one of the oldest art-crafts of man. "There is nothing new under the sun," said

POSSET-POT AND COVER, JAMES II
(*Private collection*)

POSSET-POT OF BUFF EARTHENWARE
Staffordshire, *c.* 1700
(*Victoria and Albert Museum*)

157

Solomon, and although his mind was not fixed on the arts and crafts, there is an applicability about the adage. The caprice of fashion has determined how long a period a certain form should be in use before it was replaced by some other form—a deviation from a former or a reversion to an older form. It is the pleasure of the collector to unravel the motives which led to changes or which put a dead stop to inventiveness. Every object he examines, every specimen he owns, is another link in the long chain enabling him to pick his way from one conclusion to another. The premisses are there, the data are his, if only his conclusions be sound.

SALE PRICES

POSSET-POTS

Prices vary considerably, according to the character of the example.
Charles II examples brought from 100s. to 300s. per oz. prior to 1915.
Four examples sold for as much as £400.

PORRINGERS

Unique and early examples are just as expensive as posset-pots.
Charles II specimens realized from £300 to £600.
Exceptional pieces have brought sensational prices. A Charles II example of 1661, maker I. W., sold in 1909 for £1,015 at 270s. per oz. In the same year a smaller one, made by George Gibson in 1680, sold for 330s. per oz., realizing £75.
The differences in prices between Charles II and late Georgian were roughly: William III, £5 to £12 per oz.; Queen Anne, £3 to £6 per oz.; George I and II, 50s. per oz.
The faker has been active with so-called "Queen Anne" porringers, with special fluting and marked with the Britannia or higher standard mark. Collectors who have been taken in by these can have them assayed at the London Assay Office or elsewhere, and if the mark is forged there is a legal remedy.
Within the last few years seventeenth-century porringers have realized: (1657), £190; (1662), £880; (1669), £304; (1675), £120.

THE CANDLESTICK

ECCLESIASTICAL candlesticks have been in use from earliest times. The pricket form, that is with the spike for sticking the candle on, may be seen in use to-day. This form has survived in spite of its obvious inconvenience. It might have been of use for candles of great size, but even then long candles were apt to turn over if not kept upright by the attendant priests. The pricket or spike form may be at once dismissed, although older, as being outside the field of the domestic candlestick.

Whatever may have been the receptacle for candles in common domestic use in Elizabethan days, it is now lost. The candlestick has not been so fortunate as the spoon to escape the melting-pot. Even early Stuart examples are rare. Specimens of candlesticks of the first half of the seventeenth century are so rare as to be beyond the average collector's pocket.

We are enabled to reproduce an early example of the time of Charles I, bearing the London hall-marks for the year 1637. This is the very year that Hampden refused to pay ship-money as taxes.

It will be seen that the example illustrated is simple in form. It is not so delicate as the brass candlestick of a slightly later day. The bottom is like an inverted wine cup, and the straight pillar holds the candle. The marks on this are on the rim of the bottom, upside down, which has led some persons to suppose that the base might be used as a wine cup, which is absurd.

LAMBETH DELFT CANDLESTICK
With coat of arms, and dated 1648

CHARLES I CANDLESTICK, 1637
Marks illustrated p. 257

THE CANDLESTICK

This type is the plainest possible, and suggests that little of any value preceded it. It leaves one with queer imaginings as to what the Tudor form may have been like. But one must not be too exacting. A glance at table manners gives modern precisians a shock. There was a common dish, at which all helped themselves. The habit of putting the hands into this dish to seize bits of meat does not seem to have been regarded as objectionable. This was in the fifteenth century. There were no soup plates till about the year 1600. Nor was there any large spoon for serving from the tureen till about a hundred years later, that is about 1700.

The Lambeth delft candlestick, with coat of arms, dated 1648, is more symmetrical than the example of the silversmith. It has the platform for the grease, similar to examples in the next reign made of gun-metal, and very heavy.

Charles II Examples

There was an extraordinary demand for silver plate in the reign of Charles II. This is indicated in the diaries of Pepys and of Evelyn. We are tempted to describe a pair of candlesticks of especial beauty and delicacy.

These candlesticks were sold at Christie's in 1908 for £1,420. They are 11 inches in height, and they bear the London hall-mark for 1673. The barrel is short, and fluted to represent a cluster of eight small columns. The barrel is connected with a cast and vase-shaped stem, ornamented with four lobes and four acanthus leaves. The platform has voluting shells, and the base is composed of four escalop shells. There is a delicacy about these candlesticks which is Italianate in character. From the barrel to the base the lines are graceful and subtle. There is nothing else like them in English silver. They suggest the

fanciful design of the best Japanese art, a century before that art had penetrated Europe. Remarkable in many respects, they are representative of the joyousness and vivacity of the Restoration; they have no forebears and no successors. They are unique.

The fluted column was a form which appealed to the Carolean maker. On square bases with platforms shrunken and inverted, this type departs from the fanciful curves of the pair illustrated. The straight line is predominant in the base, the platform, and the socket. Sometimes the baluster ornament of the seventeenth century is introduced in the stem.

Other late Stuart forms include the type with octagonal base, sometimes plain hammered, and deep, from which the stem springs as from a pan, and other forms with fluted column still on octagonal base, which in the later days of the seventeenth century began to be more subdued in character. By the middle of the seventeenth century the platform disappears in silver candlesticks.

An interesting specimen is the Charles II snuffers and tray, of the date of 1682. The snuffers are plain and flat and have the character of the handles of the porringer, of the date 1669. This flat openwork is peculiarly English, and belongs to the late Stuart period. It is exhibited on the handle at the back of the tray. The tray is as reticent as the silver of the early Queen Anne period (illustrated p. 166).

The Eighteenth Century

The candlesticks of the eighteenth century vary considerably in character. The fluted column rising from the octagonal base, with the relic of the old platform, is retained in a band with gadrooned edge. The illustration (p. 165) shows two styles of the first half of the eighteenth

EIGHTEENTH-CENTURY CANDLESTICKS

George I, 1719
By Paul Lamerie
(*Victoria and Albert Museum*)

George II, 1752
By John Cafe
(*The Metropolitan Museum of Art,
Rogers Fund, 1913*)

CHARLES II SNUFFERS AND TRAY, 1682
Marks illustrated below
(*Victoria and Albert Museum*)

166

century, that on the left by Paul Lamerie, that on the right by John Cafe. The baluster ornament, so common in Stuart days, was adopted, and ran through the eighteenth century, until classic influences swept it aside. This ornament, found as a terminal in silver knobs of early date, now became elongated and assumed various forms, with swelling and undulating form, sometimes with ornamented edge, till it became absorbed with the classic form of upright fluting and urn-like nozzle.

Candlesticks with removable nozzles were first introduced about 1758; the tall Corinthian column form is noticeable at this period. The urn sockets were in vogue from 1790 to 1798. It should be noted that removable nozzles when found on seventeenth-century pieces may be regarded as a later addition.

The provincial candlestick maker was not behind the London maker at the end of the eighteenth century. For instance, when the Sheffield Assay Office commenced operations in 1773 the classic style was at its height. The Adam brothers had impressed their personality on furniture and on architecture. Wedgwood had diverted Staffordshire into the paths of Olympus. Here it should be said that "Sheffield plate," so called, is not Sheffield silver plate. It is difficult to explain. Plate is the technical term we employ in regard to solid gold or silver. Plated things which may be either gold plated or silver plated are of baser metal, most frequently copper, covered with a layer of gold or of silver. Sheffield has won a renown for her antique silver-plated ware. But here we have Sheffield silver plate, that is Sheffield silver, with the marks of the assay office. We give an example (illustrated p. 169), twenty years after the granting of the charter to Sheffield. Candlesticks, silver and silver-plated, were the specialties of Sheffield, and very beautiful they are.

The ribbon festoon with knots suggests the Louis Quinze period. This indicates the departure from the stern classic types; and the nozzle is removable, a style which was then in common use.

As a study, the candlestick exhibits infinite variety. The eighteenth century, from Queen Anne to the late George III period, offers many forms. The Stuart candlestick is on another plane, and appeals to the collector of rare examples.

The candle is almost dead and gone; it reaches to the threshold of modernity like some dim ancestral ghost of former days. The electric bulb is triumphant, paraffin is plebeian, and gas stretches back to when Westminster Bridge was first lit by gas in 1813. Nobody has apostrophized a gas bracket or a paraffin lamp. But the candle is both historic and poetical, and the candlestick offers a pleasing field to the collector.

SALE PRICES

Prices vary to a great extent. As in the case of the salt-cellars, sets bring higher prices than the single examples. The differences in prices prior to 1915 were:—

EARLY EIGHTEENTH CENTURY

Sets of four	£80 to £100
Sets of two	40 to 70

LATE EIGHTEENTH CENTURY

Sets of four	£20 to £40
Sets of two	7 to 20

Single specimens varied from £2 to £10, according to design.

In buying candelabra at so much per ounce, beginners should carefully ascertain weight, as examples sold per ounce have realized large sums owing to their massiveness.

Sets of four have reached £350 to £600. A set of six—two York (1684) and four London (1675)—reached £1,020.

EIGHTEENTH-CENTURY CANDLESTICK, 1782
Classic style made at Sheffield
(*Victoria and Albert Museum*)
169

THE TEAPOT, THE COFFEE-POT, THE TEA-KETTLE, THE TEA-CADDY

THE silver plate of a country undoubtedly reflects the manners and customs of its users. The growth of luxury undoubtedly has had its influence upon the manufacture of a great number of silver articles employed in everyday use. But although the field be larger, the class of articles, to say nothing of the average artistic quality, differs in the same measure as the habits of the users. The antiquary of the twenty-first century who turns to the late nineteenth century will find marmalade-pots and pickle-forks in lieu of posset-pots and punch-ladles. He will find that hairbrushes and perfume bottles of inferior glass with silver rims have been sold in the drug stores, not silver shops.

The earliest known teapot is of the year 1670, although Pepys tells of drinking tea in 1660. This fine specimen is a lantern-shaped teapot with a history, and is illustrated on page 173. It is inscribed, "This Silver tea Pott was presented to ye Com^tte of ye East India Company by ye Right Hono^le George Lord Berkeley of Berkeley Castle. A member of that Honourable and worthy Society and A true Hearty Louer of them. 1670." It is engraved with the arms of the donor and of the East India Company. The maker's mark is T. L., and the date letter and hall-marks of London are of the year 1670.

In the year 1690 the form of teapot was melon-shaped, still tall, and still suggestive of a coffee-pot, made more

manifest by the stopper attached at the spout by a chain. But in the eighteenth century teapots underwent a change; they began to assume styles which have endured to the present day. Since Queen Anne sat in the Orangery in Kensington Gardens with her bosom friend "Mrs. Freeman" over a dish of tea to hear of Marlborough's victories, the habit has become established in popular favour.

The rivalry between coffee and tea and the attempt of chocolate to obtain supremacy are interesting side-lights in social history, tinctured by political bias and prejudice. Coffee claims the field first. The honour of introducing tea remains between the English and the Dutch, while that of coffee rests between the English and the French. The price of tea in 1660 was sixty shillings per pound, and Thomas Garway, tobacconist and coffee-man, was the first who retailed tea. His shop bill is the most curious and historical account of tea we have:

"Tea in England hath been sold in the leaf for six pounds, and sometimes for ten pounds the pound weight, and in respect of its former scarceness and dearness it hath been only used as a regalia in high treatments and entertainments, and presents made thereof to princes and grandees till the year 1657. The said Garway did purchase a quantity thereof, the first publicly sold the said tea in leaf or drink, made according to the directions of the most knowing merchants into those Eastern countries. On the knowledge of the said Garway's continued care and industry in obtaining the best tea, and making drink thereof, very many noblemen, physicians, merchants, etc., have resort to his house to drink the drink thereof. He sells tea from 16s. to 50s. a pound."

This is a seventeenth-century advertisement: can Madison Avenue in the twentieth century do better?

SEVENTEENTH-CENTURY TEAPOT, 1670
Presented by Lord George Berkeley to the
Hon. East India Company
(*Victoria and Albert Museum*)

173

COFFEE-POT
By Thomas Whipham, London, 1737
(*The Metropolitan Museum of Art, bequest of Mary Strong Shattuck, 1935*)

174

As to coffee, it is interesting to read the women's petition to Parliament, in 1674. They complained that coffee

"made men as unfruitful as the deserts whence that unhappy berry is said to be brought; that the offspring of our mighty ancestors would dwindle into a succession of apes and pygmies, and on a domestic message, a husband would stop by the way to drink a couple of cups of coffee."

In 1673 the men of England were fighting against the Dutch to defend their hearths and homes, coffee or no coffee, at the engagement off Texel.

Apart from the peculiar lantern shape of the first examples, teapots assumed various forms. They were tall and pear-shaped about 1690. By 1707, in Queen Anne's day, we find them gourd- or melon-shaped till about 1720. In 1725 they were of lesser height. From the opening years of the eighteenth century to 1765 the teapots began to assume round proportions in the body. At a later date they were octagonal. In 1776 they inclined to the Sheraton style, and in 1789 to the Hepplewhite style of design, both these latter with the straight spout.

A Kettle and Stand, with spirit-lamp, is of the year 1744 (illustrated p. 177). It is the work of the celebrated Paul Lamerie, whose genius in working plate placed him in the leading position among the silver designers of his period. It must be remembered that about this time the potter came into serious competition with the silversmith, especially in regard to teapots and coffee-pots. He actually did produce, in the early examples of Bow and Worcester and Coalbrookdale, teapots in blue and white with the same type of round body as this tea-kettle. The spout of the potter always presented greater difficulties in technique than did the spout of the silversmith. In early types of porcelain it is in form similar to the silver example of

the tea-kettle of 1744. But the potter could not attain to the flutings and chased ornament of the worker in metal. The silversmith's spout, soldered on the body, has spreading ornament eminently suitable to afford strength at the juncture.

In Paul Lamerie's work there is, in the graceful convolutions of the handle and the equally delightful curves in the tripod legs, something essentially proper to his craft. No potter could emulate this work. It would be too capricious in firing, and if made in porcelain it would be too fragile for use. It is therefore of interest in comparing the potter's work with that of his contemporary the plate-worker to see how in rivalry the masters of the latter craft surpassed the worker in clay by making full use of their own particular technique.

In all possibility the eighteenth-century teapots were taken by silver-worker and potter alike from Chinese porcelain prototypes, which must have come over in considerable numbers in the trading days of John Company, as we see that the earliest lantern example of the seventeenth century proceeded from that worthy company, and there was a great number imported from Holland. Whether this be granted or not, it may be laid down as a rough rule for guidance that whenever the silver-worker and the potter produced results closely approaching each other in form, the worker in metal was not availing himself of the unique qualities of his art. He may have been following the trammels of fashion, or he may have been a mediocre worker on a lower plane.

That the potter did actually emulate the silversmith can be seen at once in the Staffordshire silver-lustre teapots, which followed as far as possible the silver shapes. They were in use in cottages, and set on the dresser looked very

KETTLE WITH STAND AND SPIRIT LAMP, 1744
By Paul Lamerie
(*The Metropolitan Museum of Art, gift of George D. Widener and Eleanor W. Dixon [Mrs. Widener Dixon], 1958*)

177

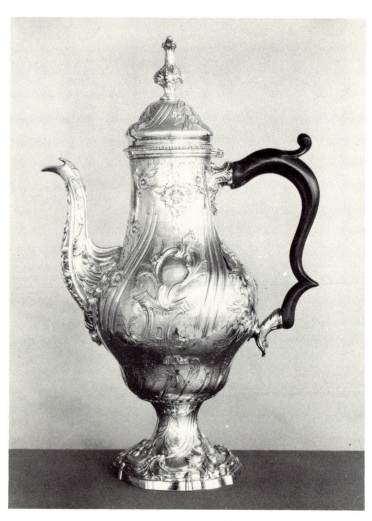

GEORGE III COFFEE-POT
By William Tuite, 1762
(*Victoria and Albert Museum*)

178

imposing. If the squire's lady had her silver, or the farmer's wife her Sheffield plated set, the cottager had her lustre ware.

In the museum at Etruria are some models carved in pear-wood of urns and bowls which Josiah Wedgwood had executed for reproduction in his ware. These remarkable carved wood vessels exhibit a strong similarity with the designs of contemporary silver plate. They illustrate the point that the potter at his highest actually did look with delight on the creations of the silversmith. It was natural that he should do so, and it was equally natural that the contemplation of them should influence his own art. There is a silver teapot designed by John Flaxman (Wedgwood's great designer). It is melon-shaped, silver-gilt, chased with scrolls, medallions, and cupids riding on dolphins. It is inscribed: "Designed by John Flaxman for his esteemed friend and generous patron Josiah Wedgwood, 1784." The maker's mark is I.B. under a crown, and the date letter is for 1789.

The Coffee-pot

It will be seen that the coffee-pot was always tall; it never lessened its height to become possessed of the pear- or gourd-shaped or circular body of its rival. It actually influenced the height and form of the teapot and it was not until the end of the first quarter of the eighteenth century that the teapot threw off its similitude to the coffee-pot in regard to height; and from that date, when tea-drinking had become established, it pursued its own way in design.

The chocolate-pot followed in the wake of the coffee-pot and has never departed very materially from its early form.

It is always rather smaller than its prototype, and may be distinguished from the coffee-pot by the handle, which in the chocolate-pot is not set opposite the spout, as is the case in the teapot and the coffee-pot, but is in the middle, set at right angles to the spout.

It is necessary to examine the customs of the period to arrive at conclusions in regard to silver. In 1697 the Earl of Bristol notes in his diary the payment to Mr. Chambers for tea-kettle and lamp, weight ninety oz. eleven dwts., at six shillings and two pence per troy ounce. These tea-kettles were probably no new thing, and, as coffee came first, were possibly a continuation of similar forms for the decoction of coffee. They were the forerunners of the tea-urns which became popular on breakfast-tables a century later. Tea and coffee and chocolate, ale and broth, and canary wine, were all drunk by different classes of the community at the same time. Before the introduction of the eighteenth-century teacups—first from Holland and the East and later from English porcelain factories, in the first stages without handles—the new beverage, especially in remote and unfashionable districts, was drunk from the silver porringers then in use. At the date of the *Tatler* the middle classes in the country were still content with milk, water-porridge, broth, ale, or small beer for breakfast. The family of John Wesley drank small beer at every meal. By the third quarter of the eighteenth century Jonas Hanway, who introduced the umbrella to England, and John Wesley, both declaimed in vain against the prevalent tea-drinking. Just as in earlier days London apprentices were to have meat in lieu of salmon, then plentiful in the Thames, so country maids accepting service in London stipulated that they were to have tea twice a day.

We are indebted to Catherine of Braganza, the Queen of Charles II, for the introduction of tea. Edmund Waller, the

QUEEN ANNE SIDE-HANDLE COFFEE-POT
By William Lukin, 1709
(*Messrs S. J. Phillips*)

GEORGE I OCTAGONAL COFFEE-POT
By Samuel Wastell, 1720
(*Victoria and Albert Museum*)

181

GEORGE III COFFEE-POT
By Hester Bateman, 1773
(*Victoria and Albert Museum*)

182

Court poet, who made an oration to the Puritan Parliament and saved his neck, has an "Ode on Tea" eulogizing Catherine and the herb. By the time of Queen Anne tea-drinking had become a fixed habit. Bishop Burnet, who died in 1715, drank twenty-five cups in a morning. There was Dr. Johnson at the other end of the century who drank his sixteen cups at a sitting.

A page of coffee-pots of varying periods of the eighteenth century shows the styles in vogue (illustrated p. 181). The group shows a rare side-handled coffee-pot of 1709 with ebony handle, and rather smaller than some of the later forms. This may be compared with the octagonal coffee-pot of 1720. This really is the established form of the coffee-pot, which has lasted to the twentieth century, in spite of various deflections in style which were only transitory. By the last quarter of the eighteenth century it had become more ornate in character. Its decoration was rococo in style, and it became massive and impressive in size, as may be seen in the example by William Tuite, of 1762.

An illustration of a fine coffee-pot with the London hall-mark for 1773 is also given. It was made by Hester Bateman. The lines of this example are of exceptional grace. The proportions of the body are well balanced. The circular foot with its fine gradations adds a lightness to the design. The lid is of fine proportions, and is terminated by a simple vase ornament giving height to the piece. The handles in both these larger and later types are broken, with a point on the lower half turning outwards. The Edinburgh example of 1769 (illustrated p. 229) shows the same character.

The Tea-caddy

The early forms of tea-caddy were square or round. It may be imagined that so precious a product had to be

stored carefully. Hence the receptacles for tea were some-
what luxurious in character. We illustrate a square type
representative of the early days of the eighteenth century
(illustrated p. 185). This set was made in 1725. The South
Sea Bubble, the formation of the South Sea Company to
take over the national debt in 1720, had just been blown.

The late eighteenth-century types were oval in form. The
illustration of an example (p. 185) shows this style. The
left-hand picture is a caddy with London hall-marks for
1789. These show very clearly the form culminating in the
satinwood Sheraton variety tea-caddy so much sought after
by collectors. The lines of the silversmith became coinci-
dent with the worker in rare woods. They touch at this
date. If one takes Chippendale's *Director* or Sheraton's
design books we can see the progress of the cabinet-maker,
first in mahogany and then in satin and other beautifully
coloured woods, in arriving at a casket similar in character
to the silver-worker's design.

Half-way between the early and late eighteenth-century
styles we illustrate (p. 189) a set of three tea-caddies,
showing where the silversmith adhered to the higher
plane of his technique, equally evading the plagiarism
of the potter or the cabinet-maker. This set of three
caddies, made in 1762 by John Swift, is indisputably
metal in every inch of their construction. Unmistakably
of the best period of Chippendale design, these exquisite
pieces have pleasing contours, the beauty of which
is enhanced by baroque cartouches and floral forms,
repoussé.

The later teapot cannot be said to have much to com-
mend it, with its straight spout and oval or geometric form.
Oftentimes it is a woodworker's design with additions.
The cabinet-maker has not essayed to make a wooden tea-
pot. But the silversmith has completed the hiatus. Take the

CHIPPENDALE TEA-CADDY CHIPPENDALE TEA-POT

George III, 1789 George III, late eighteenth century

SET OF TEA-CADDIES, GEORGE I, 1725

185

tea-caddy of 1789 (illustrated p. 185), add a straight metal spout and a handle; the result is a teapot, as will be seen from the Chippendale teapot on the same page; but it can hardly lay claim to being in the first rank of design. It stands with the modern potter's results, exceptionally fine in their own field—round, hexagonal, octagonal, oval, square, or of many other forms, all suited to his plastic art; but the silver-worker should stand on a plane apart, and in the best periods he did.

SALE PRICES

COFFEE-POTS

Queen Anne coffee-pots realized from 50s. to 60s. per oz.

George I coffee-pots about £1 per oz., and George II from 10s. to 13s. per oz.

George III coffee-pots brought from 7s. to 10s. per oz. and George IV and William IV about 5s. or 6s. per oz.

TEAPOTS

All teapots before George I are rare, and bring large prices.

Queen Anne teapots brought £5 to £10 per oz., and specimens sold for £50 to £80.

On the other hand George II teapots sold from 15s. to 40s. per oz.; George II and George IV examples, 10s. to 15s. per oz.

TEA-KETTLES

Queen Anne, with stand and lamp (1709), by N. Locke, sold in 1909 for 200s. per oz., £243.

George I, with stand and spirit-lamp (1715), 130s. per oz., £158.

George II, with stand and spirit-lamp (1738), 38s. per oz., £103.

TEA-CADDIES

Queen Anne, octagonal (1710), 75s. per oz., £27.

CHATS ON OLD SILVER

Caddies (2) by Paul Lamerie (1747), 160s. per oz., £243.
George III, oblong (1760), 30s. per oz., £12.

An eighteenth-century coffee-pot will nowadays fetch anything between £150 and £400. Chocolate-pots run well into £300's. Teapots vary much, according to weight and other considerations, the amounts ranging from £200 to close upon £500. Tea-kettles on stands may cost anything up to £1,500, and a set of three tea-caddies £180 or £200.

SET OF THREE TEA-CADDIES AND SPOONS
By John Swift, London, 1762
(*The Metropolitan Museum of Art, Rogers Fund, 1920*)

THE CASTER, THE CENTRE-PIECE, THE SUGAR-BOWL, THE CREAM-PAIL, AND THE CAKE-BASKET

THE classes referred to in this chapter embrace the most delightful of the eighteenth-century silver plate, and appeal intimately to the decorative instincts of the collector. The pieces range from the utilitarian caster capable of varied ornament, to the elaborate table centre, an object often of exquisite grace and capable of rising to perfection in the hands of an accomplished craftsman. Pierced work of great delicacy was a feature of the eighteenth-century decoration. As with furniture, the silver in the middle of the century began to grow complex in its character, in keeping with the growth of luxury. The century which began with the sober furniture and homely interiors of Queen Anne closed with the magnificence of Chippendale and the subtleties of Sheraton.

The Caster

The caster can be traced in an unbroken line as an article of table use from the end of the seventeenth century to the present day. Even with so simple an object, apparently incapable of much variation in form, it is interesting to note the successive stages of fashion and the different phases of its history.

At first it was comparatively small. The examples illus-

trated on page 193 show this. The straight cylindrical
form appears to have been the earliest type, and this
lasted from about 1680 for a quarter of a century. There
is a set of three Charles II casters of this style made by
Anthony Nelme in 1684. There is also a simple form
about the opening of the eighteenth century with plain
round top. A fine Irish example, made by George Lyng,
and marked with the Dublin hall-marks for 1699 (illus-
trated p. 241), shows a more ornate character, not
infrequent in Irish silver. The Irish silversmith was
often ahead of his English contemporaries. By 1712 the
Queen Anne caster was becoming taller and the body
retained the band found in the straight cylindrical form.
The cover offered a field for delightful and varied patterns
in pierced work. There is a charm about these individual
patterns which is irresistible to the collector. The cover is
surmounted by a baluster knob, which it retained through-
out the successive changes in the body. These ornaments
are delicately symmetrical, and in one instance coming
under the writer's observations the knob was a miniature
of the caster it crowned. The marks on casters are placed at
the top of the neck near the cover.

In 1730, at the Court of Wardens at the London Assay
Office, it was laid down that the marks be struck as far
distant from each other as possible, so that the series of
marks could not be cut out in one piece and soldered into
another piece. It had been found that it was "an antient
practice among evil-disposed goldsmiths" of converting
new plate into old by this means.

Variations in the body took place; sometimes the band
around took an octagonal form and the concave body
above and the convex body below followed this geometric
form in their curve. There is an example of this type with
the hall-marks for London for 1716, and the maker's mark

CASTERS

WILLIAM III, 1701 GEORGE II, 1747 GEORGE III, 1760 GEORGE III, 1771

A.D. in shield, wrought by Charles Adam. This is among the Chester Corporation plate.

The progress in form from the days of George II to the end of the century is shown in the group illustrated on page 193. These casters, as will be noticed, are all circular in body, and do not include geometric forms. The George II example (1747) was the fixed type from George I to the early years of George III. A Scottish example of a sugar caster (illustrated p. 227), having the Edinburgh hallmarks for 1746, shows this established form. At the latter end of the reign of George II and in the early years of George III, from 1760, it is noticeable that the body swells in bulbous form, increasing in height from the foot. The next example (1771) shows the new top, pear-shaped; the swelling lower part of the body is still pronounced and the foot is taller, as in the cream-jugs of the period. In both these George II examples the cover is surmounted by a pine-cone knob.

The Centre-piece

The caster never attempted to be other than reticent. It was like a poor relation at the table in company with the magnificence of the centre-piece. The pierced work in subdued ornament pales before the elaboration in such a centre-piece as that illustrated on page 198, with the London hall-marks for 1766. The basket is of elaborate and graceful form, and the eight branches mark it as a sumptuous specimen. The feet are equally elaborate and in rococo style. It belongs to the early years of George III, the period of Garrick, Macklin, and Foote. It was contemporary with the enormous head-dresses, the subject of so many caricatures, which followed the indecorous hoop-petticoats of the dissolute days of George II. Paste and plaster and powder raised these head ornaments to a superstructure

representing chariots, and a *fureur des cabriolets*, related by Horace Walpole. Men had them painted on their waist-coats, and women stuck a one-horse post-chaise on the top of their elaborate head-dress, which said head-dress was not changed for some weeks. Medical men of the day speak of this in terms which we will not introduce here. Sir Joshua Reynolds had commenced to paint his immortal portraits, Handel had settled in London, providing satirists with subjects as to his gluttonous habits, and producing music that has become English. Thomas Chippendale had pub-lished his *Director* in 1754, with its wonderful designs; and Robert Adam, in 1758, had put his screen and gateway across the Admiralty in Whitehall, and was translating dull London streets into classic style. These were the nights at the "Turk's Head" with Dr. Johnson, the sup-porter of the Royal House, the upholder of purity and piety in an impure and irreligious age, Burke with his flashing conversation, and Goldsmith and David Garrick, and a circle of men who counted for more than the dan-dies and the fops of Pall Mall and St. James's Street. Wealth was pouring into the country from India, and with it came rapidly acquired habits of luxury—habits that quickly reflected themselves in the furniture and domestic appurtenances. This silver centre-piece of 1766, therefore, tells the story of these days of the eighteenth century, "remarkable for the great industrial revolution, which gradually transformed England from an agricul-tural to a manufacturing country, depending for food supplies on foreign countries."

A second examination of the silver centre-piece, with the above notes in view, at once discloses its character—out of France and Italy, with here a touch and there a touch of other Continental styles. If trivial toys such as the *pantin*, a pasteboard figure on strings, could take the town by storm, the craftsman in metal, with fashions streaming from over

GEORGE II CENTRE-PIECE
By Thomas Pitts, London, 1759

197

GEORGE III CENTRE-PIECE
By Thomas Heming, London, 1766
(*The Metropolitan Museum of Art, gift of Lewis Einstein, 1952*)

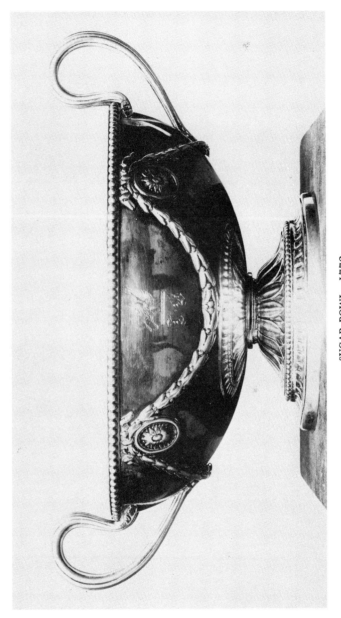

SUGAR-BOWL, 1773
By S. and J. Crespell
(*Victoria and Albert Museum*)

the Channel, could not and did not hold aloof. Traditional features linger or become rejuvenated. The basket with pierced work stands coeval with the similar work in porcelain. The feet might have come straight out of Chippendale's *Director*, with their curves and shoulders so peculiar in style. If Chippendale borrowed wisely from the cabinet-maker of France, the English silversmiths, many with French blood in their veins, found in French design something too alluring to ignore. This piece may be compared with an earlier Irish centre-piece, 1740 in date (illustrated p. 245).

The Sugar-bowl

In the specimen illustrated (page 199) the classic style is seen at its best. The body is decorated with festoons, rosettes, and the rim and foot have a plain bead ornament. The handles are snakes with the head terminating at the rim of the bowl. It suggests that it might be a bowl of Æsculapius rather than a homely sugar-bowl. Pompeii and Rome, translated through the brain of Sir William Hamilton, the Brothers Adam, and the metal-worker of the Louis Seize period, have each contributed to this composite style. It is not of the purity of form of silver vessels found in the tombs. It merely borrows ornament from classic originals, it is like Sir Bulwer Lytton's translation of Horace, rather more Sir Bulwer than Horatius Flaccus. In date this is 1773 and was made by S. and J. Crespell. It belongs to the same period as the Sheffield silver candlestick illustrated on page 169.

There is another sugar-bowl (illustrated p. 203), with the London hall-marks for 1786, showing the style *Louis Seize à l'Anglaise* which came into English cabinet design after 1793, when Sheraton published his book of designs. This is an exceptionally dainty piece of work. The classic influence is still to be observed, but changed into something more

sprightly, savouring of the boudoir of Marie Antoinette, and the metalwork on tables and lock escutcheons in the Petit Trianon. It is especially a silversmith's piece. It is a beautiful metal framework for a blue glass liner.

The Cream-pail

Taller vessels with a handle are usually termed cream-pails, though some collectors believe they were used for sugar. As they are of cut work they must have been used with a glass liner. They present some beautiful forms still clinging to classic ornamentation in combination with whatever new forms the craftsman could invent in conjunction with a severe style. The two illustrated (p. 203) show slightly differing intentions. The first on the right, with the London hall-marks for 1776, with its undulating top, is in keeping with the wavy rims of the salt cellars of the same period, of French influence. The festoon of drapery with rosettes is in classic style and the foot and lower body has the traditional acanthus-leaf decoration.

The other example on the same page (p. 203) is in date 1782, the year when, after three years' siege of Gibraltar, the French and Spanish made a supreme effort by sea and land to win the key of the Mediterranean, but were beaten with heavy loss by General Eliot. The festoons and the vase in panel are now in incised decoration and are subservient. The style begins to break away from traditional severities and to establish something original and as reticent as the classical forms without being so coldly formal and un-national.

The Bread-basket

The last half of the eighteenth century saw the growth and development of pierced sheet silver with its varied styles, and concomitant with the sheet work there are

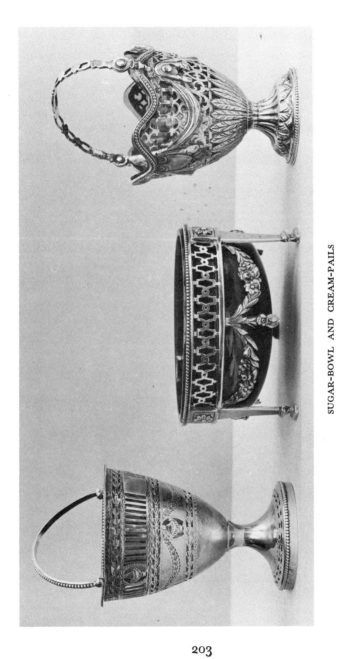

SUGAR-BOWL AND CREAM-PAILS

Pierced sheet silver with blue-glass liners

London, 1782 London, 1786 London, 1776

(*Victoria and Albert Museum*)

203

GEORGE II BREAD- OR CAKE-BASKET
By S. Herbert. London, 1753
(*Victoria and Albert Museum*)

examples exhibiting a fine perfection in wirework. Pierced bread- or cake-baskets with cable band are features of this period. The pierced mustard-pot, decanter stand, and other similar articles were common. Oval pierced baskets were introduced, with handles, in the reign of George II (1727-60). Originally they were possibly for bread only. Some collectors determine this by the pattern on some of them of wheat-ears. By the time of George III they were elaborately pierced and chased, massive, and had feet. In other examples about the middle of the century they had no feet, and were more basket-like in form. There was an example in the Dunn-Gardner collection of a bread-basket in imitation of wicker basket-work. This bore the London hall-marks for the year 1733 and the maker's initials P.L., a crown and star above, and a *fleur-de-lis* below, for Paul Lamerie, the maker. The example (p. 205) by S. Herbert illustrates the exquisite workmanship distinguishing these cake-baskets. It is dated 1753.

The Eighteenth-century Potter

In connexion with pierced and interlaced work the potter did attempt to run side by side with the worker in silver plate. The Wedgwood piece (illustrated p. 209) shows this parallel. It is a chestnut-bowl and cover. While adhering in a measure to the strict technique of the worker in clay—and here be it said it comes near to the fine reticulated work of some of the highest quality Chinese porcelain —it, at the same time, approaches the contemporary refinements in perforated sheet metal executed by the silversmith.

SALE PRICES

CASTERS

Ordinary Queen Anne examples brought 50s. to 60s. per oz.; George I and George II, 25s. to 35s. per oz.; George III and

George IV, 18s. to 20s. per oz. Later specimens only fetched 5s. to 12s. per oz.

Rare and earlier examples brought higher prices, *e.g.*:

	£
William and Mary (1701), 225s. per oz.	112
Queen Anne (2), (1713), 115s. per oz.	72

SUGAR-BOWLS

The average prices were roughly as follows: George I, 60s. to 80s. per oz.; George II, 20s. to 50s. per oz.; George III, 8s. to 50s. per oz. (varying from engraved and fluted to pierced and applied ornament); George IV, 7s. (fluted) to 35s. per oz. (pierced and applied ornament); William IV, 6s. to 20s. per oz.

Exceptional pieces of course bring exceptional prices. A sugar-basket of 1725, by Paul Lamerie, sold in 1909 for £113, at 195s. per oz. A set of three George III (1763) sugar vases and covers were sold at the Ashburnham Sale in March 1914, for £214, at 135s. per oz. While casters scarcely passed the above prices in 1915 they may now (if by a famous maker) fetch three times as much, but sets of three may range between £320 and £400.

CHESTNUT BOWL

Cream-coloured, with pierced design
Leeds, late eighteenth century

(Victoria and Albert Museum)

THE CREAM-JUG

"I MUST further advise you, Harriet," says a lady in *The Fool of Quality*, admonishing her daughter, "not to heap such mountains of sugar into your tea, nor to pour such a deluge of cream in; people will certainly take you for the daughter of a dairymaid. There is young Fanny Quirp, who is a lady by birth, and she has brought herself to the perfection of never suffering the tincture of her tea to be spoilt by whitening, nor the flavour to be adulterated by a grain of sweet." This was published between 1766 and 1770 and indicates that a set of rules for observance was afoot in a time when etiquette was formal.

But if cream was neglected by some precisians, the cream-jug bears evidence that in many circles it was a welcome and possibly very necessary addition to the strong green tea then drunk.

It was etiquette to place the spoon in the cup to show the hostess that no more tea was required. It was the custom at Scottish tea-tables and possibly elsewhere to have numbered spoons. The guests did not ask for a second cup until all the other guests had finished the first. Hence the cups were passed up to the hostess and the spoons numbered to ensure that each got his own again.

Sir Alexander Boswell in his poem "Edinburgh" (1810) writes:

> The red stone teapot with its silver spout,
> The teaspoons numbered and the tea filled out;
> Though patience fails, and though with thirst he burns,
> All, all must wait till the last cup returns.

The silver strainer had apparently become obsolete in Sir Walter Scott's day, for he writes in *St. Ronan's Well*:

"A silver strainer, in which in times more economical than our own, the lady of the house placed the tea-leaves after the very last drop had been exhausted, that they might hospitably be divided among the company to be eaten with bread and butter."

The Scots are a hardy race.

In lieu of the strainer a long-handled spoon with pierced bowl was used, the long handle being intended to thrust down the spout, as sometimes the tea refused to pour out. Etiquette forbade the hostess to blow down the spout.

The beauty and variety of the cream-jugs may be traced for a whole century. One of the earliest examples (illustrated p. 213) shows a fine helmet-shaped jug, having the London hall-marks for the year 1714, and the mark of the maker, P.P. The handle is bold in conception and has a terminal not unlike the harp-handle of Irish silver. The ornament is restrained and representative of the best types of the George I era. A cream-jug of mid-eighteenth century made in Dublin (illustrated p. 214) may be compared with the above example. The helmet form with the undulating rim is common to both specimens, but the treatment differs in character. The Irish example has three feet and possesses beauties peculiarly its own.

Early eighteenth-century examples were not always highly ornate. The simple character of the Queen Anne styles gave way reluctantly to the elaboration found in those of the reign of George III.

The series of cream-jugs (pages 214—215) shows the evolution in form in the latter reign to more slender examples; the handle becomes broken in its curves and three feet are in frequent use. The lip is pointed and elongated. This latter style lasted from about 1740 to

GEORGE I HELMET-SHAPED JUG. LONDON, 1714
Maker's mark of Pierre Platel
(*Victoria and Albert Museum*)

213

GEORGE III CREAM-JUGS
By Wm. Hughes
Dublin, 1760–70 London, 1765
(*Victoria and Albert Museum*)

214

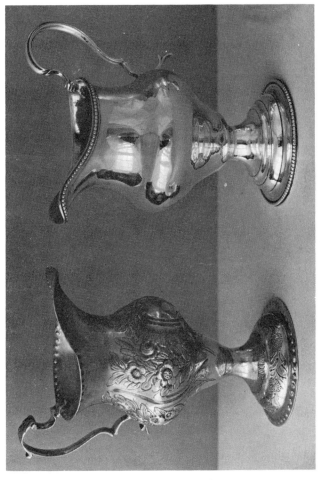

CHASED AND REPOUSSÉ CREAM-JUG PLAIN CREAM-JUG
London, 1778 With reeded rim
 By George Smith, London, 1781
 (*Victoria and Albert Museum*)

215

about 1765 (see a fine Irish example of this type illustrated on p. 237). The specimens are dated 1760-70.

Illustrated on this page are two typical examples of the last quarter of the eighteenth century. It will, be observed that the three feet have disappeared in the 1778 example. The round foot is now fashionable and varies in height. The body becomes elongated. The handles still retain the older mid-century forms, with slight variations. The tendency to increased height in the cream-jugs at this date may be compared with that of the casters illustrated in Chapter IX.

A pair of late George III cream-jugs (illustrated pp. 218 and 219) show the classic tendency in the closing years of the eighteenth century and the first decades of the nineteenth century. The example in date 1792 is tall and has a foot standing upon a square base, like a classic vase. The other example, fourteen years later, is a reversion to the potter's form with flat bottom. The flat-topped handle is a reminiscence of the classic urn. The evolution in form, as is seen, is steadily towards the fuller body.

SALE PRICES

CREAM-JUGS

The prices of these vary according to the style of ornament, chasing, and general character.

Queen Anne plain examples have brought as much as 125s. per oz., realizing £25. Early eighteenth-century specimens bring as a rule from 60s. to 100s. per oz. Later eighteenth-century drop considerably in value, from 40s. to 60s. per oz. A George IV cream-jug, made by Paul Storr in 1820, sold for 36s. per oz. and realized £17. To-day they would probably range between £50 and £60 a piece.

CREAM-JUG
1792
(*The Metropolitan Museum of Art, Rogers Fund, 1913*)

CREAM-JUG
1806
(*The Metropolitan Museum of Art, gift of Mrs. James Forrestal, 1961*)

SCOTTISH SILVER

THE study of Scottish silver is a special one. Its manufacture and the statutes governing the goldsmiths and silversmiths extend back to the fifteenth century. The chief centres of marking and assaying were primarily Edinburgh and, more recently, Glasgow also. But it is remarkable how many towns and burghs assayed silver. In comparison with England the manufacture of silver plate seems to have covered a wider area in Scotland. Examples are extant showing that Dundee assayed silver as early as the sixteenth century, with the town mark of the two-handled pot with lilies, and the same mark was used in the late nineteenth century. Perth had its Paschal lamb and the flag, emblem of St. John. Aberdeen had the letters ABD; Elgin had ELN; Banff had BA; and Inverness had INS, or its mark of a dromedary. This is enough, meagre though it be, to indicate that the identification of Scottish silver requires no little close study into the records covering an intricate field, and many marks unattributed to any special place are believed to be Scottish in origin.

Of the Scottish silver plate illustrated in this chapter it may be said that, whenever possible, details are given of the peculiarities of marking to enable the student to familiarize himself with the differences in comparison with English silver. The assay master's initials, the maker's initials, and the date letter are an array of letters possibly puzzling to the beginner.

The quaich illustrated on p. 223 was made at Glasgow *c.* 1712. The maker was W. Hodgert or Hodgy. These old vessels were used for drinking spirits, and the two handles denote that, like the English loving-cup, they were passed around. They are not used over this side of the Border. They are sometimes made of hard dark wood, and possibly their origin may be traced to Scandinavian forms. The Dutch have similar vessels. In the Willet-Holthuysen Museum at Amsterdam there is a silver brandy- or loving-cup with ears in form like the Scottish quaich or quaigh. This is of the first half of the seventeenth century. It measures 9 centimetres in height by 11 centimetres in width. The side of the cup is divided into six embossed parts, each encircling an engraved medallion of four symbolic figures—Faith, Justice, Science, and Labour. All these are surrounded by medallions in Renaissance style: the well-known conventional dragons, garlands of flowers, and cherubs' heads. The handles are also ornamented. "It is a truly Dutch sweetly pretty little thing," says Frans Coenen, the curator, the author of a brochure on the collection, "and seems to have been made on purpose to be held by a strong, powerful fist at the festive board. And festive boards were of frequency in the days of the Great Republic, when the merry cup went round with snapdragon, or even brandy pure and undiluted, as a kind of English loving-cup. And the ladies partook as well as the gentlemen. Neither did they refuse the weed which cheers but not inebriates." The author laments that this form has disappeared from use in Holland. " In course of time," he says, "bitters and gin took the place of brandy, and the pretty vessel degenerated into a characterless bottle or jug, which in its turn was replaced by the teapot."

The quaich of 1736 (p. 224) is identical in form to those made some thirty years earlier in the eighteenth

SCOTTISH QUAICH. GLASGOW, c. 1712

By W. Hodgert or Hcdgy

(How of Edinburgh Ltd.)

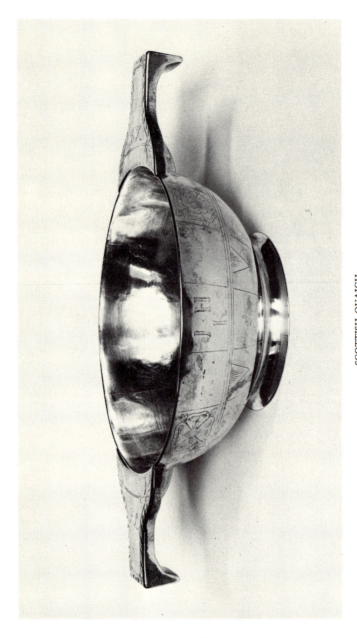

SCOTTISH QUAICH
By Charles Blair, Edinburgh, 1736
(*The Royal Scottish Museum, Edinburgh*)

224

century. It dates from some thirty years after the Union between England and Scotland. In 1707 this was legally effected. The United Kingdom was to be called Great Britain; there was to be one Parliament, in which Scotland was to be represented by forty-five members in the Commons and sixteen peers in the Upper House. The Union Jack continued as the national ensign.

The cup with the flat handle, or "lug" as it is termed in Scotland, level with the brim, was sometimes of more ornamental form, with six spheroidal sides, and the handles were chased. There is also the "bleeding-cup" used by barber-surgeons so freely in the late seventeenth and eighteenth century. There is a specimen of this class of silver vessel, diminutive in character, in The Metropolitan Museum of Art, New York.

The charming "thistle cup," which like the quaich was a particularly Scottish form, evolved in the seventeenth century and continued to be made in the eighteenth. These cups were usually quite small. The example illustrated here (p. 228) was made by Alexander Forbes of Edinburgh in 1696 and is 3⅛ inches high.

The sugar-caster (illustrated p. 227) belongs to the George II epoch of silver. Evidently the rich and varied styles extended to Scotland. The same impulses influenced both nations after the Union; in date this is 1746. This is marked with the maker's initials, E.O., and the assay master's initials, H.G. (Hugh Gordon); there is, in addition, the mark of the castle and the date letter R. The baluster ornament is in almost acorn form. The top with its perforated design is always a pleasing feature in casters. The floriated ornament in this example is of fine character and the design of the piece is admirable.

The year 1746 is a notable one in Scottish history. In 1745 the Young Pretender, Charles Edward Stuart, dear

to memory in Scotland, landed. "Charlie is my Darlin' " was a forbidden tune at Balmoral as late as the reign of Victoria. The entry of the Prince into Edinburgh in 1745 resulted in the defeat of Sir John Cope, and the victorious army invaded England and reached Derby.

The year 1746 saw the Battle of Culloden and the defeat of the Pretender. Here is a caster of these romantic days, days that find expression in various romances—romances that are true to the life. Simon Fraser, Lord Lovat, was beheaded on Tower Hill for his duplicity. Many great Scottish families tried to sit on both sides of the fence. One son went to the Hanoverian forces and the other to the Stuart invader. Robert Louis Stevenson's *Master of Ballantrae* shows the poignancy of the situation. But England held aloof in 1745. In 1715, when the elder Pretender essayed to claim his own, England was lukewarm, but in 1745 the House of Hanover had become deeply rooted and no leniency was shown to the invaders.

A type of small tea-pot favoured in Scotland in the 'twenties and early 'thirties of the eighteenth century was the "bullet" tea-pot, which was completely spherical and had a short straight spout. The example illustrated on p. 230 is only some 6½ inches tall. Bullet tea-pots were also made in England but are considered a Scottish form.

The Edinburgh coffee-pot (illustrated p. 229), in date 1769, is a delightful piece. It was made by Patrick Robertson; the marks are illustrated on page 297. This was in the early George III period. In this year was published the first of the "Letters of Junius," an acrid attack on the Government in the *Public Advertiser* on behalf of John Wilkes, the demagogue. This year saw the birth of English Radicalism. Wilkes was elected as member for Middlesex for the fourth time, but Parliament declared his opponent, Colonel Luttrell, at the bottom of the poll, to be elected. The

SUGAR-CASTER. EDINBURGH, 1746
Maker's mark, E. O. Assay master's initials, H. G. (Hugh Gordon).
Castle and date letter R
(*Royal Scottish Museum, Edinburgh*)

227

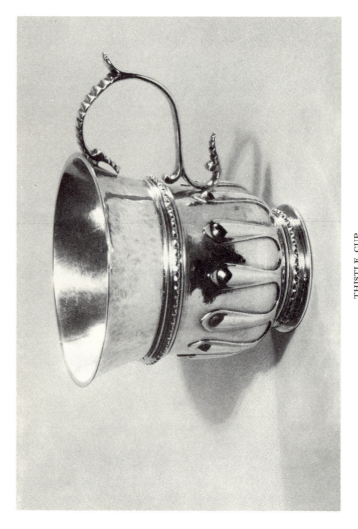

THISTLE CUP

By Alexander Forbes, Edinburgh, 1696

(*The Royal Scottish Museum, Edinburgh*)

228

EARLY GEORGE III COFFEE-POT. EDINBURGH, 1769
By Patrick Robertson. Marks illustrated p. 297
(*Royal Scottish Museum, Edinburgh*)

BULLET TEAPOT
By William Aytoun, Edinburgh, 1725
(*The Royal Scottish Museum, Edinburgh*)

meaning of the motto "Wilkes and Liberty" is thus understood.

This coffee-pot of those days claims recognition by reason of its beauty of form. The spout with dragon head is graceful and original. The handle, in ebony, follows the broken curves of the period, the cone-top and the somewhat elongated foot and narrow base to the body proclaim the contemporary style.

The tea-urn of 1778 (illustrated p. 233), also made by Patrick Robertson, is marked with the castle of Edinburgh, the Thistle standard mark, the date letter Z, and the maker's initials P.R. It is a beautiful piece in classic style, with fluted oviform body, decorated at summit and base with acanthus ornament. It has flat scroll handles with delicate beaded ornament. On tall fluted foot with bold spreading terminals, it stands on square base decorated with classic chasing. It is as classic as Princes Street, Edinburgh. It is delightfully Scottish, and represents the northern Athens as exemplified in the minor art of the silversmith. It is just prior to the days of Sir Walter Scott, the "Wizard of the North," who has charmed Scot and Southerner alike by his magic spell.

This is a very meagre exposition of the art of the silversmith in Scotland, but space does not permit of further details in a volume of this size. In the examination of Scottish silver one is confronted with so much that is excellent. The subject is like Scottish poetry; one turns to the anthology of Sir George Douglas and one finds a race of nightingales.

TEA-URN. EDINBURGH, 1778
Maker's mark, P. R. (Patrick Robertson)
Thistle and date letter Z

(*Royal Scottish Museum, Edinburgh*)

233

IRISH SILVER

THERE is no doubt that the art of the goldsmith and silversmith was practised at a very early period in Ireland, as the various ornaments discovered in excavation clearly prove. There is something characteristic in this early Irish metalwork, as especially noteworthy in its ripe and accomplished art as is the illumination in the Book of Kells. Old records show that goldsmiths were working in Dublin in the thirteenth century, though there is no mention of the actual formation of a guild or company till 1498. Apparently these early records do not determine what marks were in use. It is not till 1605 that mention is made of a maker's mark and a town mark on Dublin plate. In 1637 a charter was granted to the goldsmiths of Dublin by Charles I, and it was laid down that no gold or silver was to be of less fineness than the standard of England. From 1638 onwards there appears to have been a date letter, though in some cases its use was erratic, the same stamp being used for succeeding years.

In 1729 the Irish Parliament enacted that plate should be assayed by the assay master and bear the maker's stamp, the harp crowned, and the date letter. In 1730, by the order of the Commissioners of Excise, a fourth stamp was added, the figure of Hibernia, to denote that the duty had been paid. In 1807 the sovereign's head was ordered to be placed on all plate as a duty mark, and the figure of Hibernia was allowed to remain, so that till 1890, when

the duty was taken off silver, the two duty marks ran together. But Hibernia may be regarded as a hall-mark, though that was not its original purpose.

The city of Cork never had a date letter. Prior to 1715 the city arms, a ship in full sail between two castles, was used together with the maker's mark, which latter embodied some heraldic device. Later the only mark used at Cork was the maker's initials and the word STERLING, or the word DOLLAR; this took the place of the town mark. The official guide to the Irish metalwork at the Dublin Museum, to which we are indebted for much information, states that "Immense quantities of silver were manufactured in Cork during the eighteenth century, but comparatively little remains at the present day, most of it having been melted down as the fashions changed."

The word "dollar" alludes to the silver that was used for plate, much of it being obtained from Spanish dollars. This is parallel to the usage on the coinage. The word "Portobello" is found on English silver coined about the year 1739 from silver taken at Portobello by Admiral Vernon; and the word "Lima" on George II gold coins, signifying that they were from bullion captured from the Spaniards at that place. Anne's guineas, of 1703, have the word "Vigo," relating to Sir George Rooke's captures. At the end of the eighteenth and beginning of the nineteenth century, silver coins were so scarce that Spanish dollars were made legal tender with the head of George III stamped on them.

In the early nineteenth century the Dublin marks appear added to the Cork mark STERLING. The following are among some of the Cork marks found: STERLING and maker's mark, C.T. (Carden Terry), about 1780. STERLING and maker's mark, $\begin{smallmatrix} C & T \\ I & W \end{smallmatrix}$ (Carden Terry and John

CREAM-JUG. CORK, 1764

Chased and repoussé. Signed under lip, "Jonathan Buck, 1764"
Marks illustrated p. 301

CREAM-JUG. DUBLIN, MID-EIGHTEENTH-CENTURY

Chased and repoussé

(*Victoria and Albert Museum*)

237

Williams), about 1800. And there is Robert Goble, 1694, a piece of whose delightful work we illustrate with marks; the Cork mace at the Victoria and Albert Museum, a specimen of beautiful craftsmanship, is marked with the Cork castle and ship, and the letters R.G. There is also Jonathan Buck, 1764, and a fine cream-jug of his superb work is illustrated (p. 237).

Besides Dublin and Cork there were other places at which silver was assayed and marked: at Limerick, in the seventeenth century, with the mark of the *fleur-de-lis*; Youghal in the seventeenth century, with the town mark of a single-masted ship. In 1783 a small village near Waterford, termed New Geneva, owing to a company of Geneva watchmakers having settled there, had an assay office for a few years, mainly for watch-cases. The harp was used in their mark for gold of 22 carat. Clonmel, Waterford, Mullinger, Kinsale, Kilkenny, and Drogheda all made plate which was assayed at Dublin.

The earliest piece of Irish hall-marked plate to survive is a flagon in Trinity College, Dublin, bearing the Dublin hall-mark for 1638.

The caster (illustrated p. 241) is in date 1699, and bears the Dublin hall-marks for that year and the maker's initials G.L. (George Lyng)—marks illustrated on page 301. This example is interesting as showing the type of art existing contemporary with English work. The grace and elegance of this caster stamp it as being the work of a practised artist, and though doubtless English fashions did affect the class of articles made, the native skill in the subtle use of ornament and the perfection of symmetry was in strong evidence across the Irish Channel.

A loving-cup with two handles, in harp form, was made by Robert Goble, of Cork, about 1694 (illustrated p. 241). These cups are peculiarly Irish and were made nowhere

else, except when the English silversmith or the Sheffield plateworker copied them. The harp to this day has remained symbolic of Erin, and Beleek teacups of delicate eggshell porcelain sometimes have a harp handle.

Throughout the eighteenth century a great number of these two-handled harp cups were made. They have a fine bold form and evidently fulfil the object for which they were made. The marks, as shown in the specimen illustrated, are usually at the top of the body near the rim.

In the year 1740, when Frederick of Prussia seized the rich country of Silesia, young Oliver Goldsmith sat at the feet of his schoolmaster, that old soldier of fortune, Thomas Byrne, who had served with our army in Spain. He listened to "the exploits of Peterborough and Stanhope, the surprise of Monjuich, and the glorious disaster of Brihuega," and he lent an ear to the stories of "the great Rapparee chiefs, Baldearg O'Donnell and galloping Hogan." At fifteen he entered Trinity College, Dublin, as a poor scholar. To-day he rests on College Green, one of Ireland's proud monuments. At this date the silversmith was doing great things; the Metropolitan Museum at New York has a fine centre-piece of these far-off days. It will be seen in the illustration (p. 245) to what refinement the art of the Dublin silversmith had attained. The maker is Robert Calderwood, and in such a specimen claims recognition for craftsmanship of a very high order. His mark is R.C. with a small crown between the letters, and his work is always prized by collectors.

On page 237 a fine cream-jug made by Jonathan Buck of Cork, in 1764, is illustrated, and the marks are given on page 301. It is minutely signed in full under the lip, "Jonathan Buck, 1764." The mark has a buck in a shield. The handle in this piece still lovingly adheres to the harp form, delightfully adapted to this graceful vessel.

CASTER. DUBLIN, 1699
By George Lyng. Marks illustrated p. 301

LOVING-CUP WITH HARP HANDLES. CORK, *c.* 1694
By Robert Goble. Marks illustrated p. 301
(*Private collection*)

241

We may conjecture that this was a wedding gift to some bride, as the figures of the goddess Venus and Cupid are in fine relief. Such an example is unique with its elaborate chased and repoussé work.

There is strong classic influence in some Irish designs in which festooned drapery, medallion rosettes, and the key pattern of incised work all tell of the prevailing fashion. It is as classic as the doorways on the Quays at Dublin. But there is a robustness in Irish classicism which establishes it as something not merely copied as a prevailing fashion but embodied in the handiwork of the craftsman. Perhaps their adherence to Catholicism imparted a cosmopolitan kinship to the metalworkers and carvers and art craftsmen of Ireland. They always realized to the full Continental fashions when the wave of importation reached their shores. The delights of Gallic or Italian artists became at once acclimatized.

The " potato ring" or dish stand is a form of Irish silver not made elsewhere. They were rings of metal upon which old Oriental bowls were placed to prevent the hot vessel injuring the polished surface of the mahogany table. They were possibly used later to support wooden bowls for holding potatoes. Genuine Irish examples are always circular. They belong to the late eighteenth and early nineteenth century. Bowl and dish were synonymous terms in those days, hence they are sometimes called "Dish Rings." There are three types: (1) The plain pierced. (2) Pierced work, ornamented with flowers and birds and pastoral scenes. (3) Basket-work formed of round wire twisted, or flat square wire strips interlaced.

The following makers' marks will be of interest to those possessing old Irish silver as of use in determining dates of Dublin silver; and specimens bearing these initials are to be seen in the Dublin Museum:

CHATS ON OLD SILVER

1655, D. B. (Daniel Bellingham); 1657, I. S. (John Slicer); 1680, W. L. (Walter Lewis); 1715, J. T. (John Tuite); 1716, J. W. (Joseph Walker); 1717, I. H. (John Hamilton); 1724, M. W. (Matthew Walker); 1725, I. S. (John Sterne); 1743, R. H. (Robert Holmes); 1748, W. W. (William Williamson); 1748, W. K. (William Knox); 1750, C. S. (Christopher Skinner); 1760, G. B. (George Beere); 1763, I. L. (John Laughlin); 1765, S. W. (Stephen Walsh); 1765, W. T. (W. Townshend); 1770, D. K. (Darby Kehoe); 1771, C. H. (Capel Harrison); 1772, T. L. (Thomas Lilly); 1773, C. T. (Charles Townshend); 1775, T. J. (Thomas Jones); 1776, R. W. (Robert Williams); 1780, I. N. (John Nicklin); 1790, W. L. (William Law); 1802, R. B. (Robert Breading); 1819, I. L. B. (James le Bas).

SALE PRICES

POTATO OR DISH RINGS

Large prices have been paid for these examples of Irish silver with scroll work, pastoral scenes, fruit, and flower subjects, and pierced trellis decoration.

They realize prices varying from £50 to £250, and fine early examples bring even more. The following prices have been given for examples: (1757), £129; (1760), 230s. per oz., £98; (1772), 188s. per oz., £136; (1786), 200s. per oz., £164.

CENTRE-PIECE. DUBLIN, 1740
By Robert Calderwood
(Courtesy of The Metropolitan Museum of Art, New York)

245

APPENDIX TO CHAPTER ONE

The following Tables are intended to be of practical use to the student of Old Silver, and they are arranged in a convenient form for reference.

The Position of Marks.—Marks are not placed on old silver in a straight line. They are shown in this manner in this volume for convenience, and are the author's own arrangement. They are, in practice, irregularly stamped, sometimes in a circle and sometimes upside down. The hall-marks were stamped under the direction of the Wardens, but the maker's mark was stamped by the maker or his representative first (except in the earliest period) and the other marks were often placed on each side of it.

TABLE OF LONDON DATE LETTERS, 1598–1835

1598–1617.		1618–1637.		1638–1657.		1658–1677.	
𝕬	A 1598	*a*	A 1618	𝔄	A 1638	𝔞	A 1658
B	B 1599	*b*	B 1619		B 1639	𝔅	B 1659
𝕮	C 1600	*c*	C 1620		C 1640	ℭ	C 1660
𝕯	D 1601	*d*	D 1621		D 1641	𝔇	D 1661
𝕰	E 1602	*e*	E 1622		E 1642	𝔈	E 1662
𝕱	F 1603	*f*	F 1623	ff	F 1643	𝔉	F 1663
𝕲	G 1604	*g*	G 1624		G 1644	𝔊	G 1664
𝖍	H 1605	*h*	H 1625		H 1645	𝔥	H 1665
𝕴	I 1606	*i*	I 1626		I 1646	𝔍	I 1666
𝕶	K 1607	*k*	K 1627		K 1647	𝔎	K 1667
𝕷	L 1608	*l*	L 1628		L 1648	𝔏	L 1668
𝖒	M 1609	*m*	M 1629		M 1649	𝔐	M 1669
𝖓	N 1610	*n*	N 1630		N 1650	𝔑	N 1670
𝖔	O 1611	*o*	O 1631		O 1651	𝔒	O 1671
𝖕	P 1612	*p*	P 1632		P 1652	𝔓	P 1672
𝖖	Q 1613	*q*	Q 1633		Q 1653	𝔔	Q 1673
𝕽	R 1614	*r*	R 1634		R 1654	𝔕	R 1674
𝕾	S 1615	*ſ*	S 1635		S 1655	𝔖	S 1675
𝕿	T 1616	*t*	T 1636		T 1656	𝔗	T 1676
𝖀	V 1617	*v*	V 1637		V 1657	𝔘	V 1677

TABLE OF LONDON DATE LETTERS, 1598–1835

1678–1696.		1696–1715.		1716–1735.		1736–1755.	
𝖆	A 1678	𝕬	A 1696	A	A 1716	𝖆	A 1736
𝖇	B 1679	𝕭	B 1697	B	B 1717	b	B 1737
𝖈	C 1680	𝕮	C 1698	C	C 1718	c	C 1738
𝖉	D 1681	𝕯	D 1699	D	D 1719	d	D 1739
𝖊	E 1682	𝕰	E 1700	E	E 1720	e	E 1740
𝖋	F 1683	𝕱	F 1701	F	F 1721	f	F 1741
𝖌	G 1684	𝕲	G 1702	G	G 1722	g	G 1742
𝖍	H 1685	𝕳	H 1703	H	H 1723	h	H 1743
𝖎	I 1686	𝕴	I 1704	I	I 1724	i	I 1744
𝖐	K 1687	𝕶	K 1705	K	K 1725	k	K 1745
𝖑	L 1688	𝕷	L 1706	L	L 1726	l	L 1746
𝖒	M 1689	𝕸	M 1707	M	M 1727	m	M 1747
𝖓	N 1690	𝕹	N 1708	N	N 1728	n	N 1748
𝖔	O 1691	𝕺	O 1709	O	O 1729	o	O 1749
𝖕	P 1692	𝕻	P 1710	P	P 1730	p	P 1750
𝖖	Q 1693	𝕼	Q 1711	Q	Q 1731	q	Q 1751
𝖗	R 1694	𝕽	R 1712	R	R 1732	r	R 1752
𝖘	S 1695	𝕾	S 1713	S	S 1733	f	S 1753
𝖙	T 1696	𝕿	T 1714	T	T 1734	t	T 1754
		𝖁	V 1715	V	V 1735	u	V 1755

TABLE OF LONDON DATE LETTERS, 1598–1835

	1756–1775		1776–1795.		1796–1815		1816–1835.
𝕬	ᴀ 1756	a	ᴀ 1776	A	ᴀ 1796	a	ᴀ 1816
𝕭	B 1757	b	B 1777	B	B 1797	b	B 1817
𝕮	c 1758	c	c 1778	C	c 1798	c	c 1818
𝕯	D 1759	d	D 1779	D	D 1799	d	D 1819
𝕰	ᴇ 1760	e	ᴇ 1780	E	ᴇ 1800	e	ᴇ 1820
𝕱	ꜰ 1761	f	ꜰ 1781	F	ꜰ 1801	f	ꜰ 1821
𝕲	ɢ 1762	g	ɢ 1782	G	ɢ 1802	g	ɢ 1822
𝕳	ʜ 1763	h	ʜ 1783	H	ʜ 1803	h	ʜ 1823
𝕵	ɪ 1764	i	ɪ 1784	I	ɪ 1804	i	ɪ 1824
𝕶	ᴋ 1765	k	ᴋ 1785	K	ᴋ 1805	k	ᴋ 1825
𝕷	ʟ 1766	l	ʟ 1786	L	ʟ 1806	l	ʟ 1826
𝕸	ᴍ 1767	m	ᴍ 1787	M	ᴍ 1807	m	ᴍ 1827
𝕹	ɴ 1768	n	ɴ 1788	N	ɴ 1808	n	ɴ 1828
𝕺	o 1769	o	o 1789	O	o 1809	o	o 1829
𝕻	ᴘ 1770	p	ᴘ 1790	P	ᴘ 1810	p	ᴘ 1830
𝕼	ǫ 1771	q	ǫ 1791	Q	ǫ 1811	q	ǫ 1831
𝕽	ʀ 1772	r	ʀ 1792	R	ʀ 1812	r	ʀ 1832
𝕾	s 1773	s	s 1793	S	s 1813	s	s 1833
𝕿	ᴛ 1774	t	ᴛ 1794	T	ᴛ 1814	t	ᴛ 1834
𝖀	v 1775	u	v 1795	U	v 1815	u	v 1835

Period	Hall Mark	Standard Mark	Date Mark	Period	Hall Mark	Standard Mark	Date Mark	Duty Mark
1500-1678			1564	1751-1755			1751	
1679			1685	1756-1775			1763	
1680-1696			1685	1776-1820			1798	1784-1820
1697-1720	HIGHER STANDARD		B 1717	1821-1830			1823	1821-1830
1721			F 1721	1831-1835			1834	1831-1836
1722-1723			G 1722	1836-1875			1859	1837-1890
1724-1725			I 1724	1876-1890			1885	1877-1895
1726-1728			L 1726	1890-1895			1894	NO MARK Duty abolished in 1890
1729-1738			S 1733	1896-1915			1915	
1739-1750	1739-1751	1739 to 1755	i 1744		F	1904-1906	FROM 1906	

*

* Only used from 1876 to 1904.

255

III.—LONDON MARKS

1558 to 1577
(Twenty letters are used, omitting J.)

The three earlier letters of this alphabet were impressed with a stamp following the outline of the shape of the letter. From 1561 a shield was used. The type of this date letter is Black Letter Small. Similar type was used from 1678 to 1696, and the shields are the same shape. This type was again used in the reign of Victoria from 1856 to 1875, but the shield is different.

1578 to 1597
(Twenty letters are used, omitting J and U, the final letter being V, which was followed in succeeding alphabets till the year 1735.)

Roman Capital Letters are used at this period. The lion and leopard's head are in a stamp following the outline, a practice which continued till 1678. From 1716 to 1735, in the reign of George I, a similar alphabet was used with shields of the same shape; but the first four years have the figure of Britannia and lion's head erased, the Higher Standard Mark. In 1720 the lion and leopard's head with a new shape of shield clearly indicate the difference.

1598 to 1617

Lombardic Capitals are used in this alphabet. The peculiarities in this series are the letter A with its crossbar (1598), the letter C (1600), which is a D reversed, and the letter G (1604).

1618 to 1637

The letters used are Small Italic. The shields are slightly longer and pointed at bottom. The noticeable letters puzzling to beginners are *b* (1619), similar to *h* (1625), *l* (1628), and *s* (1635). The *l* (1628) is similar to the *s* (1753).

256

1564

1578

1606. BEAKER (p. 93)

1631 Maker, William Shute

1637. CANDLESTICK (p. 161)

LONDON MARKS

THE COURT HAND ALPHABET

1638 to 1657

CHARLES I AND COMMONWEALTH

The next alphabet used at the London Assay Office for annual date letters is of a peculiar type known as the Court Hand. Most of the letters are of a character which has not survived in modern usage and they are of a form dissimilar to any other. This Court Hand was employed from the year 1638 to 1657, that is during the latter half of the reign of Charles I and during the Commonwealth up to 1657.

This series of characters was again used from 1697 to 1715, that is to say during six years of the reign of William III, the whole of the reign of Queen Anne, and for the first two years of George I.

Two very important periods are thus covered by these two Court Hand alphabets. It should not be difficult to avoid confusing the one period with the other, as there are other factors which determine which is the latter series. The leopard's head and the lion are, from 1697 to 1720, replaced by the figure of Britannia and the lion's head erased.

The illustration of both series of Court Hand letters on pages 249 and 251 will enable readers to identify them more readily.

The examples illustrated on page 249 are, in conjunction with the maker's mark, the leopard's head, and the lion passant, for the period 1638 to 1657.

APPENDIX

1638 to 1657

Among the difficulties presented by this Court Hand, the following letters are likely to give trouble in identification owing to their similarity in shape, which becomes more pronounced when the letters are worn and the details slightly obliterated. The **a** (1638) may be mistaken for the **i** (1646); the **b** (1639) is not unlike the letter **h** (1645); and the **k** (1647) resembles the letter **b** (1639), which with its peculiar form, when worn, is only distinguishable by the bar across the centre. A worn letter **d** (1641) is apt to resemble an **s** (1655).

In examining the letters under a glass, care should be taken to see that they are not upside down, as in some instances they often resemble others. The shape of the shield is usually clearly enough defined to show the pointed base.

Although these letters are so extremely puzzling, especially to beginners, it should be borne in mind, in comparison with the similar Court Hand alphabet which was used later from 1697 to 1715, that the date marks are only confirmatory. In the later series there is the difference in the omission of the lion passant and the leopard's head, replaced by the figure of Britannia and the lion's head erased. But the character of the silver itself tells its own story in cases where date marks and standard marks happen to be wholly obliterated. A piece of Queen Anne plate differs so essentially in style from a piece of Charles I or Cromwellian that it should be impossible to fall into any error in mistaking the one for the other.

1638 Mercers' Co. Salt

1640

1648

1653. PORRINGER (p. 145)

1654

LONDON MARKS

1658 to 1696

CHARLES II, JAMES II, WILLIAM AND MARY

This period covers the late Stuart silver—Charles II, James II, and the major portion of the reign of William III.

The period represents a renaissance in the styles, and there is a noticeable rejuvenance in the specimens still preserved. For example, see candlesticks illustrated (page 161).

But it must be remembered that during the Charles I period in the days of the Civil War much of the silver was melted down to enable the king to use it in striking the coins of the realm.

Similarly in the reign of William III the old silver was called in by the Royal Mint to be melted down to convert into coin of the realm, for reasons which we have explained elsewhere. On account of the depredations of the coin-clippers much of the fine old silver of the reigns of Charles II and James II was destroyed. In consequence, the silver of the reigns of Charles I, Charles II, and James II is of considerable rarity.

With the opening of the eighteenth century, or, to be exact, from 1697 to 1720, the Higher Standard was obligatory, and with this departure, and the fashions of Queen Anne, a new period of silver is entered. Collectors are divided into schools according to their predilections. To one, nothing later than Elizabeth offers any interest. To another, early Stuart silver affords charms which no later period can supplant. Again, to others the Queen Anne period is the be-all and end-all of their ambitions in collecting.

263

APPENDIX

1658 to 1677

In this black-letter alphabet the peculiarities are the letters C (1660) and E (1662), which are only distinguishable from each other by the cross-bar to the letter E. The letter G is an exceptional form (1664), and is shown on the opposite page. O (1671) is also an unusual form. Letters T (1676) and L (1668) are somewhat similar in form, and may easily be mistaken for each other in worn examples.

The letter H (1665) is illustrated as the mark on a wine cup (page 249).

1678 to 1696

In the year 1679 an oblong shield was used for the lion, as shown on page 255. This mark is taken from the Sumner Salt in the Mercers' Company Hall, illustrated page 261. The letter E is found on a Snuffers and Tray, illustrated page 165, and the letter F on a Porringer (1683), illustrated page 153. The letter H (1685) is shown on the opposite page.

In regard to this alphabet great changes were in the air (see Higher Standard Mark, pages 40–48), and this alphabet comes to an end with the letter **t**, and no later date letter than **t** was employed. But from March to May in 1697 the letter **a** of the Court Hand alphabet was used, and from May 1697 to May 1698 the Court Hand letter **b** was used (see succeeding alphabet).

This is the only occasion when the London Assay Office departed from the regular employment of twenty letters, from A to U, excluding the letter J.

1660

1664

1675

1685

1692

LONDON MARKS

WILLIAM III (1697–1702), QUEEN ANNE (1702–1714)

During this period there were some important Acts of Parliament which relate to Silver Plate and determine certain changes which are interesting to collectors.

In 1696–97, by 8 and 9 William III, *cap.* 8, the standard of silver plate was raised higher than that of the coinage, to stop the practice of melting down the coin of the realm and converting it into plate. From the 25th of March, 1697, the new standard became compulsory, and any silver plate made less than ·959, that is, 959 parts of pure silver in every thousand, was illegal. The marks of the maker were to be the first two letters of his *surname*, and the lion passant and the leopard's head were to be discontinued. The new standard silver was to be stamped with the figure of Britannia in place of the former mark, and the lion's head erased in place of the latter.

In 1700, under 12 William III, *cap.* 4, Chester, York, Exeter, Bristol, and Norwich were reappointed Assay Towns with the right to stamp silver.

It was enacted that the new standard should be observed; that the maker's mark, the variable date letter ("Roman"), the arms of the city, the lion's head erased, and the figure of Britannia be stamped on the silver.

In 1702, 1 Anne, *cap.* 3, a similar power was conferred on Newcastle upon Tyne.

APPENDIX

1697 to 1715

This Court Hand alphabet presents a difficulty at the outset. The letter **a** was only used from March to May 1697, and from thence to May 1698 the letter **b** was used, as in the example illustrated on page 217. The maker, John Bodington, signs the first two letters of his surname below a bishop's mitre.

The letter **c** is illustrated from a mark on a cupping-bowl, 1698, and should be compared—as should all the letters in this Court Hand alphabet—with the letter **c** (1640) in the series 1638 to 1657.

The letter **c** (1698) and **q** (1711) are shown opposite. The maker's initials, K℮, stand for William Keith.

The letter **d** (1699) is given elsewhere (page 251).

The letter **f** (1701) is the mark on a sugar-caster illustrated (page 193). The maker, Christopher Canner, stamps the first two letters of his surname.

The letter **i** (1704) is unlike any modern **i,** and is from a Monteith. The maker, Louis Mettayer, uses the first two letters of his surname.

The letter **k** (1705) is equally unfamiliar. It is from a teapot and stand. The maker, Simon Pantin, signs the first letters of his Christian and surnames. In 1739 this was made compulsory by statute.

The letter **r** (1712) is shown on a caster illustrated (page 269).

All the marks on opposite page denote the Higher Standard—figure of Britannia and lion's head erased.

1698 Maker, William Keith

1705 Maker, Simon Pantin

1707 Maker, Robert Cooper

1709 Maker, Seth Lofthouse

1711 Maker, William Keith

LONDON MARKS

GEORGE I, GEORGE II, and GEORGE III (the first quarter of
his reign)

In the sixth year of the reign of George I, in 1720, the old silver
standard was revived. After 1720 the figure of Britannia and the lion's
head erased disappear from silver. In 1721 the leopard's head and the
lion passant reappear as hall and standard marks, and from this date
the provincial offices again took up the assaying of silver.

The shapes of the shields of the lion passant and leopard's head
during this time are shown in the Table (page 255).

From 1739 to 1755 the lion is in a shield which is irregular in shape
following the outline. The leopard's head from 1739 to 1750 is in a
shield of elaborate shape, and the whiskers of the leopard are clearly
marked in the stamp. From 1751 to 1755 the shield for the leopard's
head changes. These differences can be seen in the Table. The lion
from 1756 to 1895 (139 years) retains the same shaped shield.

271

1716 to 1735

The example given on the opposite page for the year 1717 belongs to the Higher Standard period.

The mark for 1722 is from a tea-caddy made by Bowles Nash, whose mark is a B with a star.

1736 to 1755

The example given on the opposite page for the year 1753 shows the date letter **s,** and is noticeable as likely to be confused with the letter **f** 1741.

1756 to 1775

For the year 1773 a sugar-bowl is illustrated (page 199). The marks are given on the opposite page. The makers were S. and J. Crespell.

1717

1722 Maker, Bowles Nash

1751 Maker, Benjamin Gignac

1753

1773. SUGAR-BOWL (p. 199)

LONDON MARKS

1776 to 1835

GEORGE III, GEORGE IV, WILLIAM IV

The most important feature in regard to marks in this period is the addition of the reigning sovereign's head, which commenced in 1784. This Duty Mark was continued throughout the reigns of George III, George IV, William IV, and during the reign of Victoria until 1890, when the mark of the sovereign's head was discontinued on the abolition of the duty on silver.

In regard to the collection of silver, it must be admitted that this period embraces decadent styles. The delicacy of the Stuart period, with its refinement and grace, and the subsequent reticence of the Queen Anne and early Georgian styles, with their sober though essentially national character, was submerged in the first half of the nineteenth century in the Victorian era. There is an absence of originality and a feeling of dull, insipid, or overloaded ornament in most of the work of this period.

Practically with this period, from a collector's point of view, the subject comes to an end. But there are bright spots now and again visible. There is the classic influence due to the same artistic impulse which directed Wedgwood and the Brothers Adam; but this only extended into the early years of the nineteenth century. The First Empire style came and went in furniture and silver, and only fitfully does it appear in design later than 1830.

275

1776 to 1795

In this period the most noticeable difference in the marks is the addition of the head of George III, in 1784, when the Duty Act was passed (24 George III).

1796 to 1815

Three examples are given from this period, 1798, 1808, and 1810; the last set of marks is taken from a silver-gilt salt with Pompeian style of ornament made by Rundell, Bridge and Rundell.

1816 to 1835

In 1821 the head of George IV replaced that of his father, and from 1831 to 1836 the head of William IV was stamped as a Duty Mark.

In 1823 the leopard's head lost its crown, and has so remained since that date. The lion at the same time had the head fuller and in profile, in which style it has continued till the present day.

LONDON MARKS

1779

1798

1808

1810

1826

277

LONDON MARKS

1836 to 1915

VICTORIA (1837–1901), EDWARD VII (1901–10), GEORGE V

Since the early 1950's, interest in the arts of the Victorian and Edwardian age has been growing, and it is now realized that there will be much of interest for the silver collector to learn about the comparatively recent past. Silver of the arts and crafts movement is especially prized by collectors.

In order to complete the series of examples herein given a selection of marks has been made covering this period, so that the reader may recognize modern marks.

The period is important in embracing several protective measures designed to safeguard the public interests and to bring the assay offices under stricter supervision. The Report of the Select Committee of the House of Commons on the Hall-Marking of Gold and Silver Plate, etc., which was issued in 1879, should be carefully studied by those students who wish to master the complexities of hall-marking.

In 1876 it was enacted (39 and 40 Vict. *cap.* 35) that all foreign plate, before its sale in England, should be assayed here and bear the letter F in an oval escutcheon. Amended by 4 Edward VII, *cap.* 6, 1904.

In regard to forgery of silver plate there is ample provision to bring the offenders to book. By Vict. 7 and 8, *cap.* 22, sections 5 and 6, penalties are provided for those altering and adding to plate, and possessing, selling, or exporting such plate without fresh assay; a fine of £10 can be imposed for each article so found in a person's possession without lawful excuse.

1836 to 1855

From 1837 the head of Queen Victoria appears as a Duty Mark, and till 1875 the leopard's head, still uncrowned, is of a different form (see Table, page 255).

1856 to 1875

In this period the shape of the shield for the date letter, which had remained the same since 1756, was now for the last time used. Its new shape is shown in the following period.

1876 to 1895

The shape of the date shield was changed with the letter B in 1877. In 1876, with the letter A, the shield of the leopard's head was changed, and the face became more feline with whiskers (see Table, page 255). In 1876 another new mark was added, the letter F, in an oval escutcheon, which was compulsory by law to be stamped on all foreign silver assayed at any office in the United Kingdom.

In 1890 the sovereign's head disappears, as the duty on silver was then abolished.

1896 to 1915

In this period it will be observed that the shields of the date letter and the leopard's head both change their shapes, and have three lobes, a shape continued in the next period 1916–35 with black-letter small as the alphabet.

280

1835 Maker, William Eames

1845 Maker, R. Garrard

1873

1891 Maker, S. C. Harris

1915

IV.—PROVINCIAL MARKS

EXETER

Although the records show that Exeter was among the Assay Offices appointed in 1700 by 12 and 13 William, *cap.* 3 and 4, it is evident that silver was assayed here by the city guild of goldsmiths, as some of the marks found on old silver, indubitably of Exeter origin, belong to the sixteenth century.

We are enabled, by the kindness of Mr. J. H. Ellett Lake of Exeter, to give a very representative selection of Exeter marks, and, in addition, to give illustrations of the pieces themselves in this volume.

It will be seen that the earlier marks date from 1572, and the X surmounted by a crown was the city- or hall-mark up to a period as late as 1640. In the early eighteenth century, subsequent to the Act of William III, the hall-mark becomes a castle with the shield divided by a vertical line.

In 1773 a Report was made by a Committee of the House of Commons, who held an inquiry and took evidence as to the manner of conducting the Assay Offices in London, York, Exeter, Bristol, Chester, Norwich, and Newcastle. The Assay Master at Exeter, in describing the method employed at his office, stated that the hall-mark was a castle, and the date letter for 1772 was Z, in Roman character, and that A was to be the letter for the next year, and that the whole alphabet was gone through.

But J, apparently, was never used at Exeter, and in later alphabets no letter after U was used, e.g. A to U (1797 to 1816), etc.

APPENDIX

EXETER MARKS

It is not possible in a volume of this size to give all the date letters of provincial offices, but the following may be of use as indicating the letters used at Exeter:—

A to Z (1701 to 1724) in pointed shield.
a to *z* (1725 to 1748) in pointed shield.
A to Z (1749 to 1772) in square shield.
A to Y (1773 to 1796). The letter I was used for two years, 1781 and
1782. Some of the letters were not capitals.
A to U (1797 to 1816) in square shield, with four corners cut off.
a to u (1817 to 1836) in square shield, with four corners cut off.
𝕬 to 𝖀 (1837 to 1856) in square shield, with four corners cut off.
A to U (1857 to 1876) in square shield, with four corners cut off.
A to F (1877 to 1882), when the office closed. Square shield with oval
base.

In regard to the marks illustrated on opposite page it will be seen that the Higher Standard Mark was used at Exeter after 1701. Examples are shown, 1706 and 1714. Collectors have sometimes stumbled into the belief that no silver was allowed by law to be assayed at any other office than London during the period 1697 to 1720. But it was only between 1697 and 1701 that the provincial offices were practically closed. From 1701 till 1720 such offices did assay and mark silver plate with the figure of Britannia, and the lion's head erased.

1575

1640

1706 Maker, John Elston

1714 Maker, Pentecost Symonds

1748

PROVINCIAL MARKS

CHESTER, NORWICH, AND YORK

The old cathedral cities were the centres of art, therefore it is not surprising to find assay offices established there from the earliest times. Besides Exeter, which we have considered, there were assay offices at Chester, Norwich, and York. It is remarkable that no assay office appears to have existed at Canterbury, nor at Salisbury, nor at Winchester.

Chester has a long history in connexion with the coinage and with assaying silver. In the sixteenth century there is a record of the assay of silver there, and Charles I struck some of his silver coinage there in 1645 with the mint mark of the three wheatsheaves of the city.

Norwich was mentioned as one of the assay towns in 2 Hen. VI, *cap.* 17, in 1423, which honour it shares with York and Newcastle as being of such ancient lineage. The corporation of Norwich possesses several pieces of plate of the Elizabethan period, with the city arms, a lion, and a castle as a hall-mark. A Tudor rose with a crown above is the standard mark. The office ceased early in the eighteenth century.

York is another office which is now extinct. At the end of the eighteenth century it was not mentioned among the other assay offices, but in the middle of the nineteenth century it had recommenced, though it did little business, and no plate seems to have been assayed there since about 1870.

The CHESTER hall-mark down to 1697 is the city arms, viz. a dagger erect between three sheaves of wheat. In 1701 the mark became three demi-lions with wheatsheaves, when Chester was reappointed as one of the assay offices in the reign of William III. The shield was again changed after 1775 to the older form with the dagger which is still in use at the Chester assay office.

We give on page 289 an example of the mark in 1775, with the three demi-lions superimposed on the shield with the three wheat-sheaves. The later mark, of the year 1800, shows the dagger with the wheatsheaves. It will be observed that these marks have the leopard's head and the lion passant, the hall-mark and the standard mark of the London office.

APPENDIX

The present marks used at the Chester assay office, together with the maker's initials, are the lion passant, the city arms, and the date letter.

Chester employed alphabets variously ending:—

1701–1725, A—Z (Roman capitals).
1726–1750, *A—Z* (Italic Script).
1751–1775, A—Y (Roman capitals).
1776–1796, a — v (Roman small).
1797–1817, A—V (Roman capitals).
1818–1838, A—V (Roman capitals).
1839–1863, **A—Z** (Black letter).
1864–1883, **a — u** (Black letter, small).
1884–1900, A—R (Roman capitals).
1901–1925, *A—Z* (Script).

An example is given of NORWICH marks stamped on a tall wine cup, about 1620, of the James I period. The castle and lion is the hall-mark. A Tudor rose surmounted by a crown is also found on Norwich silver as the standard mark.

The YORK mark prior to 1700 is of a peculiar composite character. It is now held to represent half leopard's head and half *fleur-de-lis* conjoined. The example shown is on a flagon in the possession of the Corporation of York, and was made by Marmaduke Best, whose initials are stamped; the letter R is the date letter for 1674. The other example, about 1800, shows the hall-mark with the St. George's Cross and the five diminutive lions. The date mark was obliterated on this specimen. The maker's mark is N. G. The duty mark was too worn to reproduce. It will be noticed, as at Chester, the leopard's head and lion passant are included in the marks.

The date letters used at York were:—

1560–1583, A—X (Roman capitals.)
1583–1607, **a — z** (Black letter, small).
1607–1631, **A—Z** (Old English capitals).
1631–1657, *a — z* (Italics, small).
1657–1682, *A—Z* (Script capitals).
1682–1698, **A—R** (Black letter). (Assay suspended.)
1700–1714, A—O (Roman capitals).
1714–1787 (No regular cycles).
1787–1812, A—Z (With duty mark).
1812–1837, **a — z** (Black letter, small).
1837–1857, A—V (Roman capitals).

CHESTER

1775 Maker, Richard Richardson

1800

NORWICH

c. 1620

YORK

1674 Maker, Marmaduke Best

c. 1800

PROVINCIAL MARKS

NEWCASTLE UPON TYNE (1702–1884)

BIRMINGHAM, SHEFFIELD (1773 to present day)

Newcastle is cited in the Acts of 1423 and 1462 as one of the cities appointed to assay silver. By the Act relating to the Higher Standard, and making it illegal to assay silver elsewhere than London, there is a hiatus after 1696. But the provincial assay offices did not long remain compulsorily idle. They petitioned the House of Commons, and obtained redress. In 1702, 1 Anne, *cap.* 3, was specially applicable to Newcastle upon Tyne, and this Act reappointed the town for assaying silver, and it is there on record that "there is, and time out of mind hath been, an ancient Company of Goldsmiths, which, with their families, by the said penalty are like to be ruined, and the trade utterly lost in the said town."

The NEWCASTLE date lettters are as follows :—

1702 to 1720, 𝕬, to ℚ. In circular shields. Except 𝕬, which is in a square shield. Letters used in no order.

1721 to 1739, a to T. Old English capitals, except a and T. Circular shields, except R, S and T.

1740 to 1758, A to T. Roman capitals in shield with pointed base.

1759 to 1790, *A* to *Z*. A—F squared Roman capitals, Italic capitals for rest, in shield with pointed base.

1791 to 1814, A to Z. Roman capitals. Shield hexagonal in shape.

1815 to 1838, **A** to **Z**. Block capitals. Square-shaped shield with top corners cut off.

1839 to 1863, A to Z. Roman capitals. Hexagonal shield.

1864 to 1883, a to u. Small Roman type. Oval shield. Office closed in 1884.

The complete Newcastle marks are the Lion passant, the Leopard's Head, the Town or Hall Mark of Three Castles, the Date Letter, the Maker's Mark, and the Duty Mark of the Sovereign's Head (till 1890).

Birmingham and Sheffield were both granted the rights to assay silver in 1773 by 13 Geo. III, *cap.* 52.

The Birmingham marks are an Anchor, a Lion passant, a Date Letter, and the Maker's Mark, and the Duty Mark till it was abolished in 1890.

APPENDIX

The date alphabets for BIRMINGHAM[1] are:—

1773 to 1798, A to Z. Roman capitals.
1798 to 1824, a to z. Small Roman.
1824 to 1849, **A to Z.** Black letter capitals.
1849 to 1875, A to Z. Roman capitals.
1875 to 1900, a to 3. Old English, small.
1900 to 1924, a to z. Small Roman.

The Office Year begins 1st July and ends 30th June.

The SHEFFIELD[1] marks are the Lion passant, a Crown, the Date Letter, the Maker's Mark, and the Sovereign's Head as the Duty Mark till abolished in 1890.

From 1773 to 1823 the date letters were taken at random. From 1824 to the present day they run in regular order from A to Z.

On small pieces of silver the crown and date letter are on one punch.

The alphabets for Sheffield are:—

1824 to 1843, **a to z.** Omitting i, j, n, o, w, y.
1844 to 1867, **A to Z.** Omitting J and Q.
1868 to 1892, **A to Z.** Omitting I.
1893 to 1917, a to 3. Omitting j.

The Newcastle marks, 1737, are drawn from a coffee-pot (illustrated page 173). The Date Letter is ℟ in old Church Text capitals.

The Birmingham marks (reproduced opposite) are in date 1804 and 1889. It will be seen that the Duty Mark of Sovereign's Head is in a broken oval shield.

The Sheffield marks are from candlesticks, that of 1773 being made by Samuel Roberts & Co.

[1] I am indebted for these marks to the courtesy of the Assay Master, Birmingham, and to the Assay Master, Sheffield.

NEWCASTLE UPON TYNE

1737. COFFEE-POT (p. 173)

BIRMINGHAM

1804

1889

SHEFFIELD

1773 Maker, Samuel Roberts & Co.

1778

SCOTTISH SILVER

Scottish marks are in a field by themselves. The art of the silver-smith has always been on a high level in Scotland, and the statutes governing the marks are many in number, and extend over a long period from as early as the fifteenth century. Besides Edinburgh and Glasgow, there are a number of other Scottish hall-marks. The following towns are known to have marked and presumably assayed silver: Stirling, Perth (sometimes having mark of lamb and flag, and sometimes double-headed spread-eagle), Inverness, Dundee (marked with design of town arms, a pot of lilies), Aberdeen, and Banff.

Edinburgh used the thistle as the Standard Mark after 1759. Before that date the Assay Master's initials were used. The Hall Mark is a castle with three towers, and has been in use since the fifteenth century. The Date Mark, letters A to Z (omitting J), has been regularly employed since 1681. In one cycle following Z the ampersand is used (for 1779–80). The Maker's Mark has been used since 1457. The Duty Mark of the sovereign's head was added from 1784 to 1890.

Glasgow, whose patron saint is St. Kentigern (known also as St. Mungo), has for a Hall Mark a tree with a bird perched on summit, a bell suspended from the boughs, and transversely across trunk a salmon with a ring in his mouth; the latter alluding to the miracle of the recovery in the fish's mouth of the lost ring of the Queen of Caidyow. The Standard Mark is a lion rampant, used after 1819, and the Maker's Mark his initials. The Duty Mark of the sovereign's head was used as at Edinburgh.

SCOTTISH MARKS

The Edinburgh marks of the date 1705 shown on the opposite page are from an old Scottish Quaich. Robert Inglis was the Maker, and the Assay Master was James Penman, and their initials are on separate stamps. The letter A is the date letter for 1705.

The mark for 1750 shows the letter *V* in italic capitals, and the Assay Master's initials are H.B., and the Makers' are signified by K & D.

A sugar-caster, 1746 (illustrated page 227), has the Maker's initials E. O. and the Assay Master's initials H. G. (for Hugh Gordon). The castle is also stamped as the Hall Mark, and the date letter *R* in italic script.

A coffee-pot made by Patrick Robertson, 1769 (illustrated page 229), has the marks shown opposite. The thistle is the Standard Mark; the castle is the Hall Mark; P. R. is the Maker's Mark; and the letter ⑫ for the date. Another of Patrick Robertson's pieces—a fine tea-urn in classic style—is illustrated page 233. The date letter for this is Z, indicating the year 1778.

Two Glasgow marks are shown opposite. One is for 1712, before the lion rampant was used; and the other shows the lion rampant, the Standard Mark of Glasgow since 1819 and still in use. The Duty Mark Stamp is the head of George IV. F is the date letter for 1824.

EDINBURGH

1705

1750

1769. COFFEE-POT (p. 229)

GLASGOW

1712

1824

IRISH SILVER

Irish silver offers some complications in regard to its markings, and it is especially interesting in its character.

Dublin is the centre of the silversmiths' work in Ireland, and officially the Dublin Goldsmiths' Company holds the exclusive right of assaying and marking Irish silver; but, as we shall show, there was excellent silver made elsewhere in Ireland, notably at Cork, and in the chapter devoted to Irish silver some fine specimens are illustrated.

The Standard Mark is the harp, and was used with the crown added to it, in the year 1637, under the terms of a charter granted by Charles I to the Goldsmiths of Dublin.

As we have seen, in England from 1784 to 1890 the head of the sovereign was added as a mark to denote that duty had been paid. But in Ireland a Duty Mark was in force as early as 1730, viz. the figure of Hibernia. In 1807, in the reign of George III, the duty was raised; and it was enacted 47 Geo. III that the king's head should be stamped as a Duty Mark. This was continued till 1890, as in England, but at the same time the old Duty Mark of the figure of Hibernia was retained, and has still been used since 1890. The figure of Hibernia may be practically regarded as a Hall Mark, although it was first adopted to denote that duty had been paid.

The Maker's Mark, in the early days a device, and later initials, follows the practice of assay offices in England. The date letter was used from the middle of the seventeenth century (1678).

Dublin date letters:—

1678–1716.	𝕬—𝖂.	Old English capitals.
1717–1720.	A—C.	Court hand.
1720–1746.	A—Z.	Black letter.
1747–1772.	A—Z.	Roman capitals.
1773–1796.	A—Z.	Roman capitals.
1797–1820.	A—Z.	Roman capitals.
1821–1846.	A—Z.	Roman capitals.
1846–1871.	a—z.	Roman, small.

IRISH MARKS

Dublin. 1699. The marks of this date shown opposite are from a caster (illustrated page 241). The maker is George Lyng. This was of the period prior to the adoption of the figure of Hibernia.

Dublin. 1738. These marks are taken from a cup with harp handles. The harp with crown is in a gracefully shaped shield. The maker's initials are E. B., and the date letter S.

Dublin. 1770. In these marks, drawn from a cream-pail, the figure of Hibernia appears. It will be noted that this is prior to the addition of a Duty Mark in England (in 1784), and prior to the further addition of a second Duty Mark in Ireland (in 1807), when the head of George III denoted that duty had been paid. The Maker of this piece was Will Haynes. The date is about 1770, but undecipherable.

Cork. 1694. This series of marks shown opposite includes the mark of Robert Goble, of Cork, the maker. The two castles on different stamps appear on Cork examples, and the galley with sails.

Cork. 1764. These marks are drawn from a cream-jug (illustrated page 237), with fine chased and repoussé work, signed by Jonathan Buck in full, and having as a mark a buck, together with the word STERLING, which was sometimes used on Cork and other Irish silver.

DUBLIN

1699. CASTER (p. 241)

1738 Maker, Edward Barrett

c. 1770

CORK

c. 1694. LOVING-CUP (p. 241)

1764. CREAM-JUG (p. 237)

AMERICAN SILVER

I

SILVER IN SEVENTEENTH-CENTURY NEW ENGLAND

THE productions of the silversmith in the English colonies of North America may properly be regarded as part—and a very fascinating part—of the history of English silver, although not all the silversmiths were of English stock, nor did they work exclusively in an English idiom, as will be seen.

Silver objects for domestic and church use were almost certainly present in the English colonies from the time of the settlers' earliest arrival, even if they comprised only a few spoons and some cups for the communion service.

Pilgrim Society

Neither egalitarian nor republican sentiments were the driving motivations of the Pilgrims. The leaders of the party, it should be remembered, were of gentle birth, and the Mayflower Compact of 1620 was signed in strict social order. The Royal Grant permitting them to establish a permanent settlement on land that had been claimed for the Crown, and their financing by a London syndicate of merchant adventurers were unavoidable legal ties to the

mother country, but since the group was "separatist" in a religious, not a political, sense such ties were not at first considered irksome. These facts had an important bearing on the use and acquisition of silver in the Massachusetts Bay Colony and in all the colonies that came after.

The Pilgrims not only managed to produce enough agriculturally for their own needs—increasing as their numbers grew—but also exported their surpluses to England, whence commodities and manufactured wares otherwise unobtainable could in turn be brought. Even such basic items as nails and tools had to be imported at first. The colony prospered, and by 1628 the Pilgrims were free of their debt to the merchant adventurers—a truly remarkable proof of their success.

From the first, all the New England colonies enjoyed an expanding economy based on the exchange of surplus goods for other goods or for money. Although modes of life based on mere subsistence and localized bartering no doubt existed in many early communities, there were from the first centers of trade where the surpluses of agriculture and fisheries could be expressed in less perishable terms.

Since the institution of banking was yet in its infancy, at least as far as it affected ordinary folk, the seventeenth-century colonist held his reserve capital, as he would have done in England, either in the form of minted money or in silver plate, which (being of the same standard of purity as the coinage) could always be exchanged for ready money or melted down at no loss.

Silver for fashioning into plate was available from melted-down silver coins and other wrought plate rather than silver ore of local provenance. Contrary to the earliest expectations, the North American continent had not revealed mineral wealth such as was found in the Southern continent, and the two goldsmiths William

Johnson and Richard Belfield, who arrived in Virginia in 1608 (as recorded by Captain John Smith), were provided with none of the precious metals on which to exercise their craft.

There was no religious, social or moral anathema against the possession or use of silver plate, and as the seventeenth century progressed, the means for fortunate individuals to acquire it existed in the generally favorable and expanding growth of the population and its trade. There was, however, in Massachusetts, a preference for restraint in silver design as a result of religious views.

Imported Plate

The importation and sale of ready-fashioned plate made in England may be assumed to have been carried on from a reasonably early period in the seventeenth century. Wills and inventories are not deficient in the mention of household and personal objects made of silver. The most frequently occurring piece (which is true also of English wills and inventories of the same period) is the spoon, but cups, beakers, tankards and bowls are also mentioned. Later documents, including the advertisements of some colonial silversmiths themselves, specifically mention English-wrought silver for sale. English plate brought over by settlers must also have existed, for not all the colonists were of humble origin, as is sometimes believed. In addition there were always individuals who traveled back to England and out to America again, some more than once, and it appears to have been the custom of such travelers, who were usually men of some substance, to buy new household plate and gifts from the silversmiths of England—especially, of course, those of London. Some plate from England also arrived as the result of a direct

order being sent by letter, for contacts across the Atlantic, although slow, were constant and sure.

Colonial Crafting

Before describing American silver it cannot be too strongly emphasized that our present knowledge of it rests entirely on those pieces which have survived. Based on these survivors there has emerged a historical pattern which probably will not be changed in the larger aspect with more discoveries, but it is only fair to say that new pieces are continually coming to light and that each fresh discovery will alter in some minute degree the pattern as it is now seen. At present it appears that the northern colonies, pre-eminently Massachusetts, were the first to support native silversmiths and produced the greatest number of them. The more southern colonies—Virginia, Georgia, North and South Carolina, Maryland, Delaware and even New Jersey—produced relatively few native-born or native-trained silversmiths, if one can judge from surviving wares, nor did they patronize colonial silver-smiths very much, until just before the Revolution.

Given the sparse population (four million in 1776) and the availability of imported plate, it is perhaps not sur-prising that many American silversmiths appear to have carried on other trades concomitantly with their silver-smithing, such as, to mention but a few: dentistry, gun-smithing, tavern-keeping, clock-making and repairing, jewelry-making, engraving and general retailing.

The imported English plate, arriving presumably in increasing volume as demand grew from, let us say, 1630 to the Non-Importation Agreement of 1770, affected the volume of plate that might otherwise have been locally produced; but it was beneficial in so far as it brought the

succeeding European styles, especially those of London, to the notice of the people living in the colonies. Thus the quite different and strongly characterized Jacobean, Commonwealth and Restoration styles, to mention only those of the seventeenth century, could be seen not long after their adoption at home, and the following century had even more changes of style in decoration and form and saw the introduction of many pieces for new functions.

Early American silver was made either by silversmiths who arrived fully trained or by those born and trained here. Those who came, however, were not necessarily from England. They might be from Ireland or Scotland, or the Channel Islands; or they might be Huguenots who came directly from France or via Holland or England. Some of the latter had served an apprenticeship in London, often to a Huguenot master.

Two Mintmaster-Silversmiths

If proof were needed of the economic progress of the first New England colony, Massachusetts, one has only to reflect that in 1652 the General Court of Massachusetts Bay ordered a mint to be set up in Boston to produce a standard silver currency by melting down and refining the plentiful supply of English, Dutch and Spanish coin then used in money transactions. This silver money, the product of trade with England and the West Indies, was of different degrees of purity, according to the amount of alloy permitted by each of the countries minting it. A quantity of base and counterfeit money was also circulating in the colony so that a local coinage of uniform standard was considered highly desirable. John Hull (1624–1683) and Robert Sanderson (1608–1693), both silversmiths, were confirmed as mint-masters, and for the next thirty

years their mint produced the famous pine and oak tree shillings and sixpences. In the year of their appointment, John Hull was twenty-eight years old and Robert Sanderson forty-four. Each had presumably been making silver independently before 1652, the year when they became partners not only in supervising the mint but also in silversmithing. From 1652 their initials appear together on objects coming from their workshop, although a few pieces, presumably predating 1652, are known bearing only the mark of one or the other. It is, at any rate, safe to infer that silver was being fashioned in Boston in the 1640's, for Robert Sanderson arrived in the colony fully trained as a silversmith in 1638 and John Hull probably had completed his apprenticeship by 1643 or 1644. These two are the earliest recorded American silversmiths whose work is now known, although it is possible that John Mansfield's hitherto unrecorded work may one day be recognized. He had been trained in England and is known from documentary sources to have arrived in Boston in 1634.

Hull and Sanderson Pieces

The earliest piece of datable silver made by Hull and Sanderson now surviving is a modest straight-sided beaker presented in 1659 to the First Church in Boston by a parishioner. (Hull and Sanderson, incidentally, were also members of this church.) The beaker (Fig. 1) may not have been new in 1659, for it is a domestic rather than an ecclesiastical piece, and its Puritan appearance is a reflection of the severe styles of the Commonwealth period in England, its only decoration being a granulation of the surface which extends to within half an inch of the lip and the base.

FIGURE 1. BEAKER
By Hull and Sanderson, Boston, 1659
(*Museum of Fine Arts, Boston, lent by First Church, Boston*)

FIGURE 2. PORRINGER
By Hull and Sanderson, Boston, *c.* 1655
(*Museum of Fine Arts, Boston, Spaulding Collection*)

309

FIGURE 3. SPOON
By Hull and Sanderson, Boston, 1661
(*The Cleveland Museum of Art, gift of Hollis French*)

FIGURE 4. CAUDLE CUP
By Hull and Sanderson, Boston, 1652
(*Museum of Fine Arts, Boston, Spaulding Collection*)

Undated but probably made about 1655, is another very plain object made by these partners. It is a porringer (Fig. 2) bearing the initials of Arthur and Johannah Mason, who were married in 1655. The straight sides join the flat bottom at a slight curve and the trefoil handle is decorated with a simple pierced design. Next to spoons, this kind of vessel with a single lug-type handle set level with the rim and at right angles to the body was the most popular of the silver objects made in the seventeenth century in the colonies, nor did it lose its popularity in the next century.

A Hull and Sanderson spoon dated 1661 (Fig. 3) is fashioned in the uncompromising Puritan style current in England during the Commonwealth. The bowl is a full oval; the handle is straight, narrow and rectangular in section, cut with a slight shoulder and rounded at the end. Puritan styles are seen much longer in New England than in England herself, where the Puritan regime came to an abrupt end in 1660 with the restoration of the monarchy, the re-erection of the "impious" maypoles, and the reopening of the theaters. The Restoration brought a similar revivifying breath to English silver design and decoration.

A Hull and Sanderson caudle cup (Fig. 4) follows rather gingerly the model of a Restoration caudle cup and was probably inspired by one recently brought over from England. The sides swell outward from the base, then curve inward slightly and flare outward again at the lip, giving the profile of the vessel a definitely sinuous line. This departure from the Puritan ideal is emphasized by a row of rather soldierly tulips executed in flat chasing and set in panels of granulated matte work on the lower half of the vessel. The scroll handles were made by casting. This interesting piece, which may have been made

between 1670 and 1680, demonstrates the ability of the partners to produce work that was fashionable rather than traditional in design, and that made new technical demands on them, though their opportunities for doing so would rest, of course, on the outlook of their clients. Many New England caudle cups have survived, for the hot spiced drinks seem to have been as popular here as they were in England; but though of the familiar full form, most American caudle cups made before about 1690 were undecorated.

The very severe plainness of a dram cup by Hull and Sanderson (Fig. 5) is a reflection of the plain styles that lingered in the colony after 1660, the simple scroll handles that rise high above the rim being utilitarian rather than decorative. This piece bears on the underside the initials of Joseph and Ann Gerrish, who were married before 1673.

It will have been realized that most of the Boston silver with the earliest datable associations was the work of the two partners. For the most part they made practical objects such as cups, beakers, goblets, caudle cups, wine tasters, porringers and spoons, all well proportioned and soundly made but usually with sparse decoration. The latter feature is probably due not to a lack of skill or ambition, nor to the want of models, but to the pervading regional taste. Apart from the spoons, much of the surviving Hull and Sanderson silver ware is now the property of various churches in Massachusetts. Most of these objects appear to have been given as sacramental vessels by individuals who had earlier used them in the house. The rejection of special shapes for church use, especially the chalice and paten, was common to all the non-conformist sects, so that the making over of domestic pieces (often in the form of a bequest) for use at the communion table was

FIGURE 5. DRAM CUP
By Hull and Sanderson, Boston, c. 1673
(Museum of Fine Arts, Boston, bequest of Dr. Samuel A. Green)

FIGURE 7. BEAKER
By Hull and Sanderson, Boston, late 17th century
(*The First Church of Christ, Marblehead*)

FIGURE 6. COMMUNION CUP
By Hull and Sanderson, Boston, 1674–1683
(*Museum of Fine Arts, Boston, lent by First Church, Boston*)

perfectly acceptable. It was incidentally the means of preserving until today some part of the earliest Boston-made (and therefore the earliest American) plate, which otherwise would be totally lost to us. Some church plate, however, was made directly for church use and there is a Hull and Sanderson cup as an example of this. Datable to between 1674 (the year of the bequest) and 1683 (the death of one of the partners), is a plain standing cup (Fig. 6) executed in a style approximating that of an English domestic cup of some forty years earlier. This cup was one of three bought in 1674 by the First Church in Boston with money bequeathed for the purpose by the Rev. John Oxenbridg, one of its pastors. The standing cup, consisting of a beaker-shaped drinking vessel raised on a simple or complex baluster stem and resting on a spreading base, was the most enduring of the New England forms, surviving into the eighteenth century. Deriving from English domestic cups of the 1630's it came to be especially associated with churches. The cup made by Hull and Sanderson illustrated is somewhat abbreviated in the stem, considering the width of the bowl and base.

Unique survivals of two forms which the partners may have produced in some quantities are a tankard and a tall beaker, the latter being Dutch rather than English both in form and decoration. The beaker (Fig. 7) is of a type that had a vogue in East Anglia, where Dutch influences were always present and were especially strong in the sixteenth and seventeenth centuries. Perhaps the partners used as their model a beaker of Norwich workmanship belonging to a family originally from that area, whence came so many of the early dissenters who settled in New England.

II

NATIVE BOSTON SILVERSMITHS

John Hull and Robert Sanderson took in apprentices, as was customary in England and throughout Europe, and these apprentices must be considered the first generation of native-born and native-trained American silversmiths. Thus did Robert Sanderson, the senior of the two partners, become "the father of American silversmiths." In Boston alone the names of some thirty silversmiths have been recorded as active before 1700. Two of the most famous of them were John Coney (1655–1722) and Jeremiah Dummer (1645–1718), but Timothy Dwight (1654–1691), John Allen (1671–1760) and John Edwards (1671–1746) (who seem to have worked mostly in partnership) and Edward Winslow (1669–1753) were others whose work was abundant and varied. This first generation of native American silversmiths enjoyed the patronage of the Boston public and also that of the Massachusetts hinterland for which Boston was the metropolis. By the last third of the seventeenth century this public was by no means entirely narrow and unworldly. To the spoons, standing cups, goblets, beakers and caudle cups of the earliest phase of Boston silversmithing were now added objects such as tankards, mugs, beer canns (a sort of lidded mug), standing and trencher salts, candlesticks, plates, tazze, spout cups, chocolate pots, and boxes for sweetmeats, usually called in colonial wills and inventories simply "sugar boxes." The objects reflect the availability of some luxuries and a greater ease and even ceremony in ordinary life than had been possible for the earliest colonists.

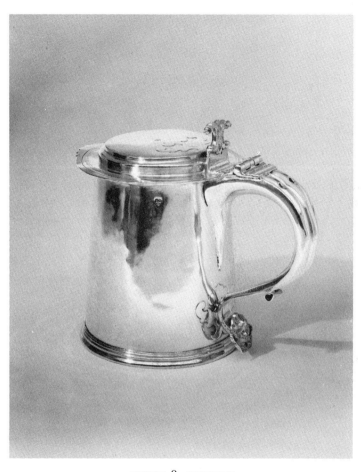

FIGURE 8. TANKARD
By Jeremiah Dummer, Boston, *c.* 1675
(*The Metropolitan Museum of Art, anonymous gift, 1934*)

FIGURE 9. SUGAR BOX
By John Coney, Boston, c. 1680–1690
(Museum of Fine Arts, Boston, gift of Mrs. J. R. Churchill)

All these pieces tend to be more decorative than the earlier productions of Hull and Sanderson, and all the modes of decoration practiced in England became current in New England, with the single exception of the chinoiseries of the 1680's and 1690's. There now regularly appeared chased and embossed work usually for designs of a floral nature, gadrooning and fluting for designs of a more abstract nature, relief patterns of cut-card work or acanthus leaves and, finally, engraving. Figure 8 illustrates some of the characteristics of Boston tankards. It has a flat cover which is decorated with cut-card work, a feature seen again at the lower junction of the handle. The substantial thumb-piece is a "split-scroll" and there are narrow mouldings around the base. An elongated tongue running down from the upper junction of the handle against the wall of the tankard prolongs and thus strengthens the joint. Later Boston tankards sometimes have finials on the lid, and cast motifs on the tip of the handle.

John Coney's production was the most versatile of all. In addition to the list of objects given above as made by the late seventeenth-century Boston silversmiths, there are extant, by Coney, a unique triangular standish, braziers, forks, teapots, casters and monteiths. Sweetmeat boxes were perhaps the most sumptuous objects in size, design and purpose that the seventeenth-century silversmiths produced. The one in Fig. 9 is by John Coney and was probably made between 1680 and 1690. It is oval with an outward-swelling low body and a domed lid. It is raised on four scroll feet, and the lid is equipped with a hasp for fastening. The body has generous concave ovals separated by narrow convex flutes against a matte ground, and a somewhat similar alternating pattern is seen on the lid. In the center of the lid is matte work with acanthus

leaves in relief, and an opulently coiled serpent forms the ring-handle.

Jacob Hurd (1702–1758), born in Charleston, Massachusetts, is a noteworthy member of the second generation, so to speak, of American-born and American-trained silversmiths. His work is graceful, versatile and competent, and he appears to have had a fashionable clientele in Boston, for apart from the more humble type of vessel, such as the porringer, there have survived from his hand engraved gold boxes, pepper-pots, no fewer than eleven chafing dishes (a great luxury), elegant covered bowls of delicate proportions, teapots, and the only known colonial tea kettle and stand with a spirit lamp. Hurd's mark also appears on a silver oar, two feet long, engraved with an anchor and the Royal Arms. This was an official piece, used at all sittings of the Province's Admiralty Court as a symbol of its authority. Many of his domestic wares are engraved with the armorials of the armigerous colonists for whom they were made, and show further the social standing of his customers. An example is the teapot which we illustrate (Fig. 10). It is globular, on a moulded foot, with a hinged cover setting flush with the body and fitted with a turned finial of ebony and silver. The spout is S curved, the lower part octagonally faceted below a diagonal moulding. The plain curved wood handle is pinned into silver sockets that join the body. A border of engraving surrounds the opening for the lid. It is modeled on the early rococo engraving of diapering and masks that was current in England in the 1720's and 1730's. The pot is engraved with the Henchman arms and an inscription that records it as the gift in 1737 of Theophilus Burril to the Rev. Nathaniel Henchman, pastor of the First Church in Lynn, Massachusetts. Jacob Hurd may have been the master to whom Daniel Henchman, son of the pastor,

served his apprenticeship; at all events, Jacob's daughter
Elizabeth married Daniel Henchman, a noted silversmith
of the next generation (1730–1775). Jacob Hurd's two
sons Benjamin and Nathaniel also became silversmiths.
The latter (1729–1777) was in addition the greatest of the
colonial engravers of both silver and copper plate, and
many very beautiful bookplates were printed from
copperplates engraved by him.

III

RHODE ISLAND

The colony of Rhode Island was an offspring of the
Massachusetts Bay Colony inasmuch as the founders of
Newport and Providence were men expelled from
Massachusetts for unorthodoxy. Providence, founded in
1636, was mainly dependent on agriculture and had little
in the way of surpluses until well into the eighteenth
century. The great age of Providence silversmithing was,
however, not to occur until the nineteenth century. The
situation of Portsmouth and Newport, founded in 1638
and 1639, was very different. Situated on the island of
Aquidneck they soon became, from their advantageous
position on the bay, an entrepôt for the transhipment
of supplies to the hinterland and for the export of its
produce; fishing and manufacturing also thrived and the
two settlements quickly built up a trade with Connecticut,
England, the West Indies, Europe and even, after a cool
period, with Massachusetts itself. This activity produced
surpluses and the inevitable growth of a well-to-do class
of people not only able to afford the luxury of silver plate
but also hampered by no Puritan scruples as to its display

and decoration. Newport within a very few decades became the closest thing to a cosmopolitan center in New England, having great toleration for various Protestant religious sects as well as those of the Anglican communion, and having a number of Dutch and Portuguese Jews among the trading community. Unfortunately a large amount of Newport-made silver seems to have disappeared and the suggestion has been favored for some time that many of the denizens of the Island of Aquidneck, being Loyalists, took their silver with them when the island was evacuated by the British during the Revolutionary War. Probably all the plate owned by the well-to-do in the early days of Newport and Portsmouth was of London or Boston make; this seems to be borne out by the existing silver given to local churches during the seventeenth century. However, by the end of the seventeenth century Newport was producing native silversmiths, such as Arnold Collins (whose birth is unrecorded but who married, probably after he was established as a master, in 1690, and who died in 1735). He is remembered as the maker of the "Anchor and Hope" seal of Rhode Island, in 1690. A beaker by Collins survives in the United Congregational Church in Little Compton, to which it was bequeathed in 1711 by Joseph Church.

With the eighteenth century Newport could show silversmiths as able and versatile as any from Boston. This was indeed the great century of Rhode Island craftsmanship, her cabinetmaking and silversmithing being among the most distinguished artifacts produced in the pre-revolutionary colonies. Samuel Vernon (1683–1737) of Newport was a very talented silversmith, as is testified by an unusually large body of surviving work. A tankard by him in the Metropolitan Museum of Art has a characteristic finial on the lid and a carefully cast

FIGURE 10. TEAPOT
By Jacob Hurd, Boston, 1737
(Museum of Fine Arts, Boston, Spaulding Collection)

FIGURE 12. FLAGON
By Benjamin Brenton, Newport, 1734
(*Trinity Church, Newport*)

FIGURE 11. TANKARD
By Samuel Vernon, Newport, early 18th century
(*The Metropolitan Museum of Art, gift of Sylvester Dering, 1915*)

324

thumbpiece in the form of an eagle (Fig. 11). Daniel Russell (*ca.* 1698–1770) and James Clarke (1714–1802), were two other Newport silversmiths whose small body of surviving work shows them to have been sound craftsmen with a personal sense of design. Benjamin Brenton (1695–1749) was of the same generation. He shared with Daniel Russell and James Clarke the task of carrying out the bequests of communion silver to various Rhode Island churches made by the will of Nathaniel Kay, the Collector of Customs in Newport who died in 1734. He made a flagon for St. Michael's Church in Bristol and another for Trinity Church in Newport (both Anglican congregations). The latter is illustrated (Fig. 12) and is a splendid object by an obviously expert craftsman. The inscription reads, "An oblation from Nathaniel Kay a Publican for the Use of the Blessed Sacrament in the Church of England. 1733 Lux Perpetua. Credentius Sola."

The great age of Newport silversmithing was the first three quarters of the eighteenth century. The effects of the Revolution greatly reduced her commerce and with it her wealth and consequence.

Just eight miles from Newport in a southwesterly direction lay King's County on the mainland across the bay. Here the soil was suitable for large scale farming and dairying and favored the establishment of large plantations which, uniquely in New England, employed slave labor on an extensive scale. The produce was mainly corn and tobacco and the stock farming was in cattle, sheep and horses, the latter being successfully bred for export. The plantation owners and even the smaller farmers were affluent enough to lead easy and cultivated lives, the delights of which included private education and travel, lavish hospitality, fox-hunting and horse racing. Such a society could naturally support the activities of local

silversmiths, and six of these have been identified by name and linked with a few surviving pieces, which nevertheless remain rare. Samuel Casey (*ca.* 1724–1770), seems to have been the most important and productive of the King's County silversmiths, and a good quantity of his work which has come down to us testifies that he was the equal in skill and taste of any of the smiths of Boston or Newport. Tankards, teapots, three-legged creamers, beakers and porringers are known by this maker who was particularly skillful in the execution of complex engraved designs. The teapot illustrated (Fig. 13) has a pear-shaped body on a spreading foot with raised decoration on the spout and handle, very similar to English models of the mid-eighteenth century. Note should also be taken of the engraved design on the body of the pot.

IV

CONNECTICUT

Quite contrary to conditions in King's County, Rhode Island (the territory of the Narragansett planters), the soil of neighboring Connecticut favored only intensive farming by a number of independent small holders with relatively little free capital. Very few individuals in the seventeenth century built up a fortune ample enough to lead to the ownership of silver plate. One of these, Theophilus Eaton, was not a farmer but a London merchant who emigrated to Boston in 1637 and participated in the founding of New Haven in 1638. He was the first governor of Connecticut and its wealthiest citizen. The value of his plate left at the time of his death in 1657 was £107 11*s*. 0*d*.; but this was quite exceptional.

Silver plate owned by the Connecticut colonists in the seventeenth century must have been bought from outside the colony, since the earliest recorded silversmith (of whom no work is yet known) is Job Prince (1680–1703), who could not have begun to produce independently before 1697 or 1698 at the earliest. Many of the silversmiths working in the colony in the first half of the eighteenth century seem to have been born and trained elsewhere—among them were the Huguenot René Grignon (died 1715), the New Yorkers Cornelius Kierstede (or Kierstead, 1674–1757) of Dutch descent, Peter Quintard (1699–1762) and Timothy Bontecou (1693–1784), both of Huguenot descent, and the Bostonian John Potwine (1699–after 1737). Of the native Connecticut silversmiths Pygan Adams (1712–1776) is perhaps the best known. New Haven was the richest town of the colony and the main center of silversmithing; Hartford, New London and Middletown were secondary centers.

v

NEW YORK

New York, of all the colonies, was originally founded not with the object of settlement but as a trading outpost of the New Netherland Company and later the Dutch West India Company. As early as 1610 a vessel loaded with merchandise suitable for trading with the Indians was sent out by the newly independent United Netherlands, and this was the beginning of the profitable and active trade in furs between the Dutch and the Indians. By 1615 two permanent trading posts were established; one consisting of only a few huts was on the most southerly

tip of Manhattan Island and the other, more important and protected by a stockade, was up the Hudson in the area now known as Albany, but then named Fort Nassau. An important treaty with the Iroquois was made in 1617, proclaiming peace and alliance between the Dutch and the Indians. The first permanent colonists, consisting of thirty families, sailed on the ship "New Netherland" in 1624, and while some remained at the Manhattan post and a few small groups set up new posts further afield, the greater part of them joined Fort Orange, the successor to Fort Nassau, and there took part in the founding of the settlement that is now Albany. Three more vessels bringing colonists arrived in 1625, and in 1626—the area having been formally named a province of the United Netherlands—Peter Minuit, the first director-general, arrived with still more colonists. Soon after, the whole of Manhattan was bought from the Indians; the settlement there was named Fort Amsterdam (later called New Amsterdam) and became the seat of government for the province; but Albany, directly accessible by river from Fort Amsterdam and more convenient for trade with the interior, remained very important, so that the early silversmiths of the province were almost as active there as they were in New Amsterdam.

Settlers continued to arrive, but it has been estimated that by 1664, when the province passed to English control, there were still only about ten thousand souls in all the settlements of New Netherland. Until this time fur trading and some tobacco growing seem to have been the only organized activities bringing foreign exchange into the province. After that date wheat growing and milling for the export of flour seems largely to have taken the place of the tobacco farming, but fur trading continued, and the beavers, flour barrels and windmill sails of the seal of New

FIGURE 13. TEAPOT
By Samuel Casey, Little Rest, *c.* 1750
(*Newport Historical Society*)

FIGURE 14. BEAKER
By Cornelius Vanderbergh, New York, 1685
(*Yale University Art Gallery, Mabel Brady Garvan Collection*)

330

York, designed in 1686, are a reminder of these early sources of the province's prosperity.

In 1638 and 1640 certain revisions in the rules governing settlement and trading within New Netherland were greatly liberalized by the Dutch West India Company, with the result that settlers from friendly foreign nations and from the New England colonies and Virginia started to arrive. The admixture of English-speaking settlers naturally accelerated after 1664 so that by 1700, the two populations were about equal. There appears to have been a remarkable toleration between the two groups—possibly assisted by the circumstance that from 1689 to 1702 the Dutch William and the English Mary, to whom the colonists owed allegiance, were joint monarchs of England.

Earliest New York Silver

No known silver of local manufacture dates from the period of Dutch control. The earliest silver of the province consists of communion beakers made in Amsterdam and Haarlem for the use of Dutch congregations in Albany, New Amsterdam and Tarrytown. One name of a Dutch silversmith recorded in 1643 is that of Jeuriaen Blanck, but it is not known if he actually practiced his craft after his arrival.

Pirate Metal

With a growing population and a naturally increasing variety of activities in the settlement it is not surprising that some individuals grew wealthy enough to afford the luxury of silver plate. Silver coin, the basic material of all colonial silversmiths, was always in short supply and both the barter system and Indian wampum were widely used

for trade. However, an unusual circumstance in the last third of the seventeenth century brought a very great amount of silver coin of many nations into the hands of New York merchants. This was the license allowed to privateers by their home governments to prey on the shipping of "unfriendly" nations. In times of peace such activities were rightly called piracy, but there seems to have been very little objection on the part of the authorities or the general population to either privateering or piracy. New York merchants traded at great profit with privateers and pirates alike, supplying them principally with wines and strong liquors, gunpowder and shot. Sometimes contact was made in foreign ports and the goods and money acquired in exchange were brought home in vessels owned or financed by the merchants; sometimes the privateers and pirates put in at ports along the eastern seabord of America—Charleston and New York itself being frequently visited. The pirates paid the merchants not only in plundered goods but also in silver coin of various countries so that the silversmiths in turn were amply provided with the metal for their craft.

General Characteristics

The relatively numerous silversmiths active in New York in the last quarter of the seventeenth century were mostly Dutch, but included some Huguenots who did not, however, work in a noticeably French style as tended to happen when they sought refuge in London. It was the Dutch who established for the succeeding century the governing characteristics of New York plate, which is quite distinct from that of the other colonies. In summary, these characteristics are: greater size in the domestic vessels and a thicker gauge in the actual walls of the

objects; greater conservatism in styles of both shape and decoration; a smaller repertoire of objects made in silver, most of which were associated with the consumption of food and drink; and a more general use of repoussé, engraving and cast work as decorative techniques. Because of the larger size of the vessels, they were naturally heavier both under their own weight and under the load of food or drink they held. Strengthening bands and handles therefore show a greater sturdiness than is seen on similar objects of, for instance, Boston or Philadelphia provenance.

An Engraved Beaker

A beaker with the maker's mark C_BV, for Cornelius Vanderbergh (1653–1699, also called Carol Van Der Brugh) illustrates many of these points (Fig. 14). It stands eight inches high and is of the shape and proportions that were common in Holland before 1600. Beakers such as this were standard drinking vessels for domestic use but had also been adopted as communion cups after the Reformation in Holland. The greater number of New York-made beakers of the seventeenth and indeed the earlier eighteenth century were made directly for the use of churches, as the religious scenes on most of them indicate; but the example under discussion clearly was intended solely for domestic use. Nicely spaced out engraved decoration occupies the outer wall. This consists of a strapwork band below the lip enclosing flower designs, and three medallions in which are depicted geese, a beaver and a vase of flowers. At the foot of the beaker are allegorical designs taken from popular illustrations to one of Jacob Cat's moral poems. The illustrations were by Adriaen van de Venne and occurred quite frequently in

Holland transferred to silver decoration. This illustration shows a snake attacking a heron as it is in the act of catching a lizard while the lizard itself is about to swallow an insect. The fineness and fluidity of the engraved line is characteristic of Dutch work both in New York and Holland. The foot of this beaker is strengthened with a moulded band, above which is another band decorated with a stamped repeating geometrical design, and above this again a scalloped "fringe." This combination of moulded band, geometric band and fringe is very commonly seen on New York pieces. Sometimes, most often on tankards, the scalloped fringe is engraved and cut to resemble leaf motifs.

The beaker is inscribed on the side "Robert Sanderson 1685" and is traditionally believed to have been presented by Robert Livingston to Robert Sanders, an Indian interpreter and trader who lived in the neighborhood of Albany and Schenectady. The beaker remained in the possession of the Sanders family until well into the present century.

Caudle and Brandy Cups

Vanderbergh was born in New York and his work was entirely typical of the conservative New York Dutch style. However, he was open to other influences, for he was the maker of a caudle cup for the Van Cortlandt family for which a New England caudle cup must have been the model. So few New York caudle cups are known that caudle is generally believed to have been a comparatively rare drink in this province. Taking the place of the capacious caudle cups are two-handled cups of a lower and more open shape, not provided with covers, which are even more characteristic of New York than the

flaring beaker since they are a local version of the Dutch "brandewijnkom" or brandy bowl. These brandy bowls are found in a wide variety of sizes, some quite small, others as in the example illustrated (Fig. 15) as much as ten inches in diameter at the lip. The bowl pictured rests on a vertical foot band decorated with a repeating stamped geometrical design with an everted flange. The sides are divided by rounded grooves into six panels occupied by carnations in repoussé, each flower surrounded by pricked scrolls within a heart-shaped outline also described by a rounded groove. Another flower decorates the bottom. Each handle, decorated with beaded ornament and a caryatid head at the highest point of the curve, was cast in one piece in a mold. The brandy bowl is engraved with the initials of Theunis Jacobsen Quick and his wife Vroutje Janse Haring, who were married in 1689. The mark "CK" in a rectangle is struck near the handle and stands for Cornelius Kierstede (1675–1757), who was born in New York and moved to Connecticut in about 1722, continuing to practice his craft until the great age of 82. His work was more continental in inspiration and more ambitious than that of his contemporaries. For example, the Metropolitan Museum in New York has a unique tea kettle and a pair of candlesticks with snuffer stand *en suite*, engraved with chinoiseries, (possibly modeled on similarly engraved English silver of the 1680's) and grotesque figures. (See Fig. 16.)

Porringers

The porringer appears to have been used in all the American colonies, but more commonly in the more northerly ones. In poorer households they were undoubtedly made of pottery or faience, as in England, but

in the homes of the well-to-do they were of silver. The silver porringers of New York would seem to date rather from the eighteenth century than the seventeenth, probably as a result of the greatly enlarged English population among whom the use of the porringer was customary. It appears to have been unfamiliar to the Dutch. Dutch silversmiths, however, did not disdain to make the form, and the example we illustrate here (Fig. 17) is by Peter Van Dyck (1684–1750), an early New York smith who was apprenticed to Bartholomew Le Roux, one of the earliest of the Huguenot silversmiths to work in the city (and whose daughter Van Dyck married). He is one of the best known of the New York silversmiths, much silver by him having survived, including tankards, teapots, porringers, spoons, bowls and a mustard pot—the only one from the colonial era, although silver mustard pots do not seem to have been too uncommon, judging from contemporary inventories. New York porringers were distinguished by two styles of pierced decoration of the handle. Either the patterns called for so much cutting away of the metal that only thin ribbons of silver were left to hold the handle together, or, at the other extreme, very little indeed was cut out. The porringer by Peter Van Dyck illustrated, which was probably made some time between 1700 and 1725, is an example of the former. The handle is reduced almost to a lacework. At its tip, a heart over a cross is to be seen worked into the pierced design, a combination of motifs seen on porringer handles by other New York smiths such as, for instance, Bartholomew Schaats (1670–1758) and John Newkirke, who flourished around 1716. It is also seen on the handle of a porringer by the well-known but long unidentified silversmith Peter Van Imburgh (1689–1740) whose punch consisted of the initials PVB. This

FIGURE 15. BOWL
By Cornelius Kierstede, New York, first quarter of the 18th century
(*The Metropolitan Museum of Art, Samuel D. Lee Fund, 1938*)

FIGURE 16. PAIR OF CANDLESTICKS AND SNUFFER WITH STAND
By Cornelius Kierstede, New York, c. 1705
(*The Metropolitan Museum of Art, gifts of Mr. and Mrs. William Moore, 1923,
Robert Livingston Cammon, 1957, and Mr. Clermont L. Barnwell, 1964*)

337

FIGURE 17. PORRINGER
By Peter Van Dyck, New York, first quarter of the 18th century
(*The Metropolitan Museum of Art, gift of Miss Annie Clarkson, 1927*)

338

porringer is of especial interest since it bears the inscription "1668 wunn att hanpsted plaines march 25." Since the silversmith who made it lived after 1668, it is reasonably thought that a seventeenth-century silver race prize was later remade into the porringer by Peter Van Imburgh who copied the original inscription, even to the style of the earlier script. Such refashioning of outmoded plate was undertaken quite frequently by silversmiths both of England and the colonies.

Tankards

The tankard, along with the porringer and caudle cup, was also a New England form, unfamiliar in Holland (though used both in Scandinavia and Germany). It was adopted in New York, acquiring at the hands of the Dutch silversmith there characteristic features that make New York tankards readily distinguishable from other colonial tankards, even by the layman. The example we illustrate (Fig. 18) embodies most of these characteristics. The "corkscrew" thumbpiece is to be noted as well as the moulded base band decorated with a meander design on the middle wire and the fringe of stamped leaf motifs above. The flat-topped lid rises in two stages and the "front"—the side opposite the handle—is curved outward slightly from the true perimeter of a circle and decorated with a serrated pattern. The sturdy handle is a simple scroll decorated with a rather flat cast figure of a lion affixed just below the point where the hinge of the lid joins the handle. The lion is set as though walking "up" the handle and is consequently seen in a vertical rather than horizontal position. The outward returning tip of the handle is decorated with a winged cherub's head, made by casting, and in quite a bold scale considering

the size of the feature it decorates. The handle and front of the body of the tankard are alike engraved with a W over E E, which initials stand for Evert and Engeltie Wendell of Albany, who were married in 1710. The marker's punch is I B in a shaped outline and is stamped on the cover, on the body near the top of the handle and on the bottom. This is the punch of Jacob Boelen (1654–1729), the eldest member of a distinuished line of New York silversmiths. His father, Boelen Roeloffs, arrived in New York in about 1660, bringing Jacob, who would have been about six years old. The son was not only a very able silversmith (with much silver surviving to the present day to attest to his creative energy and popularity among contemporary clients), but he also occupied a series of public posts in the city and in 1695 was appointed the co-officer with Cornelius Vanderbergh for regulating the weights and measures used in the city and province. Boelen made the first box containing the customary parchment proclaiming the honorary gift of the freedom of the city, in 1702, to the Governor, Viscount Cornbury. The box was of gold, and the work's being entrusted to "alderman Boelen" indicates that he was one of the principal silversmiths of the day.

The tankard illustrated here lacks only one or two features to make it a total compendium of all the particular characteristics found on New York tankards of the later seventeenth and first part of the eighteenth century. These "omissions" are decoration on the flat of the lid—which often consisted of engraved or embossed work—or a large cipher of the owner's initials or even sometimes an inset coin or medal. The front of New York tankards was also frequently elaborately engraved with armorials in the midst of plentiful scrolling or acanthus leafage. Other variations in decoration were a "beaded" or plain

FIGURE 18. TANKARD
By Jacob Boelen, New York, *c.* 1710
(*Henry Francis du Pont Winterthur Museum*)

FIGURE 19. MUG
By Koenraet Ten Eyck, Albany, *c.* 1700–1725
(*The Metropolitan Museum of Art, gift of Miss Annie Clarkson, 1927*)

341

FIGURE 20. TEAPOT
By Jacob Boelen, New York, early 18th century
(*The Metropolitan Museum of Art, gift of Mrs. Lloyd K. Garrison, 1961*)

FIGURE 21. TEAPOT
By Adrian Bancker, New York, *c.* 1730–1770
(*The Minneapolis Institute of Arts, gift of James F. and Louise H. Bell*)

rat-tail running down the center of the handle, and a high double bracket thumbpiece in place of the corkscrew.

Mugs

Mugs were also made in New York, and it may be said that in the early decades they resembled tankards without covers, usually on a smaller scale. They tended to have similar plain scroll handles and straight sides tapering very slightly toward the top, as did the majority of tankards. They also had the base mouldings with or without the meander decoration on the middle wire and the fringe of stamped leaf decoration above. Some repeated the base moulding around the mid point and, if the meander motif were present on the lower moulding, it would tend to be repeated on the upper one. A flattened and scalloped rat-tail is sometimes seen on the handle. A plain mug in the Metropolitan Museum demonstrates some of these points (Fig. 19). A third moulding around the lip should be noted, as well as the very handsome engraved cypher on the front. The return of the handle is decorated with a simple roundle. The date of this piece could be any time between 1700 and 1725, judged more from the dates of the maker, Koenraet Ten Eyck of Albany, than from stylistic considerations, for mugs similar to this remained popular throughout the eighteenth century. Koenraet Ten Eyck (1678–1753) is particularly well known for this type of mug. Later in the century a mug with a more bulbous shape was used concurrently with the straight-sided type.

Pots for Coffee, Tea, and Chocolate

Tea, coffee and chocolate were certainly known in the colonies, but it is probable that before about 1700 these

343

drinks were more commonly taken in public coffee houses than in the home. As early as 1670 a Mrs. Dorothy Jones was "approved of" to "keep a house of public entertainment" in Boston for the sale of coffee and chocolate. Also in Boston, Benjamine Harris and Daniel Vernon were licensed in 1690 to sell "Coffee, Tee and Chucaletto." The earliest known American teapot, however, is of New York, not New England, workmanship (Fig. 20). By Jacob Boelen, it has a globular body with a straight tapering spout set opposite the handle and rests on a vertical foot with stamped geometrical decoration. The body is handsomely engraved with the arms of the Philipse family among profuse scrolled mantling, and the cover is flanged and gadrooned. The wood handle is pinned into silver sockets fixed to the body of the pot and the finial of the lid is also wood. A later form of the teapot in New York is reminiscent of teapots quite current both in England and on the Continent, but which developed here between 1730 and 1775, somewhat later than on the other side of the Atlantic. Various New York silversmiths made teapots in this shape; the example illustrated (Fig. 21) is by Adrian Bancker (1703–1772). It is pear shaped with a high-domed cover hinged to the handle socket. The spout, of the so-called duck's neck type, is octagonally faceted. Coffee and chocolate pots were of course also made in New York, reflecting the greater luxuries indulged in during the eighteenth century.

A Maker of Rococo

Myer Myers (1723–1795) is a specially interesting New York silversmith who practiced in the third quarter of the eighteenth century. He was Jewish and had a shop on Greenwich Street which seems to have been patronized

by the leading citizens of the day. He worked mainly in the rococo style with no trace of the traditional New York features of the earlier period. His surviving pieces include not only the expected teapots, coffeepots, sugar bowls and other domestic articles, but also a number of unusual items such as a silver saucepan, the only known colonial dish ring and Jewish ritual silver. A pair of Torah bells (to decorate the Scrolls of the Law) illustrate the latter group (Fig. 22). They were made in 1772 for the Congregation Mikveh Israel in Philadelphia. The tubular shafts terminate in three knops—the lower and upper chased, the middle one ajouré—from which hang small bells on scroll brackets. Myers made silver for Christian Churches as well: a silver plate is known that was given to the Old First Presbyterian Church of New York by Peter Livingstone. Myer Myers was President of the New York Silversmiths Society in 1776 but left soon after for Connecticut, where he spent the war years.

VI

PHILADELPHIA

Philadelphia was the third great center of silversmiths' work in the colonial period. Fortunate in the care with which its site on the Delaware River had been chosen, according to Penn's instructions to his three commissioners, where the river "is most navigable, high, dry and healthy; that is where most ships can best ride without boating or lightering of it," the city seemed marked from the first for progress and prosperity. Before the first settlers arrived the commissioners had laid out its limits in a rectangle measuring about two miles from the east bank

of the Schuylkill to the west bank of the Delaware and about a mile from north to south. Within two years of its founding Philadelphia had 300 houses and a population of some 2,500 souls. By 1700 this number had risen to 15,000 Though founded much later than either Boston or New York, Philadelphia's population and trade increased rapidly so that during most of the eighteenth century Philadelphia was the most important of the three —socially, politically, commercially, and, it may be added, artistically.

Silversmiths, in fact, appeared before the artists and fine cabinetmakers, for it is known that as early as the 1690's silversmiths were working in the city. Two who are known by name were both Huguenots; the City of Brotherly Love did not attract or limit itself solely to settlers of the Quaker faith, for total religious toleration had been a cornerstone of Penn's belief from very early in his career as a religious leader. César Ghiselin (1670–1734), who probably came from England to Philadelphia, is recorded as early as 1693, and John Nys (1671–1734, also called Johan de Nise) also settled in Philadelphia in the 1690's, after having apparently spent his early years in Holland, followed by training in New York. The tankard illustrated (Fig. 23) bears out his New York training. William Penn's own account book shows that he patronized both Ghiselin and Nys in 1701, although in the same year he had sent to him a considerable quantity of domestic plate from England. Regular importation of English-made silver seems to have been rather greater in volume in Philadelphia in the eighteenth century than in New York or Boston, and there is today still a great store of English plate among the descendants of eighteenth-century families. English styles inevitably set the fashion for the Philadelphia smiths, but nevertheless much

FIGURE 22. PAIR OF TORAH BELLS
By Myer Myers, New York, 1772
(*Congregation Mikveh Israel, Philadelphia. Photograph, The Virginia Museum of Fine Arts*)

347

FIGURE 23. TANKARD
By John Nys, Philadelphia, early 18th century
(*The Philadelphia Museum of Art. Photograph, A. J. Wyatt*)

348

Philadelphia silver has a discernible character of its own. This may be summarized as a certain elegance combined with strength, but which sometimes appears after the mid-eighteenth century as a trifle overloaded with decoration.

The Richardson Family

Francis Richardson (1681–1729) was working in the early eighteenth century and is found in William Penn's account book as supplying toward the end of 1701 a "Paire of shoe buckles for Letitia," Penn's daughter. These buckles were no doubt taken as a present for Letitia by Penn when he returned to England in December of 1701. Francis Richardson's known work numbers only nine items, mostly small articles such as buckles, spoons and boxes. His mark, F R in a heart, appears on one tankard, however, showing that he did make more ambitious pieces. In common with most early Philadelphia tankards, this one (Fig. 24) has a stepped and low-domed cover, a simple scroll handle with a shield-shaped end, a beaded rat-tail on the handle and a high scroll thumbpiece for raising the cover. The sides taper slightly toward the top and applied mid and base bands are both present. (Some Philadelphia tankards omit the mid band.) On the handle of this example are engraved the initials of William and Mary Branson.

Joseph Richardson (1711–1784) was the younger and apparently more prolific of Francis Richardson's sons. He inherited and continued to work in his father's shop on Front Street below Walnut. Sixty-seven pieces of silver plate made by Joseph Richardson are now known, and among these twenty-three different forms are found. His account books ("day books") for the years 1733–1740,

349

now in the possession of the Pennsylvania Historical Society, record most informatively his dealings with a numerous clientele. The elaborate coffeepot and sugar bowl illustrated (Fig. 25) were made in 1754 by Richardson for the wedding of Sarah Shoemaker and Edward Penington. These two objects date from the decade in which Philadelphia drew level with and then surpassed Boston in population and wealth. Famous for the stylishness of its proverbial hospitality, Philadelphia seems to have used more tea and coffee services in silver than any other colony. The coffeepot and sugar bowl, with Richardson's mark I R in a rectangle stamped four times on the bottom, has cast decoration at the foot, spout and finials of the covers as well as engraved and flat chased work on the body. Richardson also belonged to the Quakers' "Friendly Society for Propagating Peace with the Indians by Pacific Measures" and in 1757 made for this society the crescent-shaped neck ornaments known as gorgets (see Fig. 26) and cast silver medals for presentation to friendly Indians. A third generation of silversmiths in the Richardson family is represented by Joseph's sons Joseph Jr. and Nathaniel.

A Historic Inkstand

Philip Syng Jr. (1703–1789), a contemporary of the senior Joseph Richardson, also belonged to a dynasty of Philadelphia silversmiths. His Irish father was apprenticed and worked in Cork before coming with his family to Philadelphia in 1714. Syng had a son, the third of that name who was also a silversmith, but he died at the age of twenty-seven. Philip Syng Jr. and Joseph Richardson were the leading silversmiths of their day and appear to have been on the best of terms. Syng especially was

FIGURE 24. TANKARD
By Francis Richardson, Philadelphia, *c.* 1700–1730
(*The Philadelphia Museum of Art, lent by Dr. Isaac Starr*)

FIGURE 25. COFFEEPOT AND SUGAR-BOWL
By Joseph Richardson, Philadelphia, 1754
(*The Historical Society of Pennsylvania*)

351

FIGURE 26. GORGET
By Joseph Richardson, Philadelphia, 1757
(*The Historical Society of Pennsylvania*)

FIGURE 27. INKSTAND
By Philip Syng Jr., Philadelphia, 1752
(*National Park Service Photograph*)

socially prominent and active in city affairs, apart from attending to his business. He is represented here by the elegant inkstand (Fig. 27) made at a cost of £25 16s. 0d. for the Provincial Assembly of Pennsylvania in 1752, the same year that the "Liberty Bell" arrived from England to commemorate the fiftieth anniversary of the colony's revised "Charter of Liberties" agreed to by William Penn in 1701. Possibly the inkstand was ordered to celebrate the same anniversary. This historic stand was used at the signing of the Declaration of Independence and the Constitution, and may still be seen in Independence Hall.

VII

OTHER AREAS OF ACTIVITY

Apart from the large centers already described, there were, from almost the beginning of the colonial period, individual silversmiths who practiced their craft in many of the smaller towns. These were, to name but a few, New Castle in New Hampshire, Salem, Barnstable, Marblehead and Newbury in Massachusetts, Princeton, Elizabeth, Morristown, Newark and Trenton in New Jersey, Annapolis in Maryland, Wilmington in Delaware and Alexandria, Fredericksburg, Lynchburg and Williamsburg in Virginia. Very little silver seems to have been made in the more southern colonies, with the exception of Charleston, South Carolina, where a small group of silversmiths practiced their craft from about 1730. Charleston was a busy seaport, equally important for its shipbuilding industry as for its great commercial connections to the North and South and across the Atlantic. In supporting

the work of local silversmiths, even in a small way, it was very different from its hinterland, which was occupied by small farmers too poor to own silver plate at all and by owners of large plantations whose profits allowed them to buy their silver where they sold their crop, that is, in England. This pattern was repeated also in Georgia, Virginia, and North Carolina, there being until the 1770's a marked reluctance to support or engage in any industries or manufactures not connected with agriculture.

<div align="center">VIII</div>

<div align="center">THE LATE EIGHTEENTH CENTURY</div>

As the eighteenth century advanced, colonial silver-smiths were strongly influenced, with a very short time lag, by the London fashions, and regional distinctions therefore tend to become less noticeable. This trend has already been noted in the work of Myer Myers of New York, and the coffeepot and sugar bowl (Fig. 25) already described are also examples of the influence of English styles.

A Cann by Soumaine

A greater suavity in shape was characteristic of English mid-eighteenth century silver and this feature may be seen adopted in a simple cann (Fig. 28) by the American Samuel Soumaine (1718–1765). The bulbous body pinches inward somewhat at about mid-height and recurves to a slightly flaring lip. The handle is in the form of a double scroll, a larger one curving away from the cann meeting a smaller tighter one that curves back

<div align="center">354</div>

FIGURE 29. TRAY
By Paul Revere, Boston, 1761
(Museum of Fine Arts, Boston, Sleeper Collection)

FIGURE 28. CANN
By Samuel Soumaine, Annapolis, c. 1750
(Presbyterian Historical Society, lent by the Rehoboth Presbyterian Church)

FIGURE 30. TEA SET
By William Hollingshead, Philadelphia, *c.* 1775
(*The Philadelphia Museum of Art. Photograph, A. J. Wyatt*)

356

again. The handle is set away from the body by a flat disc at the lower junction and a plain short rod at the upper. The foot is moulded and slightly splayed. This cann is one of a pair probably made by Soumaine while he was still working in Annapolis, for the first owners, whose initials are engraved on the canns, were Robert and Anne King of Maryland. Sometime between 1752 and 1754 Soumaine moved from Annapolis to Philadelphia, where he continued to work as a silversmith.

"Piecrust" Tray

The handsome tray (Fig. 29) by Paul Revere of Boston —about whom more will be said later—is a prime example of a piece of American silver closely following a London fashion. It is datable to about 1761 and might very well be London work of the same year. Although such trays with raised "piecrust" borders had been the mode there already for some years, they continued to be popular. The rim has a scalloped margin with shell-like ornaments set at intervals around it. It rests on little scrolled feet and is most exquisitely engraved in the center with the arms of the Chandler family set in an asymmetrical cartouche and surrounded by decorative rococo motifs. According to tradition, this tray was made for Lucretia Chandler upon her marriage to Colonel John Murray in 1761. Her father was the "Honest Tory," Judge John Chandler.

Silver for Hospitality

The London styles were not always, however, slavishly followed. The Philadelphia tea set by William Hollingshead (Fig. 30), probably dating from about 1775, is an example of a blend of established and novel features. The

gracious undulating lines of the creamer and sugar bowl should be noted, both having pear-form bodies and a splayed foot decorated with gadrooning. The rim of the creamer is shaped and the lip is high, balancing the even higher flight of the slender handle. Both these pieces are essentially in a style that had been established for some thirty years. On the other hand the accompanying teapot is not only fully contemporary, with its straight spout and cannister-like body and beaded decoration at the shoulder and round the base, but the small pierced gallery which surrounds the opening for the lid makes it instantly recognizable as Philadelphia work. This feature, though seen on English and American tables of the period, seems to have been adapted for silver only in Philadelphia. The realistically modeled pineapples are also a contemporary motif on the lids of the teapot and sugar bowl—one that is also characteristic of Philadelphia but not exclusively so; however, since this is the traditional symbol of hospitality, a custom on which Philadelphians prided themselves, the pineapples may have been adopted quite consciously.

Sauceboat by Faris

A sauceboat (Fig. 31) bearing the mark of William Faris (1728–1804) which was made about 1770 is by contrast quite "old-fashioned." Every aspect of this piece —the boat-shaped body, double scroll handle and three "slippered" legs joining the body below shell-shaped decorations—is in a style that had been seen some thirty-five years earlier in England. It provides interesting evidence of a conservative taste existing at the same time that colonial clients were also reaching out for the newest styles. William Faris was born in London and seems to have been originally a watchmaker by trade. He resided

FIGURE 31. SAUCEBOAT
By William Faris, Annapolis, c. 1770
(The Baltimore Museum of Art, gift of Mrs. Miles White Jr.)

359

FIGURE 32. COFFEEPOT
By George Aiken, Baltimore, after 1787
(*The Newark Museum*)

360

in Annapolis and is known to have employed trained silversmiths to work for him. The sauceboat may therefore be the work of an unknown journeyman though bearing Faris' own mark "W F."

The neo-classic style that supplanted the late rococo in English silver about 1770 was not fully felt in the colonies until the end of the Revolutionary War, for very little silver was made during the war or in the years of depression that preceded it.

Neo-Classic Coffeepot

The coffeepot made after 1787 by George Aiken (1765–1832) is in the neo-classic ideal with its severe sweep from square, plinthlike base to high domed cover. (See Fig. 32.) The finial of the cover, it should be noted, is in the form of a complete miniature urn and cover. Still, earlier features remain, in the double scroll of the handle. George Aiken was born in Philadelphia but worked in Baltimore, a city that was to become more important for silver in the nineteenth century than it had been in the eighteenth when only a few smiths worked there sporadically.

Paul Revere

Because of his activities as a patriot, Paul Revere (1735–1818) is certainly the best known American silversmith. He served his apprenticeship under his father, Apollos Rivoire (1702–1754), a Huguenot refugee who anglicized his name to Paul Revere and named his son after himself. Paul Revere senior served an apprenticeship to John Coney, who has already been mentioned as one of the earliest and most notable Boston silversmiths. Thus the younger Revere was, through his father, a direct link with the beginnings of the silversmiths' craft in America.

The tray already described (p. 357) is an example of one of Revere's early pieces. In the years of depression which preceded the Revolution, Revere, in addition to working as a silversmith, turned his hand to dentistry, woodcarving and engraving on copper plates. The latter included plates for book illustrations and political cartoons and, during the war, plates for printing paper money.

The attractive tea set illustrated in Fig. 33 dates from his prosperous post-war years. The set can be dated precisely to 1792, for on April seventeenth, 1792, these pieces are itemized in Revere's Day Book and charged to "Mr. John Templeman" for a total cost of £51 11s. 8d. Engraved in an oval on the side of the teapot are the initials J.M.T. for John and Mehitable Templeman who were married in Salem on March eighteenth, 1783. The pine cone finial of the lid was very commonly used on Revere's and indeed much other Boston silver. The body of the teapot is fluted and decorated with lightly engraved tasselled drapery and more schematic designs in "bright-cutting." This was a new decorative technique introduced in England towards the end of the century and soon followed here. It consisted of literally slicing out small elliptical chips of silver at an angle to the surface of the ware, so that the tiny shallow facets that resulted would catch the light, giving a sparkling effect. A softer touch in engraving and the bright-cutting technique were evolved for the decoration of objects not made by the traditional method of raising and stretching a disc of silver with the hammer. In making his teapot, Paul Revere employed the new and economical process of cutting his form from a sheet of rolled silver, seaming it vertically and soldering it to a flat base also cut from the sheet. Such vessels were lighter and thinner walled than

FIGURE 33. TEA SET
By Paul Revere, Boston, 1793
(*The Minneapolis Institute of Arts*)

FIGURE 34. PRESENTATION PITCHER
By Paul Revere, Boston, 1806
(*The Paul Revere Life Insurance Company*)

ones made by the older method. In the fashioning of the cream pot and sugar urn neo-classic influences are seen: a high simply curved handle, urn shapes and simple square plinths acting as bases.

It is fitting to conclude this review of early American silver of the colonial period with Paul Revere. He was born forty years before the Revolution, took an active part in the struggle for Independence and lived to see the beginning of the Federal Age. After the war, he not only continued to produce silver that was highly contemporary in design (Fig. 34) but he also imported and retailed hardware, operated a metal foundry and established a mill for rolling sheet copper by a new process. Thus his later career seems to foreshadow those great entrepreneurs of industry who were to make such a contribution to the nineteenth century, while his earlier career is firmly established in the craft traditions of the eighteenth century.

The Decline of Hand Crafting

We close this chapter at the late eighteenth century because after the Revolution one cannot really call silver made in America an offshoot of English silver either in a political or a design sense. Furthermore, as a craft the work itself changed; many non-hand methods were introduced and the majority of silversmiths, especially in New England, were absorbed into semi-industrial companies. As has been noted throughout this chapter, similar trends were found in both English and American silver, and the change from a single craftsman working by hand to a greater mass production by a group of men and machines also occured in England. In both countries this change began to take place around the end of the eighteenth century.

INDEX

INDEX

INDEX

371

Dover Books on Art

Dover Books on Art

THE FOUR BOOKS OF ARCHITECTURE, Andrea Palladio.
A compendium of the art of Andrea Palladio, one of the most
celebrated architects of the Renaissance, including 250 mag-
nificently-engraved plates showing edifices either of Palladio's
design or reconstructed (in these drawings) by him from clas-
sical ruins and contemporary accounts. 257 plates. xxiv + 119pp.
9½ x 12¾. T1308 Clothbound $10.00

150 MASTERPIECES OF DRAWING, A. Toney. Selected by a
gifted artist and teacher, these are some of the finest drawings
produced by Western artists from the early 15th to the end of
the 18th centuries. Excellent reproductions of drawings by Rem-
brandt, Bruegel, Raphael, Watteau, and other familiar masters,
as well as works by lesser known but brilliant artists. 150 plates.
xviii + 150pp. 5⅜ x 11¼. T1032 Paperbound $2.00

MORE DRAWINGS BY HEINRICH KLEY. Another collection
of the graphic, vivid sketches of Heinrich Kley, one of the most
diabolically talented cartoonists of our century. The sketches
take in every aspect of human life: nothing is too sacred for him
to ridicule, no one too eminent for him to satirize. 158 drawings
you will not easily forget. iv + 104pp. 7⅜ x 10¾.
 T41 Paperbound $1.85

*THE TRIUMPH OF MAXIMILIAN I, 137 Woodcuts by Hans
Burgkmair and Others.* This is one of the world's great art
monuments, a series of magnificent woodcuts executed by the
most important artists in the German realms as part of an
elaborate plan by Maximilian I, ruler of the Holy Roman Empire,
to commemorate his own name, dynasty, and achievements. 137
plates. New translation of descriptive text, notes, and bibliogra-
phy prepared by Stanley Appelbaum. Special section of 10pp.
containing a reduced version of the entire Triumph. x + 169pp.
11⅛ x 9¼. T1207 Paperbound $3.00

*LOST EXAMPLES OF COLONIAL ARCHITECTURE, J. M.
Howells.* This book offers a unique guided tour through America's
architectural past, all of which is either no longer in existence
or so changed that its original beauty has been destroyed. More
than 275 clear photos of old churches, dwelling houses, public
buildings, business structures, etc. 245 plates, containing 281
photos and 9 drawings, floorplans, etc. New Index. xvii + 248pp.
7⅞ x 10¾. T1143 Paperbound $2.75

Dover Books on Art

200 DECORATIVE TITLE-PAGES, edited by A. Nesbitt. Fascinating and informative from a historical point of view, this beautiful collection of decorated titles will be a great inspiration to students of design, commercial artists, advertising designers, etc. A complete survey of the genre from the first known decorated title to work in the first decades of this century. Bibliography and sources of the plates. 222pp. $8\frac{3}{8}$ x $11\frac{1}{4}$.

T1264 Paperbound $2.75

ON THE LAWS OF JAPANESE PAINTING, H. P. Bowie. This classic work on the philosophy and technique of Japanese art is based on the author's first-hand experiences studying art in Japan. Every aspect of Japanese painting is described: the use of the brush and other materials; laws governing conception and execution; subjects for Japanese paintings, etc. The best possible substitute for a series of lessons from a great Oriental master. Index. xv + 117pp. + 66 plates. $6\frac{1}{8}$ x $9\frac{1}{4}$.

T30 Paperbound $2.25

PAINTING IN THE FAR EAST, L. Binyon. A study of over 1500 years of Oriental art by one of the world's outstanding authorities. The author chooses the most important masters in each period—Wu Tao-tzu, Toba Sojo, Kanaoka, Li Lung-mien, Masanobu, Okio, etc.—and examines the works, schools, and influence of each within their cultural context. 42 photographs. Sources of original works and selected bibliography. Notes including list of principal painters by periods. xx + 297pp. $6\frac{1}{8}$ x $9\frac{1}{4}$.

T520 Paperbound $2.50

THE ALPHABET AND ELEMENTS OF LETTERING, F. W. Goudy. A beautifully illustrated volume on the aesthetics of letters and type faces and their history and development. Each plate consists of 15 forms of a single letter with the last plate devoted to the ampersand and the numerals. "A sound guide for all persons engaged in printing or drawing," Saturday Review. 27 full-page plates. 48 additional figures. xii + 131pp. $7\frac{7}{8}$ x $10\frac{3}{4}$.

T792 Paperbound $2.25

PAINTING IN ISLAM, Sir Thomas W. Arnold. This scholarly study puts Islamic painting in its social and religious context and examines its relation to Islamic civilization in general. 65 full-page plates illustrate the text and give outstanding examples of Islamic art. 4 appendices. Index of mss. referred to. General Index. xxiv + 159pp. $6\frac{5}{8}$ x $9\frac{1}{4}$.

T1310 Paperbound $2.50

Dover Books on Art

PRINCIPLES OF ART HISTORY, H. Wölfflin. This remarkably instructive work demonstrates the tremendous change in artistic conception from the 14th to the 18th centuries, by analyzing 164 works by Botticelli, Dürer, Hobbema, Holbein, Hals, Titian, Rembrandt, Vermeer, etc., and pointing out exactly what is meant by "baroque," "classic," "primitive," "picturesque," and other basic terms of art history and criticism. "A remarkable lesson in the art of seeing," SAT. REV. OF LITERATURE. Translated from the 7th German edition. 150 illus. 254pp. 6⅛ x 9¼. T276 Paperbound $2.00

FOUNDATIONS OF MODERN ART, A. Ozenfant. Stimulating discussion of human creativity from paleolithic cave painting to modern painting, architecture, decorative arts. Fully illustrated with works of Gris, Lipchitz, Léger, Picasso, primitive, modern artifacts, architecture, industrial art, much more. 226 illustrations. 368pp. 6⅛ x 9¼. T215 Paperbound $2.50

METALWORK AND ENAMELLING, H. Maryon. Probably the best book ever written on the subject. Tells everything necessary for the home manufacture of jewelry, rings, ear pendants, bowls, etc. Covers materials, tools, soldering, filigree, setting stones, raising patterns, repoussé work, damascening, niello, cloisonné, polishing, assaying, casting, and dozens of other techniques. The best substitute for apprenticeship to a master metalworker. 363 photos and figures. 374pp. 5½ x 8½.
 T183 Clothbound $8.50

SHAKER FURNITURE, E. D. and F. Andrews. The most illuminating study of Shaker furniture ever written. Covers chronology, craftsmanship, houses, shops, etc. Includes over 200 photographs of chairs, tables, clocks, beds, benches, etc. "Mr. & Mrs. Andrews know all there is to know about Shaker furniture," Mark Van Doren, NATION. 48 full-page plates. 192pp. 7⅞ x 10¾. T679 Paperbound $2.25

ANIMAL DRAWING: ANATOMY AND ACTION FOR ARTISTS, C. R. Knight. 158 studies, with full accompanying text, of such animals as the gorilla, bear, bison, dromedary, camel, vulture, pelican, iguana, shark, etc., by one of the greatest modern masters of animal drawing. Innumerable tips on how to get life expression into your work. "An excellent reference work," SAN FRANCISCO CHRONICLE. 158 illustrations. 156pp. 10½ x 8½. T426 Paperbound $2.75

Dover Books on Art

AFRICAN SCULPTURE, Ladislas Segy. 163 full-page plates illustrating masks, fertility figures, ceremonial objects, etc., of 50 West and Central African tribes—95% never before illustrated. 34-page introduction to African sculpture. "Mr. Segy is one of its top authorities," NEW YORKER. 164 full-page photographic plates. Introduction. Bibliography. 244pp. 6⅛ x 9¼.

T396 Paperbound $2.25

CALLIGRAPHY, J. G. Schwandner. First reprinting in 200 years of this legendary book of beautiful handwriting. Over 300 ornamental initials, 12 complete calligraphic alphabets, over 150 ornate frames and panels, 75 calligraphic pictures of cherubs, stags, lions, etc., thousands of flourishes, scrolls, etc., by the greatest 18th-century masters. All material can be copied or adapted without permission. Historical introduction. 158 full-page plates. 368pp. 9 x 13.

T475 Clothbound $10.00

A DIDEROT PICTORIAL ENCYCLOPEDIA OF TRADES AND INDUSTRY. Manufacturing and the Technical Arts in Plates Selected from "L'Encyclopédie ou Dictionnaire Raisonné des Sciences, des Arts, et des Métiers," of Denis Diderot, edited with text by C. Gillispie. Over 2000 illustrations on 485 full-page plates. Magnificent 18th-century engravings of men, women, and children working at such trades as milling flour, cheesemaking, charcoal burning, mining, silverplating, shoeing horses, making fine glass, printing, hundreds more, showing details of machinery, different steps in sequence, etc. A remarkable art work, but also the largest collection of working figures in print, copyright-free, for art directors, designers, etc. Two vols. 920pp. 9 x 12. Heavy library cloth.

T421 Two volume set $22.50

SILK SCREEN TECHNIQUES, J. Biegeleisen, M. Cohn. A practical step-by-step home course in one of the most versatile, least expensive graphic arts processes. How to build an inexpensive silk screen, prepare stencils, print, achieve special textures, use color, etc. Every step explained, diagrammed. 149 illustrations, 201pp. 6⅛ x 9¼.

T433 Paperbound $2.00

STICKS AND STONES, Lewis Mumford. An examination of forces influencing American architecture: the medieval tradition in early New England, the classical influence in Jefferson's time, the Brown Decades, the imperial facade, the machine age, etc. "A truly remarkable book," SAT. REV. OF LITERATURE. 2nd revised edition. 21 illus. xvii + 240pp. 5⅜ x 8.

T202 Paperbound $2.00

Dover Books on Art

ART ANATOMY, Dr. William Rimmer. One of the few books on art anatomy that are themselves works of art, this is a faithful reproduction (rearranged for handy use) of the extremely rare masterpiece of the famous 19th century anatomist, sculptor, and art teacher. Beautiful, clear line drawings show every part of the body—bony structure, muscles, features, etc. Unusual are the sections on falling bodies, foreshortenings, muscles in tension, grotesque personalities, and Rimmer's remarkable interpretation of emotions and personalities as expressed by facial features. It will supplement every other book on art anatomy you are likely to have. Reproduced clearer than the lithographic original (which sells for $500 on up on the rare book market.) Over 1,200 illustrations. xiii + 153pp. 7¾ x 10¾.

T908 Paperbound $2.25

THE CRAFTSMAN'S HANDBOOK, Cennino Cennini. The finest English translation of IL LIBRO DELL' ARTE, the 15th century introduction to art technique that is both a mirror of Quatrocento life and a source of many useful but nearly forgotten facets of the painter's art. 4 illustrations. xxvii + 142pp. D. V. Thompson, translator. 5⅜ x 8.

T54 Paperbound $1.75

THE BROWN DECADES, Lewis Mumford. A picture of the "buried renaissance" of the post-Civil War period, and the founding of modern architecture (Sullivan, Richardson, Root, Roebling), landscape development (Marsh, Olmstead, Eliot), and the graphic arts (Homer, Eakins, Ryder). 2nd revised, enlarged edition. Bibliography. 12 illustrations. xiv + 266 pp. 5⅜ x 8.

T200 Paperbound $1.75

THE HUMAN FIGURE, J. H. Vanderpoel. Not just a picture book, but a complete course by a famous figure artist. Extensive text, illustrated by 430 pencil and charcoal drawings of both male and female anatomy. 2nd enlarged edition. Foreword. 430 illus. 143pp. 6⅛ x 9¼.

T432 Paperbound $1.45

PINE FURNITURE OF EARLY NEW ENGLAND, R. H. Kettell. Over 400 illustrations, over 50 working drawings of early New England chairs, benches, beds, cupboards, mirrors, shelves, tables, other furniture esteemed for simple beauty and character. "Rich store of illustrations . . . emphasizes the individuality and varied design," ANTIQUES. 413 illustrations, 55 working drawings. 475pp. 8 x 10¾.

T145 Clothbound $10.00

Dover Books on Art

*THE COMPLETE BOOK OF SILK SCREEN PRINTING PRO-
DUCTION, J. I. Biegeleisen.* Here is a clear and complete picture
of every aspect of silk screen technique and press operation—
from individually operated manual presses to modern automatic
ones. Unsurpassed as a guidebook for setting up shop, making
shop operation more efficient, finding out about latest methods
and equipment; or as a textbook for use in teaching, studying,
or learning all aspects of the profession. 124 figures. Index. Bibli-
ography. List of Supply Sources. xi + 253pp. 5⅜ x 8½.
 T1100 Paperbound $2.00

A HISTORY OF COSTUME, Carl Köhler. The most reliable and
authentic account of the development of dress from ancient times
through the 19th century. Based on actual pieces of clothing that
have survived, using paintings, statues and other reproductions
only where originals no longer exist. Hundreds of illustrations,
including detailed patterns for many articles. Highly useful for
theatre and movie directors, fashion designers, illustrators,
teachers. Edited and augmented by Emma von Sichart. Trans-
lated by Alexander K. Dallas. 594 illustrations. 464pp. 5⅛ x 7⅛.
 T1030 Paperbound $2.75

CHINESE HOUSEHOLD FURNITURE, G. N. Kates. A sum-
mary of virtually everything that is known about authentic
Chinese furniture before it was contaminated by the influence
of the West. The text covers history of styles, materials used,
principles of design and craftsmanship, and furniture arrange-
ment—all fully illustrated. xiii + 190pp. 5⅜ x 8½.
 T958 Paperbound ⁻$1.50

THE COMPLETE WOODCUTS OF ALBRECHT DURER,
edited by Dr. Willi Kurth. Albrecht Dürer was a master in vari-
ous media, but it was in woodcut design that his creative genius
reached its highest expression. Here are all of his extant wood-
cuts, a collection of over 300 great works, many of which are
not available elsewhere. An indispensable work for the art his-
torian and critic and all art lovers. 346 plates. Index. 285pp.
8½ x 12¼. T1097 Paperbound $2.50

*Dover publishes books on commercial art, art history, crafts, design, art
classics; also books on music, literature, science, mathematics, puzzles and enter-
tainments, chess, engineering, biology, philosophy, psychology, languages, history, and
other fields. For free circulars write to Dept. DA, Dover Publications, Inc., 180
Varick St., New York, N.Y. 10014.*